The Art
of the American
Snapshot

1888–1978

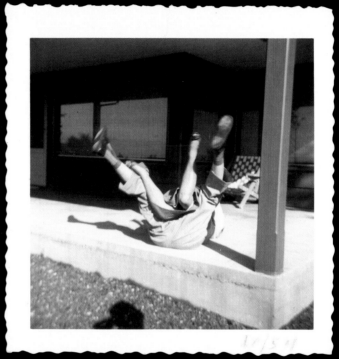

The Art
of the American
Snapshot
1888–1978

From the Collection of
Robert E. Jackson

Sarah Greenough and Diane Waggoner
with Sarah Kennel and Matthew S. Witkovsky

National Gallery of Art, Washington
in association with Princeton University Press

This exhibition was organized by the National Gallery of Art, Washington

The exhibition is made possible through the generous support of the Trellis Fund and The Ryna and Melvin Cohen Family Foundation

Exhibition dates

National Gallery of Art
October 7–December 31, 2007

Amon Carter Museum, Fort Worth
February 16–April 27, 2008

Library of Congress
Cataloging-in-Publication Data

Greenough, Sarah
The art of the American snapshot, 1888–1978: from the collection of Robert E. Jackson / Sarah Greenough and Diane Waggoner ; with Sarah Kennel and Matthew S. Witkovsky.
 p. cm.
Includes bibliographical references and index.

ISBN 13: 978-0-691-13368-3
(hardcover: alk. paper)
ISBN 13: 978-0-89468-343-5
(softcover: alk. paper)

1. Photography — United States — History — 19th century — Exhibitions. 2. Photography — United States — History — 20th century — Exhibitions. I. Waggoner, Diane. II. Kennel, Sarah. III. Witkovsky, Matthew S. IV. National Gallery of Art (U.S.) V. Title.

TR23.G74 2007
770.973—dc22 2007015393

Published with the assistance of The Getty Foundation

Produced by the Publishing Office, National Gallery of Art, Washington
www.nga.gov

Judy Metro, Editor in chief
Chris Vogel, Production manager
Tam Curry Bryfogle, Senior editor

Designed by Margaret Bauer, Washington, DC
Separations in four-color process plus PMS by Robert J. Hennessey

Typeset in Chapparel Pro and Univers by Duke & Company, Devon, PA; printed on PhoeniXmotion Xantur by EuroGrafica, SpA, Vicenza, Italy

Hardcover edition published in 2007 by the National Gallery of Art, Washington, in association with Princeton University Press

Princeton University Press, 41 William Street, Princeton, New Jersey 08540

In the United Kingdom: Princeton University Press, 3 Market Place, Woodstock, Oxfordshire OX20 1SY
press.princeton.edu

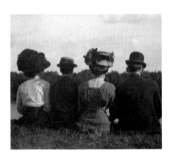

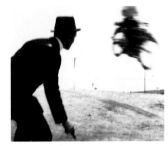

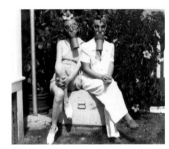

7 73 147

Contents

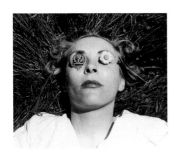

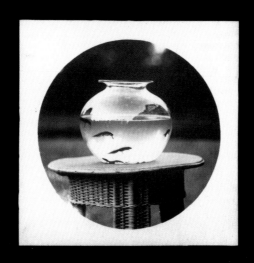

Director's Foreword / Earl A. Powell III

In the last two decades the National Gallery of Art has organized many photography exhibitions. Some, like *Robert Frank: Moving Out* (1994), *All the Mighty World: The Photographs of Roger Fenton, 1852–1860* (2004), or *André Kertész* (2005), have focused on the accomplishments of seminal figures in the history of photography to present insights into the nature and extent of their accomplishments. Others, like *On the Art of Fixing a Shadow: 150 Years of Photography* (1989), *Modern Art and America: Alfred Stieglitz and His New York Galleries* (2001), *The Streets of New York: American Photographs from the Collection, 1938–1958* (2006), or *Foto: Modernity in Central Europe, 1918–1945* (2007), have examined work by many individuals to indicate the fertile exchange of ideas that inspired the creation of some of the finest examples of the art of photography. But never before have we devoted an entire exhibition to anonymous snapshots.

Our reasons for presenting *The Art of the American Snapshot, 1888–1978: From the Collection of Robert E. Jackson* are numerous. In the years since 1888, when George Eastman and others made it possible for anyone to make a photograph, billions of snapshots have been made in this country alone. Most of them poignantly remind their makers of a person, place, or event with special meaning or importance to their lives. But some, whether by intention

or accident, soar above their purely personal associations to reveal more fundamental aspects of American photography and American life. It is these kinds of snapshots that this catalogue and its accompanying exhibition celebrate. As the following essays make clear, American snapshots are not naïve or artistically ignorant but are informed by a rich vocabulary of shared subjects, approaches, and styles that have evolved over time in response to changing technologies and cultural influences. As we stand at the dawn of the digital age, it is also increasingly clear that silver-based snapshots, like those included in this exhibition, are things of the past. As such, they have a history that deserves to be more fully studied.

This catalogue and exhibition are drawn from the collection of Robert E. Jackson. Trained as an art historian before turning to business, Mr. Jackson has assembled over the last ten years one of the foremost collections of American snapshots. It is distinguished by its quality and breadth and also by the new insights it provides into the art of this humble but profoundly influential medium. We are deeply grateful to Mr. Jackson for working with us to bring this exhibition to fruition and for his donation of 138 snapshots to the National Gallery's photography collection. We also wish to thank him for sharing with us his unwavering belief that creativity is not solely the province of artists but resides in all of us.

While Mr. Jackson's finely tuned eye and keen understanding of snapshots informs all our efforts with this project, the curators here at the National Gallery responsible for the conception, selection, and organization of the exhibition were Sarah Greenough, curator and head of the department of photographs, and Diane Waggoner, assistant curator in the department of photographs. Both have written essays for the catalogue, as have Sarah Kennel and Matthew Witkovsky, assistant curators in the department of photographs.

I wish also to extend our thanks to the Getty Foundation for their support of this important publication. Our deepest gratitude goes to Ryna and Melvin Cohen of the Ryna and Melvin Cohen Family Foundation and especially to Betsy Karel of the Trellis Fund for their strong and loyal support, which has enabled us in the past three years to present an ambitious series of beautiful and thought-provoking exhibitions of photographs at the National Gallery.

Note to the Reader

Snapshots in the catalogue, both plates and comparative figures, are either in the collection of Robert E. Jackson or in the collection of the National Gallery of Art, Gift of Robert E. Jackson (see p. 294).

Plates illustrating snapshots in the exhibition are numbered in red throughout, whether they appear within the essays or in the plate section following each essay.

Snapshots are reproduced close to actual size, with the exception of those mounted on album pages (see pls. 16a–b, 17a–b, 18a–b, 41, and figs. 1.10, 1.15–1.17, 2.2).

Most have been taken by unknown photographers and have no formal titles, but if original inscriptions appear on either the recto or verso of the snapshot, they are quoted, usually in full, in the captions.

Specific dates or places are derived from information provided on the photographs, in most cases inscriptions or photo-processing stamps.

General dates are estimated based on subject matter, motifs, styles, photographic techniques, or other factors characteristic of the periods.

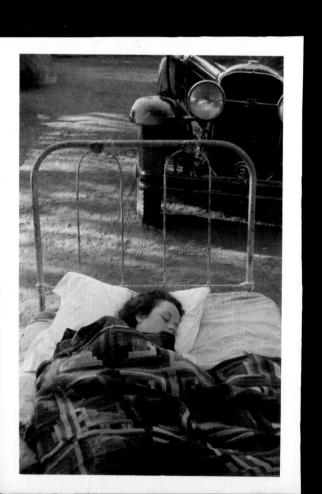

Introduction / Sarah Greenough

In 1902 Charles M. Taylor wrote a book titled *Why My Photographs Are Bad* in the hope that his study would "aid the ambitious beginner, and enable him to avoid the most common mistakes incident to the first stages of this interesting study."[1] Noting that photography demanded "perseverance almost equal to that bestowed upon the kindred arts," he cautioned that readers should not expect to master its intricacies "in too short a time and without labor and study."[2] He urged them to join camera clubs and seek out training from commercial photographers. Illustrating his book with "good" and "bad" photographs, Taylor described typical "mistakes" amateurs made, such as double exposures, abruptly cropped or out-of-focus forms, tilted horizons, or the inclusion of the photographer's shadow. And he gave hints on how to correct these gaffes: to avoid blurred portraits, he suggested using a headrest; to eliminate the photographer's shadow, he recommended working at midday. While he admired the originality of snapshots and their strong personal associations, certain types of photographs, he said, were far too difficult and should simply not be attempted. For example, he admonished amateurs not to take instantaneous photographs because they did not give the photographer time to study the scene carefully enough to achieve the best results.

With such rote prescriptions, Taylor's "good" photographs are, not surprisingly, stiff, bland, and boring. Not only do they possess none of the humor of the "bad" photographs, but they have none of their immediacy or authenticity. Nor has Taylor's book stood the test of time. Only a few years after its publication, artists associated with dada and surrealism celebrated snapshots as a rich reservoir of antirational activity, where chance and contingency reigned supreme. At the same time, such photographers as André Kertész, Henri Cartier-Bresson, or Martin Munkácsi were deeply inspired by the freer, looser style they saw in snapshots. They, as well as later artists such as Lisette Model, Robert Frank, Lee Friedlander, or Garry Winogrand, freely exploited all of Taylor's "mistakes," including blurry or abruptly cropped forms, tilted horizons, and their own shadows within the photographs. Keen to catch life on the fly, they also embraced instantaneous photography. Some were known to shoot their cameras blindly, without even looking through the viewfinders to construct their compositions. They did this not only to suggest the partial and fleeting nature of contemporary experience and to impart a sense of veracity and authority to their works but also to celebrate the accidental quality of both modern life and modern photography. Demonstrating the visual richness and the conceptual fecundity of the humble snapshot, still other artists in the 1960s and 1970s, among them Vito Acconci and Dan Graham, appropriated its banality and deadpan, artless nonstyle as they used it to document their projects and also to rid their work of formal interest and affectation. More recent photographers such as Philip Lorca diCorcia or Jeff Wall embraced the look of snapshots, even though their photographs are actually carefully constructed and controlled.

As snapshots seeped into every aspect of twentieth-century fine art photography, the language of the snapshot became the medium's universal parlance. The term itself derives from hunting and refers to a shot quickly fired with little or no aim, but it began to be applied to photographs in the 1890s following the invention of the Kodak camera.[3] By the 1940s and 1950s photographers like Model or Frank did not say they had "made" or "exposed" their photographs, as earlier counterparts had, but instead said they had "shot" them. Indeed, Model implored her students to "shoot from the gut."[4] Carrying the hunting analogy still further, Walker Evans said of his photographs surreptitiously made on the New York subways in the late 1930s and early 1940s, "I am stalking, as in the hunt. What a bagful to be taken home."[5]

The National Gallery of Art is not in the habit of celebrating bad works of art, and the photographs included in this catalogue and the accompanying exhibition are, like all other works presented in this museum, worthy of serious consideration. For more than a hundred years, snapshots — that is, photographs that are casually made, usually by untrained amateurs, and intended to function as documents of personal history — have fascinated, perplexed, and challenged all who are interested in photography. They call into question our most basic ideas about the medium — its ontology, its history, and its place within twentieth-century culture. Striving to assess the profound power of these modest photographs, the seminal theoretician Roland Barthes used a snapshot of his mother as a way to understand "at all costs what photography was 'in itself.'"[6] From it he derived the twin concepts of *studium* — the cultural, linguistic, and political interpretations of a photograph — and *punctum,* the often highly personal detail that establishes a

connection between the viewer and the photograph.[7] Historians such as Michael Lesy have examined commercial photographs and snapshots in relation to other contemporary documents, including newspaper or archival records, thus reinvigorating the photographs with many of the associations and meanings they had for their original viewers.[8] Other scholars have explored the importance of snapshots as cultural artifacts that provide significant insights into the ways people in the twentieth century lived and worked, how they related to each other, and how they amused themselves. And they have discussed the profound role that snapshots have played in the creation of personal, familial, group, or ethnic identity as well as memory in the twentieth century.[9]

Curators, too, have recognized that some snapshots, once they are removed from the personal narratives that impelled their creation and endowed them with their original meanings, are immensely satisfying visual objects, worthy of careful scrutiny. Since modernist photographs first began to be regularly exhibited in American art museums in the late 1930s, snapshots and the questions they raise about the relationship between amateur and fine art photography have also been addressed. In 1944 the Museum of Modern Art mounted an exhibition titled *The American Snapshot,* which actually included 350 award-winning amateur photographs that had been submitted to contests sponsored by Kodak and were later reprinted and recropped, either by Kodak or the museum curators.[10] A little more than twenty years later John Szarkowski presented a far more serious examination of the subject, also at the Museum of Modern Art, in his highly influential exhibition and catalogue, *The Photographer's Eye.* He asserted that photographers could create meaningful pictures either by being "artistically ignorant" or by abandoning their allegiance to traditional

pictorial standards inherited from painting and the other arts.[11] To illustrate his points he compared works by well-known photographers, commercial images, and "artistically ignorant" snapshots, positing that five technical components (thing, detail, frame, time, and vantage point) were fundamental elements of all photographs, regardless of authorship.

In recent years snapshots have frequently appeared on the walls of art museums, often presented as more humble but no less satisfying counterparts to the pantheon of modernist photographers from Kertész to Winogrand whose works usually hang there. Two of the most important exhibitions were *Snapshots: The Photography of Everyday Life, 1888 to the Present,* at the San Francisco Museum of Modern Art in 1998, and *Other Pictures: Anonymous Photographs from the Thomas Walther Collection,* at the Metropolitan Museum of Art in 2000.[12] Each of these exhibitions presented many snapshots whose defects — abruptly cropped forms, double exposures, botched exposures, or even poorly articulated subjects — created odd but sometimes unexpectedly compelling images. By focusing on those works that Mia Fineman, curator of the Metropolitan's exhibition, dubbed "successful failures," these museums celebrated the same "bad" photographs that Taylor had condemned almost a hundred years earlier.[13] But in so doing, they also gave greater weight and authority to the collector or curator who had the vision to pluck these gems from the formidable morass of snapshots than to the ingenuity or creativity of the photographers themselves.

Despite this extensive scrutiny, however, few scholars, historians, or curators have examined the evolution of this popular art in America. Even though snapshots have existed for more than a hundred years, most people have viewed them as

a monolithic entity with an unvarying palette of subjects and styles, an inflexible set of intentions, and a predictable bag of mistakes. Few have looked at snapshots in a chronological manner or examined them as a historical phenomenon; few have noted the stylistic and thematic similarities as well as the common tricks and technical gaffes of snapshots made by amateurs around the country at the same time; few have charted the cultural influences and technological advances that both encouraged amateurs to embrace new subjects and styles and forced them to confront new pictorial challenges; few have addressed the notions each generation shared about what constituted correct behavior when posing for the camera; and few have examined the transformation of snapshot imagery over time. That is what this book and exhibition seek to do.

We begin our study in 1888 with the release of the first Kodak camera, which launched the invention of the photo-finishing industry, enabling anyone who could press a button to become a photographer. In the first essay in this book Diane Waggoner examines the kinds of photographs amateurs made from the late 1880s through World War I, when they were first given the opportunity to document and memorialize their lives. Noting the large number of staged snapshots from this time, which defy the commonly held belief that most snapshots are dependent on chance, she analyzes the subjects and practices that amateurs used at the turn of the century, which had their roots in earlier nineteenth-century customs, such as amateur theatricals. She also considers the ways in which the camera and the act of taking snapshots became enmeshed with new forms of leisure and the desire for self-definition. In the second essay Sarah Kennel examines the 1920s and 1930s, particularly how prewar methods of self-representation and the docu-

mentation of pleasure merged with a self-conscious desire for modernity. New technologies — not only faster films but lighter and better cameras — greatly assisted the amateur, yet they alone do not explain the newfound interest in exploiting the unique ways in which the camera depicts the world. Instead, Kennel suggests that the larger popular culture — the advent of photographically illustrated newspapers and periodicals and the profusion of technical manuals and illustrated magazines directed specifically at the amateur — inspired much of this transformation. In the third essay I focus on the 1940s and 1950s, examining the pervasiveness of photographic imagery in the postwar era, which was propelled both by the advent and soon almost universal embrace of television and by the new affordability and ease of photography — coupled, after the 1947 invention of the Polaroid camera, with its now nearly instant gratification. As everything and anything became suitable subjects for photography in this period, amateurs began to explore aspects of their private lives that had not previously been within the scope of their cameras and at the same time came to see photography as a vehicle for self-promotion, even fame. The final essay by Matthew Witkovsky looks at the 1960s and 1970s, which were characterized by the collision of public and private worlds, when the camera became the constant accessory of modern life, the bracelet that hung on the wrist of all young "swingers"; when all things were photographed, nothing was held sacred, and human activity became ritualized into a series of opportunities to be photographed. His essay examines the pictorial impact of the square-format cameras that were so widely embraced in these decades and discusses the profusion of artists who consciously adopted a snapshot aesthetic and snapshot subjects.

Since the 1970s critics such as Susan Sontag and Janet Malcolm have observed that the patina of time will transform any artifact into an object of veneration, even art, and Malcolm in particular has warned against the resulting commodification that inevitably occurs.[14] These dangers are certainly worthy of consideration, but when applied to the history of photography, they become especially murky, for the vast majority of photographs — from daguerreotypes made by anonymous itinerant photographers in the 1840s, to studies of the New York slums at the turn of the century, to NASA photographs of the moon from the 1960s — were not made by people who considered themselves artists, nor were they made to be art. Rather, created as personal, social, governmental, or scientific documents, they were made as cherished keepsakes of beloved friends or family members, as evidence of squalor and deprivation for use in social or governmental reform, or as records of new worlds. And just as often, the primary agent behind their creation and their intended initial use was not the photographer, the mere operator of the camera, but the individual who conceived and commissioned them. These kinds of photographs, which are now commonly described as vernacular and understood to be any photograph not made specifically as art, are also very often anonymous. Thus the usual art historical issues of intention and chronology are complicated and uncertain at best; and the appellations of genius and masterpiece, as well as the issue of canon, are rendered meaningless.[15]

Snapshots pose their own set of challenges and opportunities. Unlike other kinds of vernacular photographs — commercial studio portraits, for example — they are made for pleasure not profit. Liberated from the constraints of the marketplace, they are curious mixtures of originality and conventionality that often present highly inventive pictorial solutions — whether by accident or intent — while simultaneously preserving inherited subjects and poses. As art historians look at them more carefully, we quickly realize that they are neither naïve nor artistically ignorant and that they show from one time period or generation to the next an evolution of style, subject matter, and function. But snapshots also raise ethical questions. Made purely for private not public consumption, they were never intended to be seen on the walls of museums or reproduced in books. In the almost sixty years since the advent of the 1948 television show *Candid Camera,* which popularized the notion that anyone could achieve fame and notoriety by being captured unexpectedly by the camera and appearing on television or in print, Americans have not just become inured to the camera's very real invasions of privacy but have even courted it with MySpace and YouTube. We should admit, however, that part of the allure, even the frisson, evoked by the humble, predominantly twentieth-century snapshots presented in this book and exhibition is due not only to what we perceive to be their charming naïveté but also to the voyeurism in which we, as more media-savvy twenty-first-century viewers, indulge when looking at them. These are private moments, deeply felt and authentic, and we are the interlopers. Walker Evans waited more than twenty years to publish his subway photographs in a book, hoping that "the rude and impudent invasion [had] been carefully softened and partially mitigated by a planned passage of time."[16] While the sentiment may seem quaint, the example is worth noting.

In addition, though, snapshots have provided a new impetus for a critical reevaluation of the history of photography.[17] Confined until recently to the study of a modernist canon established in

the late 1930s, most histories of photography have examined only a very narrow range of photographic practice, including those twentieth-century photographs made expressly as art and the nineteenth-century ones that were deemed to be their precedents and thus gave the later works a foundation of tradition and authority. Yet because of the immense appeal of snapshots, because they so clearly form a significant part of the rich visual tradition of their time, and because they have had such a profound impact on twentieth-century art and culture, historians have now begun to wrestle with the larger question of how to construct a new history of photography that addresses not only the fine art tradition but also all types of vernacular photographs, including snapshots. They have concluded, just as Alfred Stieglitz, the high priest of fine art photography, did after many years of tortuous twists and turns: "Art or not art. That is immaterial. There is photography."[18]

By some estimates, in 1977, the year before our examination ends, more than 8.9 billion snapshots were made annually in the United States, up from 3.9 billion in 1967.[19] With such a truly staggering number of potential candidates for inclusion in our exhibition and publication, the question of selection becomes critical. We have based our presentation on a collection of more than 8,000 snapshots assembled in the last ten years by Robert E. Jackson of Seattle. If his collection represents one small drop in the vast sea of snapshot photographs, then our selection of approximately two hundred of those works is but a few nanoliters of that larger whole. Collectors of snapshots can approach the subject in many ways. Like stamp collectors, they can seek to acquire one representative illustration of each subject ever explored by amateurs, or like archivists, they can endeavor to preserve the origi-

nal contexts — the albums, drugstore processing envelopes, or shoeboxes — where the snapshots once resided. Those primarily interested in American history or even specific issues within that history — the depiction of marginalized aspects of society, for example — can focus exclusively on snapshots that illustrate those subjects. But taxonomy, recontextualization, and American history were not Mr. Jackson's primary objective, nor did he confine his collection to representing the felicitous gaffes that so commonly befell the hapless amateur. Instead, Mr. Jackson has focused on creativity, on those snapshots that break down the barriers of time, transcending their initial function as documents of a specific person or place, to speak with an energy that is raw, palpable, and genuine about the mysteries and delights of both American photography and American life. The snapshots presented in these pages exert an undeniable power. Honest, unpretentious, and deeply mesmerizing, they show us moments of simple truth. They tell us what it felt like to live, work, and most especially to love and have fun in the twentieth century; they remind us of our past and vividly demonstrate how much our past has in common with that of so many other Americans; and they show us, in a way that is both direct and profound, what a truly extraordinary thing photography is.

DIANE WAGGONER

Photographic
Amusements

1888–1919

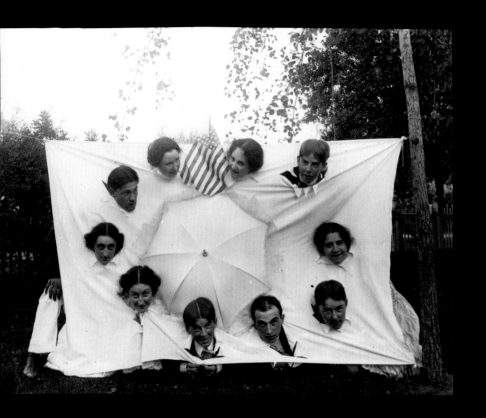

1

—

**gelatin
silver print,
c. 1910**

Within the first fifty years after its invention in the late 1830s, photography evolved from a wondrous curiosity to a part of everyday life. By the 1880s photographs already adorned the walls, mantelpieces, and tables in countless homes across America, displayed in every nook and cranny from the parlor to the bedroom (fig. 1.1). Portraits of famous people and views of native and exotic landscapes were inexpensive and plentiful. Burgeoning numbers of local photographers' studios, which produced *cartes-de-visite* or tintypes, made portrait photography accessible and affordable for most Americans. But the ability to *take* a photograph — to operate a camera, develop negatives, and make prints — remained the province of the professional or the skilled amateur with the requisite leisure, enthusiasm, and technical expertise to pursue the craft. It was not until the average person was able to take photographs that the history of the snapshot begins.

A series of landmark technological inventions transformed the practice of photography, making snapshots possible. The cumulative effect of these changes redefined what was considered feasible — and appropriate — for the medium. First, the introduction of commercially manufactured gelatin dry-plate glass negatives in the late 1870s reduced the need for unwieldy paraphernalia, and smaller, lighter, handheld cameras that accommodated these plates

began to replace large cameras mounted on tripods. Then the introduction of flexible film negatives and roll holders gradually made the heavy glass plate negatives obsolete, and cameras became even more portable. Although one had been able to take instantaneous photographs under certain conditions, most photographs required more than a second of exposure time, effectively limiting their subjects to carefully posed portraits, landscapes, and other static compositions. But improvements in lenses and in the light sensitivity of negative emulsions soon made instantaneous exposures increasingly viable: hence the advent of the "snapshot"—a term originally used in hunting to refer to a gunshot fired quickly and haphazardly. The business of photography, which had been almost exclusively an individualized craft, became an industrialized operation, in which the labor-intensive, time-consuming, and complicated tasks of developing and printing were

offered as a service product. Finally, as photography grew less expensive, it could be practiced by men and women of most ages and economic classes.

This transformation in photography during the last decades of the nineteenth century corresponded to the growth of other technological innovations that were changing the character of American life: the harnessing of electricity, the invention of the telephone and telegraph, the greater mobility brought about first by railroads, then by streetcars and bicycles, and ultimately by the automobile in the early twentieth century. Each of these leaps forward collapsed distances and accelerated the pace of life. Meanwhile, industrialization created a larger and more prosperous middle class. Responding to such dramatic developments, Americans embraced the idea of the family and domesticity as the greatest source of personal happiness, which led, in concrete terms, to the rise of the middle-class, single-

1.1
—
gelatin
silver print,
c. 1900

1.2
—
"Evolution
of a smile,"
gelatin
silver print,
c. 1910

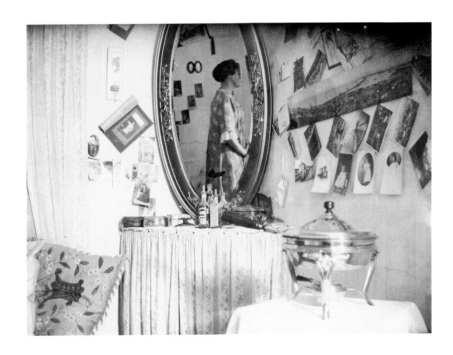

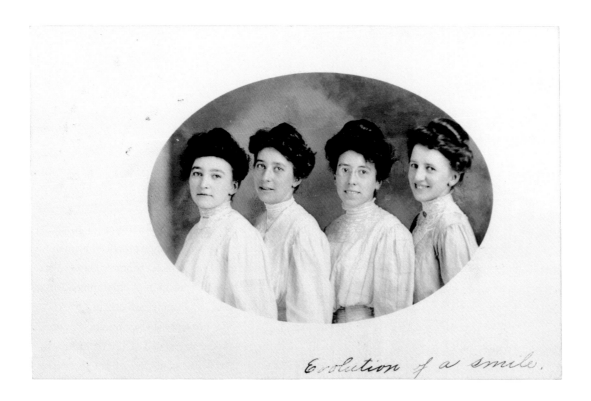

Evolution of a smile.

family, detached home and the expansion of the suburbs — soon to be the site of so many snapshots.[1] The emphasis on family led in turn to a higher value placed on childhood as a time of innocence,[2] while the concept of adolescence as a separate stage of life, distinct from childhood and adulthood, also received new attention.[3] The rise of a consumer society and the pursuit of leisure activities articulated a consequent division between work and play.

In shifting from the tripod to the hand, the camera tracked this evolution to a faster-paced society. It promoted the growing interest in leisure, recreation, and travel as well as the ideal of childhood and family life. When the hand camera placed new amateurs in charge of creating their own images, they immediately chose to photograph those people and things and places they held dear, recording their domestic and social lives and attempting to convey happiness, satisfaction, and confidence. Before this time the studio portrait, in which the sitter held a pose for several seconds in an unfamiliar setting, would have been the only kind of personal photograph that most Americans knew. The instantaneous exposure, as opposed to the timed one, encouraged subjects to relax more and even to smile, particularly when posing for someone close to them. One image titled "Evolution of a smile" plays with the idea of being asked to smile for a photographer

(fig. 1.2). In addition, adapting to the abundance of exposures in the new rolls of film, amateurs felt free to experiment visually and to explore new subject matter. Still, older models persisted, as seen in the staged qualities of much early snapshot photography. The choice of subjects was guided to some extent both by the photographic industry and by established amateurs. Unlike the earlier conventions of seriousness, however, both the experimentation and theatricality of the new snapshots were almost uniformly injected with humor: photography served as an amusement. To the first-time purchaser of the new hand camera, the initial glimpse of photographs of the family home, one's children and pets, a vacation vista, a picnic with friends, or the performance of a skit must have seemed marvelous indeed.

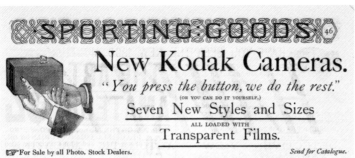
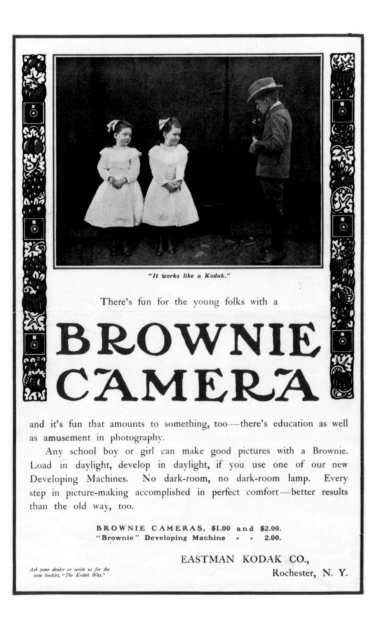
George Eastman and the Kodak

Although many practitioners and institutions in Europe and America contributed to the development of snapshot technology, George Eastman (1854–1932) and his company's Kodak camera had the greatest impact. Eastman dramatically altered the business and thus the art of photography, creating an ever-widening market of amateur photographers. In 1881 he founded the Eastman Dry Plate Company in Rochester, New York, to produce gelatin dry-plate glass negatives in mass quantities. In 1884, to simplify photography and eliminate cumbersome glass plates, he invented paper negatives spooled onto a roll holder that fit into most standard plate cameras of the time. Building on this innovation, he launched the "Kodak" hand camera, preloaded with a roll of paper negatives in 1888, coining the name because it was unique and could not be mispronounced. He advertised the camera with the slogan "You press the button, we do the rest," neatly encapsulating his strategy for tapping into a new market of photographers (fig. 1.3).[4]

The design of the Kodak camera did not differ significantly from earlier hand cameras that held gelatin dry-plate negatives. The Kodak and its quick successor, the No. 1 Kodak, were simple boxes weighing about 1.3 pounds. They had a string mechanism to cock the shutter and a button to release it, and they made exposures at a shutter speed of 1/25 second.[5] A key turned the roll holder to advance the film. Because the inexpensive lens projected onto the film a circular image with soft-focused edges, a mask was inserted into the camera to obscure the distortions at the perimeter and create images with sharply defined borders. The earliest Kodaks therefore made images that were distinctively round, 2½ inches in diameter (see pl. 39).

Printed by direct contact with the negatives, these snapshots had essentially the same size and format as the negatives. In some cases the prints were masked to create a white border or trimmed to the edges before being mounted on individual cards or album pages. The cost of the first Kodak was $25, comparable to the price of other hand cameras on the market, but nevertheless a large sum for Americans of middle-class income. Eastman produced 3,250 Kodaks in the first two years. The No. 2 Kodak, which made circular negatives (and corresponding prints) 3½ inches in diameter, followed in 1889, with 7,000 manufactured by the next year.[6]

The first Kodaks did not include a viewfinder, so the earliest "Kodaker" could not see exactly what would be captured in the photographic frame as he or she exposed the film. The No. 2 Kodak and subsequent models did include small viewfinders, placed so that the photographer held the camera at waist or chest level and looked down into it (fig. 1.4). Yet it was difficult to see clearly with the tiny viewfinder. One photographer characterized it as a "dimly lit one-inch square," and another listed some of the mistakes easily caused by it: "Groups are taken with the marginal figures left out, and central figures off to one side apparently looking for them. It is in vain that one strains one's eyes looking out into the finder in the blaze of a noonday sun."[7]

The service aspect of the Kodak system ("we do the rest") was the Eastman company's greatest success. Customers sent the entire camera to the Rochester factory when the exposures on the preloaded film were ready for developing and printing. Initially, Eastman's American Film, as it was called, was made of paper coated with an emulsion. To make transparent negatives, the emulsion was transferred from the paper to a glass plate and subsequently to a thin, flexible gelatin support. The

Kodak factory would make prints from these negatives, then send the prints and the camera, loaded with a new roll of film, back to the customer for a cost of $10. This freed the individual photographer from having to set up a darkroom and learn how to load negative film and develop prints. As a Kodak sample album proclaimed, "Reader! You, Anyone, can make photographs...without study, trouble, experiment, chemicals, dark room, *and even without soiling the fingers*."[8]

The amateur could still undertake the labor-intensive darkroom processes on his or her own: the slogan "You press the button, we do the rest" was sometimes accompanied by the parenthetical "(Or you can do it yourself)." Manuals for the first Kodaks gave detailed instructions on how to develop and print from roll film. Eastman thus reassured experienced photographers that the Kodak did not require changing established practices and at the same time appealed to new clients who might find photography intimidating under the old system but would delight in taking pictures. Other innovations further simplified darkroom activities, and many surviving snapshots make it clear that amateurs in these decades often did their own printing.

In 1889 Eastman introduced negatives on transparent, flexible film made of cellulose nitrate, which eliminated the complicated transfer from paper to glass to gelatin support. Such transparent plastic supports would dominate the field until the appearance of the digital photograph at the end of the twentieth century. Also in 1889 Eastman released the No. 3 and No. 4 Kodak box cameras, followed in 1890 by the No. 4 and No. 5 Kodak folding cameras, each with a small viewfinder. These models were bigger, heavier, more expensive, and produced larger rectangular negatives. The No. 1 and No. 2 Kodak cameras, which had made circular

1.3
——
"New Kodak Cameras," advertisement, c. 1890. Hartman Center, Duke University

1.4
——
"Brownie Camera," advertisement, 1902. Hartman Center, Duke University

negatives, were discontinued by the mid-1890s, and rectangular prints became the most common shape for snapshots thereafter.

By continually making photography more accessible through technological innovations, Eastman Kodak (as the company came to be known in 1892) attracted an ever-expanding consumer base. In 1891 Eastman marketed cameras that allowed amateur photographers to load their own film in daylight rather than sending the entire camera back to the Kodak factory for processing. By 1902 the company had introduced the Kodak Developing Machine, which enabled customers to develop film without a darkroom. Kodak brought out non-curling film in 1903 and safety film in 1908, replacing the flammable cellulose nitrate base with a more stable cellulose acetate base. Flash technology, which made it possible to take photographs in dimly lit interiors, had relied on magnesium powders since the 1860s. In 1915 Kodak made flash photography even easier by producing "flash sheets," which no longer required powders and a lamp.

Kodak also began to sell cameras through pharmacies and department stores in addition to specialty photography shops. It was lower prices, however, that ultimately led to the explosion in the hand camera market. In 1895 the Pocket Kodak, which produced tiny negatives of 1½ × 2 inches, was offered at a price of $5. Other models were also available for under $10, and by 1898 Kodak reported that it had sold 100,000 cameras. But the major turning point was the 1900 introduction of the Brownie camera, which sold for $1, with rolls of film costing 15 cents. Eastman sold more than 150,000 Brownies in the first year alone.[9] The Brownie was similar to the Kodak but constructed of cheaper materials. Like the original Kodak, the first Brownie produced a distinctive image format: a 2½-inch

square. The No. 2 Brownie made rectangular negatives, 2¼ × 3¼ inches, as did subsequent models. Again like the original Kodak, the Brownie did not automatically come with a viewfinder, though one was available as an option. The shutter speed was 1/50 second.[10] The name of the Brownie came from folklore characters popularized by Palmer Cox in magazine illustrations and a series of children's books, thereby evoking ease of operation and magical results, as if the helpful though mischievous little creatures took the pictures themselves and produced the prints.[11] Thus Eastman promoted the Brownie primarily, but not exclusively, to children, cultivating a previously untapped market for photography (see fig. 1.4).

Although Kodak was the industry leader, it was not the only American manufacturer of cameras and film. In 1891 the Blair Camera Company, one prominent competitor, introduced the Kamaret, a handheld camera with roll film, its name echoing the catchy name of the Kodak. Blair also sold the Hawk-Eye Camera, which could accommodate either glass plates or roll film, and it advertised developing and finishing services. The Blair Company did not last long, however, as Kodak bought it outright in 1899. In fact, Kodak purchased many of its competitors, including the American Camera Company in 1898, the Folmer and Schwing Manufacturing Compan y in 1905, and Century Camera Company in 1907. Other firms, such as Seneca Camera Company, Anthony and Scovill Company (renamed Ansco in 1907), and Sears, Roebuck, and Company, challenged Kodak with their own photographic products.[12] But only Kodak became a household name for cameras.

The Serious Amateur
and Photographic Instruction

When the Kodak camera entered the market in
1888, the community of amateur photographers was
already flourishing. The availability of the gelatin
dry plate beginning in 1878 had attracted thousands
of new hobbyists to the practice of photography,
and enthusiasts from New York to San Francisco
began to organize local camera clubs, which contin-
ued to multiply through the turn of the century.
These clubs fostered social exchanges, discussion of
scientific and artistic issues, lantern-slide presen-
tations, and group exhibitions.[13] The launching
of specialized periodicals — including *The American
Amateur Photographer*, *The American Journal of
Photography*, and *Camera Craft* to name just a few —
addressed the expanding market.[14] *The American
Amateur Photographer*, for example, reported on the
activities of camera clubs across the country and
catered to the more experienced amateurs while
seeking to educate the newer class of photographers
to traditional artistic and technical standards.

There was a natural tension between ama-
teurs who considered themselves not only artists
but also technically proficient and the flood of new-
comers purchasing hand cameras that required
only the push of a button. Indeed, the instantaneous
pressing of the button became emblematic of the
new breed of photographer: Edward Steichen once
referred to them as "ye jabbering button-pushers."[15]
In 1890 Catherine Weed Barnes, a prominent
amateur and writer on photography, wrote: "Snap
cameras to the uninitiated seem almost miraculous
in their workings, while the skilled eye and hand
needful to make a properly timed exposure is
too often undervalued in comparison."[16] In "Hints
for Kodak Workers" Howard Park Dawson urged

novices "never to make an instantaneous exposure
when you can possibly make a timed one. If the
users of kodaks will follow [this]…simple [rule]
they will be surprised at the decrease of their
failures."[17]

These attitudes were typical of the educated
amateur, who insisted that the only way to learn
true photography was by placing the camera on a
tripod and making a timed exposure rather than
snapping quick pictures at random. They also main-
tained that composing and focusing the photograph
on the camera's ground-glass (a matte glass sur-
face placed at the focal plane of the camera, which
shows the image that will be projected onto the
emulsion) was superior to looking into the tiny
viewfinder of the hand camera. Although the popu-
lar literature recognized these two modes of picture
taking, the photographic establishment privileged
the older model and the composed and still images
it produced.

Fine art photography's champion Alfred
Stieglitz supported the adoption of the hand camera
for artistic work but criticized "every Tom, Dick and
Harry…[who] without trouble, learn how to get
something or other on a sensitive plate." Stieglitz
opined that "thanks to the efforts of these persons
[the] hand camera and bad work became synony-
mous."[18] Even camera companies maintained these
distinctions. As a Seneca manual asserted, "the
photographer whose knowledge has been confined
to pressing the button can never hope to make
good pictures."[19] To the photographic community of
serious amateurs, good pictures had to adhere
to the compositional rules of traditional art forms
such as painting, drawing, and printmaking.

The American Amateur Photographer published feature after feature on travel photography that advocated pretty landscapes as suitable subjects. Other new periodicals provided illustrations and detailed instructions for the new photographer. Although it is impossible to measure the impact, the sheer number of guides and manuals catering to photographers suggest that many snapshooters would have been aware of at least some of these examples.

Serious amateurs pursued different avenues to achieve good pictures, though all strove for artistic effects. Debates were common regarding the nature of photography and of art as well as the relationship between the two. Some amateurs sought to capture fine detail, while others embraced more subjective and evocative qualities. Following trends in painting, photographers adopted naturalistic, impressionistic, or aesthetic styles. What would later come to be known as pictorialism arose in reaction to the button-pushing snapshooter, and it emphasized carefully composed subjects and sophisticated craft in printmaking, with soft gradations of light and shadow.

Another style practiced by the serious amateur was the narrative or genre photograph. The British photographer H. P. Robinson, who exhibited from the 1860s until his death in 1901, argued for this aesthetic in publications such as *Pictorial Effect in Photography.* American photography periodicals in the 1880s and 1890s often reproduced Robinson's photographs, which largely depicted country people in rural or seaside landscapes. At one point the Photographers' Association of America even sponsored a competition for photographs that illustrated poems by Alfred, Lord Tennyson, which was won by Catherine Weed Barnes (fig. 1.5). Even the Seneca manual for the amateur photographer recommended adding an anecdotal element to a nature scene — "the figure of an old man sitting on a log, lost in reverie" — to make the photograph "pleasing and suggestive."[20]

This approach had its roots in the narrative photographs of the British tradition, such as works by Julia Margaret Cameron and O. G. Rejlander as well as H. P. Robinson. Those images in turn reflected the conventions of the theater and the *tableau vivant* (or living picture, a popular pastime in the nineteenth century, which American vaudeville began to incorporate in the 1890s).[21] *Tableaux vivants* presented literary or historical situations, both dramatic and comic, using elaborate costumes, props, facial expressions, and gestures. Barnes's prize-winning photograph featured all of these characteristics. Even Stieglitz often included some narrative or genre aspects in his early work before he turned more toward pictorialism.

Genre photographs appeared side by side with pictorial landscapes at amateur photography exhibitions from 1890 through 1920, and both kinds of photographs influenced snapshooters. As more novices joined local camera clubs, they sought to emulate these models and submitted their attempts to local exhibitions. Thus the serious amateurs' reaction to what they perceived as "the snapshooter run amok" was to create an artistic elite, ultimately establishing photography as a legitimate fine art in America.[22]

At the same time a whole category of literature sprang up to give advice to the everyday photographer. In addition to camera manuals, Kodak published guides such as *Picture Making and Picture*

Taking (c. 1900), *The Modern Way in Picture Making* (1905), *How to Make Good Pictures* (from 1912), and *Kodakery: A Journal for Amateur Photographers* (from September 1913). Each of these publications provided examples of "good" photographs, which emphasized images of innocent, carefree, and pretty children as well as leisure pursuits, attractive landscapes, and portraits (see fig. 1.8). They described and illustrated good vantage points, good and bad lighting for portraiture, good subjects (children, women, pets, and so on), and how to photograph tricky subjects like snow or moonlight. *Kodakery* included two-page spreads in each issue that showed photographs of these preferred subjects. These Kodak publications, including *The Modern Way of Picture Making* and various camera manuals, also recommended photographs by prominent art photographers such as Alfred Stieglitz, Rudolf Eickemeyer Jr., and H. P. Robinson as exemplars.

Other photographic firms, of course, also provided manuals with their cameras. Scovill & Adams produced a voluminous series of publications, ranging from books by H. P. Robinson to those on specific topics such as studio or landscape photography. This firm also published *Photographic Amusements* (1898) by Walter E. Woodbury, editor of *The Photographic Times*. Independent publishers issued *The Amateur Photographer's Hand Book* (1891) by Arthur Hope, *Amateur Photography: A Practical Guide for the Beginner* (1893) by W. I. Lincoln Adams, and *Why My Photographs Are Bad* (1902) by Charles M. Taylor Jr. Although some of these books were mostly technical in nature, others struck a different tone from the Kodak publications. Woodbury's book detailed several amusing and novel effects that could be obtained by experimenting with the camera: how to create silhouettes, plays on perspective, and double exposures that made ghostly forms appear. Taylor's book, asserting the difficulty of learning to use the camera properly by trial and error or by reading instruction books, listed

common mistakes and how to avoid them: portraits with heads cut off, images blurred by a subject moving, problems with foreshortening, lack of focus, unintended double exposures, shadows cast by the photographer, too much foreground or too much sky. At the end of the book Taylor furnished examples of "good" photographs, including portraits in interiors, boats on the water, views of waterfalls, carriages pulling up to a train station, a rural laborer, and a racetrack. With the exception of the laborer, these were all subjects frequently found in snapshots. All of the advice, discussion, and models available to the new amateur clearly defined what constituted a suitable photograph.

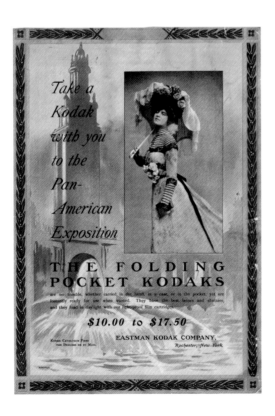

Kodak Advertising

Alongside practical guides, Kodak advertisements played a vital role in shaping how the camera was perceived and used. Just as Eastman Kodak proved the most successful in introducing and exploiting technological advances that created the amateur photography market, its savvy promotional strategy also distinguished it from its competitors and assured its dominance. "To Kodak" became a verb, and "Kodaker" a noun. The company moved beyond trade journals to establish a presence in popular magazines such as *Harper's Bazaar, Ladies' Home Journal,* and *Youth's Companion,* which were growing in circulation. As a Kodak employee of 1918 explained, "Mr. Eastman realized fully that it was the *charm of photography,* not merely his little twenty-five dollar black box, that must be sold to the public."[23] Kodak's emphasis on advertising is consistent with the emerging commodity culture at the turn of the century, when corporate advertising in general surged in an effort to depict products as objects not only of need but of desire.

As Nancy Martha West has investigated in depth, while Kodak's most famous ad campaign, "You press the button, we do the rest," touted the technical distinctions of its camera, its other advertisements advocated the potential pleasures of photography.[24] Employing slogans such as "Kodak as You Go," "Every trip that is worth taking is worth a Kodak story," "The companion of every outing — the friend of all lovers of the open — the Kodak," and "A vacation without a Kodak is a vacation wasted," Eastman encouraged picture taking as an accompaniment to — and even the essence of — leisure and travel activity. Indeed, one vacationer described a trip to Switzerland: "I saw a great many amateurs, mostly Americans.... The Kodak

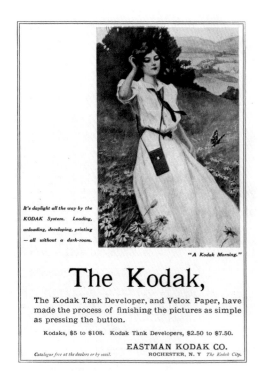

was the instrument used by the majority of the Americans, very few of whom were willing or able to develop their exposures."[25]

Other slogans such as "At home with a Kodak" and "Let Kodak keep the story" put forward picture taking not only as an integral part of domestic and family life but as an important means of memorializing and recording personal history.[26] Its advertisements intimated that women had a knack for taking photographs that captured family life, particularly children.[27] Ads for the Brownie featured children as Kodakers, suggesting that these cameras could be "operated by any school boy or girl" and promoting the camera as a toy. Kodak thus fully exploited the increasing importance placed on the family, the role of motherhood, and the distinct culture and rituals of childhood.

In addition to slogans, Kodak employed pictures in its advertisements. The company's most visible emblem was the "Kodak Girl," who first appeared in 1893 in the context of two women photographing sights at the Chicago World's Fair.[28] Throughout the decades around the turn of the cen-

tury, the Kodak Girl would be represented in both drawn illustrations and photographs. In some she was shown as a stylish, poised woman, carrying her Kodak camera as a fashionable accessory (fig. 1.6). In others she appeared as a fresh-faced young woman, active, self-sufficient, and on the go, shown holding her camera in position to snap a picture or traveling with her camera on trains and automobiles, on a boat, or in the countryside (fig. 1.7). The Kodak Girl embodied various aspects of the contemporary "American Girl" figure, tapping into widespread use of women as symbolic of cultural ideals.[29]

Kodak found other ingenious ways of steering people to take certain subjects, sponsoring many photograph competitions that were divided into various categories.[30] The inaugural contest in 1897 drew 25,000 entries, and an exhibition of the winners, presented first in London and then in New York, drew large audiences.[31] Other exhibitions followed over the years. In 1914 in *Kodakery* the company offered prize money for photographs illustrating their various slogans, doubly ensuring that particular subjects would be featured. The award-winning image for "Kodak the Children" in 1916 showed an attractive young woman and companion photographing an adorable pair of children on the beach (fig. 1.8). This image perfectly combined the idea of the snapshot as a vehicle for recreation and for capturing pleasant memories. In all of these advertisements Kodak simultaneously promoted two types of picture taking: as a form of action and as an embodiment of positive emotions. Thus it established photography as both an essential part of daily life and as a necessary means of remembering happy moments.

1.6
——
"The Folding Pocket Kodaks," advertisement, 1901. Hartman Center, Duke University

1.7
——
"The Kodak," advertisement, 1906. Hartman Center, Duke University

"Kodak the Children"—The Winning Picture

WHY THIS PICTURE WON A PRIZE

THE illustration on this page represents one of the photographs that was entered in the 1915 Kodak Advertising Contest, for illustrating the slogan, KODAK THE CHILDREN. This picture proved a prize-winner. Do you wonder why?

Let us briefly analyze it: It contains human interest and suggests action—and the action it suggests is that which the slogan implies.

Note the simplicity of the composition. The eye goes directly to the objects of interest. There is nothing within the picture to divert the attention from the figures. There is no divided interest. You are compelled to look at the group, which, by the way is a story-telling group, and the story this group tells is well and briefly told. It is the story of the slogan. That is why it won a prize.

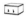

When in doubt take your Kodak with you.

Keeping the Story

While photograph albums in previous decades were readily available with slots that fit standard-size *cartes-de-visite*, those with blank pages allowed customers to paste their photographs down in whatever arrangement they chose (see pls. 16a–b, 17a–b, and 18a–b).[32] The latter option easily accommodated the new abundance of snapshots and gave people the ability to chronicle their lives through pictures. Two family albums testify to the newfound importance of recreation and leisure as well as domestic relationships as the aspects of life most worthy of recording. The families that compiled the volumes were, as evident from the photographs, relatively wealthy and able to afford the $25 No. 1 Kodak and the $32.50 No. 2 Kodak when they first appeared.

The album assembled by the family of Charles Walter Amory and Elizabeth Gardner of Boston features circular photographs taken with a No. 1 Kodak from 1888 to 1893 and several rectangular prints taken with a larger camera from 1895 to 1897. The Amorys summered on the coast, and the assemblage of photographs primarily chronicles the activities of their four children (and later grandchildren). Most of the people in the pictures, the spirited younger members of the family and their friends in the out-of-doors, readily adopt individualized behaviors in front of the camera. They seldom strike a formal pose, though they are centered in the frame. Instead, they look to one side, turn their backs, or walk away. Indeed "Marie" holds her hand out to block the view of her face, not wanting to be photographed (fig. 1.9) — an entirely new theme in photography originated by the snapshot camera: the unwilling subject. In a series of photographs of a picnic outing (see pl. 16a) "Annie Bowditch" smiles and leans toward the camera, which makes her head

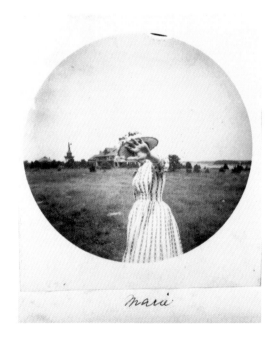

Marie

1.8
—
"'Kodak the Children'—The Winning Picture," *Kodakery* 4, no. 2 (October 1916): 14. Library of Congress

1.9
—
"Marie," albumen print, detail from Charles Walter Amory family album, 1889

1.10
—
Page of albumen prints from Charles Walter Amory family album, 1889

appear out of proportion to her body; and "Judy" turns to look at the camera, while her companions seem oblivious to its presence. Other subjects clown for the camera, with "Bessie, Marie, and Clara" in bathing suits and forming a kick line on a dock (fig. 1.10), while other images depict people in action: rowing boats, swimming, or playing tennis.

Motion, in fact, is a subtext throughout the album. Some photographs of the picnic show participants seated on the grass, but others catch the billowing skirts of women alighting from a carriage or climbing over a fence (see pl. 16a). Likewise, the

dozens of snapshots of sailboats on the water echo the pictorialist fascination with the picturesque effects of full sails and rippling water. Travel also plays a part in the album, as the family took photographs while touring in Europe and visiting friends' houses in Massachusetts.

Almost all of the circular prints center the subjects, which include boats, dogs, cats, horses, and people. Despite the uniform framing, however, the photographs are seldom close-ups because of the fixed focal length of the No. 1 Kodak lens: subjects are usually at least several feet from the

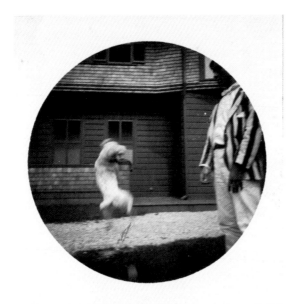

Freddy & Jockey.

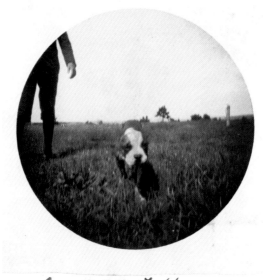

George & Tubby.

Tom Training Sambo —

1.11a and b
—

"Freddy & Jockey"
and "George &
Tubby," albumen
prints, details
from Charles
Walter Amory
family album,
1888

1.12
—

"Tom Training
Sambo," albumen
print, detail
from Charles
Walter Amory
family album,
1895

photographer, making the lower vantage point of the camera held at waist level particularly clear. The photographer, skilled at using the hand camera without the viewfinder, would have calculated his or her position according to diagonal lines projecting outward from the camera. Yet at the perimeter of the image the visual information is cut off, as seen in two frames that focus on young men with dogs. The captions "Freddy & Jockey" and "George & Tubby" signal that the men are as important as the dogs, but the dogs are successfully centered whereas only partial glimpses of the men's bodies appear (fig. 1.11a and b).

The technical challenges and limitations of the earliest Kodak eased considerably with the Amorys' purchase of a newer and larger camera in 1895. The later images are rectangular, and most measure approximately 3¾ × 4¼ inches, expanding the amount of information captured in each photograph. Whereas the circular Kodak prints had not given the photographer any freedom to experiment with cropping, the larger rectangular prints could be trimmed. "Tom Training Sambo" has the same composition as one of the earlier circular prints, for example — a leaping dog and a man to the right — but the rectangular format includes the full figure of the man with a view of road and trees behind (compare figs. 1.11a and 1.12). The types of subjects remained the same: boats, dogs, portraits, and group outings. But because of the span of time covered by the album, the children in the earlier pictures have grown into young adults. Dorothy Amory appears as a girl in a field of flowers in 1890, then with a friend in the same field in 1897 (compare figs. 1.13 and 1.14). Flowers fill almost the full frame of the rectangular photograph, and although Dorothy is shown at the same distance in both images, the later composition no longer has to rely on the relentless centering necessary in the circular format.

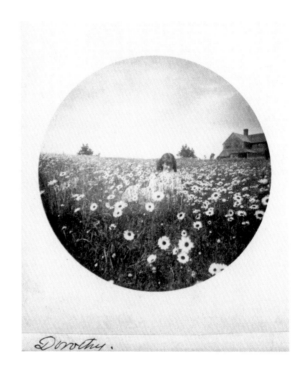

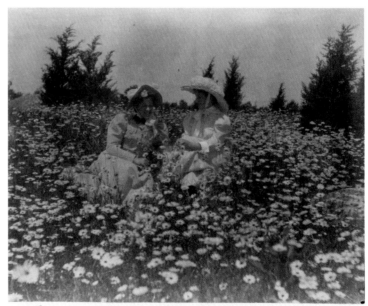

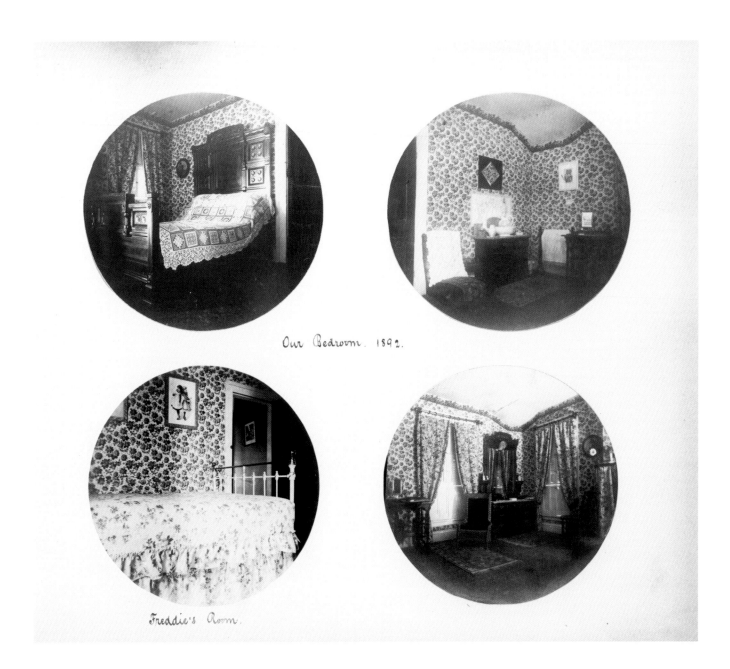

Our Bedroom. 1892.

Freddie's Room.

The anonymous No. 2 Kodak album, dating from 1890 to 1894, is more consistently arranged, with four prints to a page, each trimmed to the circular image area, suggesting that they may have been professionally mounted. Whereas the Amory volume focused primarily on summer leisure activities, the unidentified subjects in this album represent a wider range of places and possessions. The first pages present photographs of the family home (fig. 1.15) — the parlor, library, "our bedroom," the bedrooms of the children, the exterior of the house — and of such treasures as the linen closet, a bookcase, and a china cabinet. Subsequent pages

include portraits of pet dogs and of various family members on the lawn or steps of the house as well as photographs of their street and their carriage. The portraits almost inevitably include the photographer's shadow in the foreground (fig. 1.16). Most of the subjects are successfully centered but are usually so far away from the camera that their faces are barely distinguishable in the bright daylight. No one is snapped by the photographer unawares or in motion. Most are consistently standing and looking at the camera.

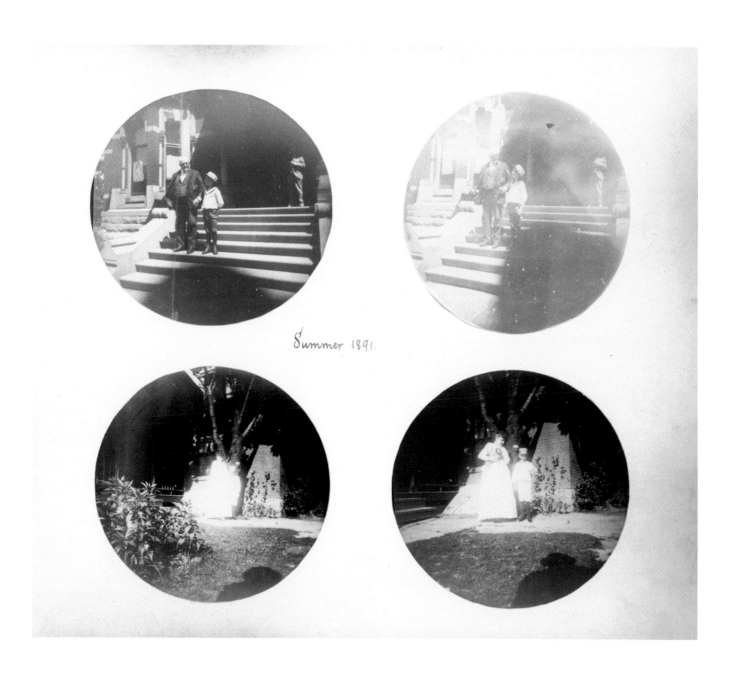

1.15

"Our Bedroom,"
page of albumen
and gelatin
silver prints from
an anonymous
family album,
1892

1.16

"Summer,"
page of albumen
prints from
an anonymous
family album,
1891

"Park-Views,"
page of albumen
prints from
an anonymous
family album,
1891

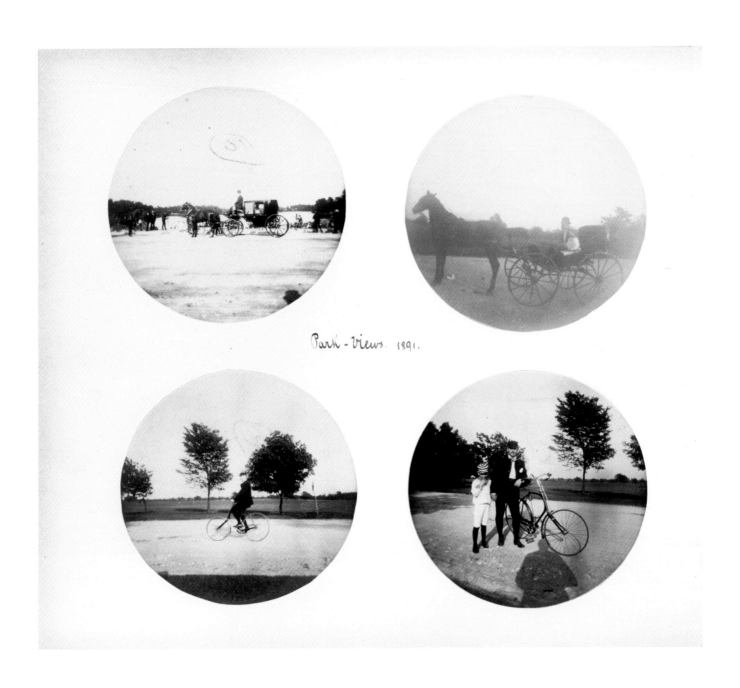

The remainder of the album contains mainly photographs of summer vacations and travel to areas around Buffalo, New York, on Lake Erie. As in the Amory album, these pictures are less formal than those taken at the family home. They record groups picnicking, boating on the lake, posing in front of carriages, riding or standing next to bicycles (fig. 1.17). People at the lake appear in bathing suits, wading in the water, standing on the beach, or swimming. In a calculated pair of contrasts, two boys in bathing suits stand on a rock in the water, once facing away and once facing toward the camera (see pl. 17a). Despite the evident visual anomalies that the earliest Kodaks caused, acquiring the Kodak camera allowed each of these families to accumulate and assemble concrete memories of people, places, and events across time. Each album highlights the familiar themes of leisure, travel, recreation, as well as enjoyable socializing and domestic happiness, thus bearing witness to the preoccupations of middle-class and upper-class Americans.

At Home

Prepared by Kodak and the photographic establishment, new amateurs immediately wanted to take portraits of their own, and they naturally had the conventions of the posed studio portrait in mind, though the settings now transferred to the home. One photograph of a child posed with the family dog and cat clearly aspires to look like a formal studio portrait, but an adult peeks through the slats of the chair while trying to keep the child and two animals in line for the duration of the exposure (pl. 2). Similarly, in a cyanotype of a woman seated against a clapboard house (see pl. 34), the subject has assumed a careful pose, but her blank expression, relaxed

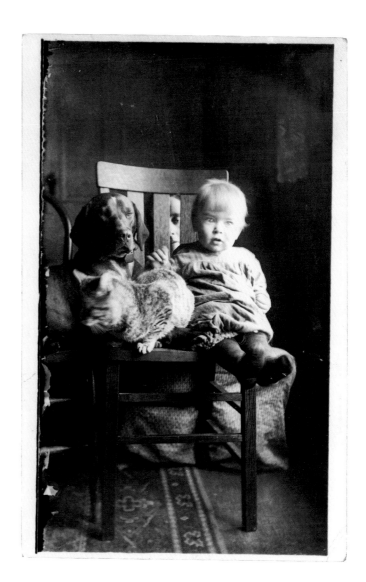

2

"This is our boy, dog and cat and I am sticking my nose through the back of the chair. Burns just woke up so he looks kind of mussed up," gelatin silver print, c. 1910

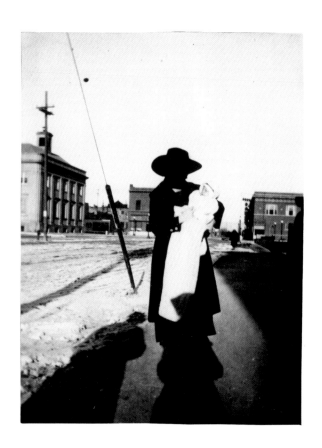

posture, and closeness to the camera give a sense of informality quite different from traditional portraiture. Both of these snapshots illustrate common "mistakes" defined by Kodak and other arbiters of "good" photography. Though the inscription on the verso of the first print indicates that the boy's mother viewed the image as a record of her loved ones rather than as an unsuccessful portrait, the child is clearly rumpled and the cat's movement has created a blur. In the second example the photographer allowed too much emphasis on the grass in the foreground and ignored Kodak's warning that "there is no uglier… background than the clapboard side of a house."[33]

Sometimes inexperience produced other unintended effects. An outdoor photograph of a baby in white being held by a woman in a dark hat and dress turns a domestic subject into a menacing combination of darks and lights (pl. 3), with the shadows of the photographer and another figure intruding so far into the space of the picture that they touch and even overlap the silhouette of the woman. In another photograph a baby, "Bess," is held on the lap of a person entirely covered in fabric (pl. 4). This may reflect a desire to position the infant against a neutral, studio-style backdrop, meant to be cropped later, but the result is disconcerting.

Camera manuals encouraged this staging of studio conventions at home. Seneca suggested using a rug, erecting a screen for the background, and placing a plant to one side in the out-of-doors to give the illusion of an interior setting for a portrait; it also advocated posing subjects against a blank wall or window shade indoors to provide a studiolike backdrop.[34] Despite the "failures" seen in these examples, such compositions and subjects appeared again and again in snapshots, and the centered baby, the child posed with pets, and individual portraits, whether from close up or far away, became trademarks of the genre.

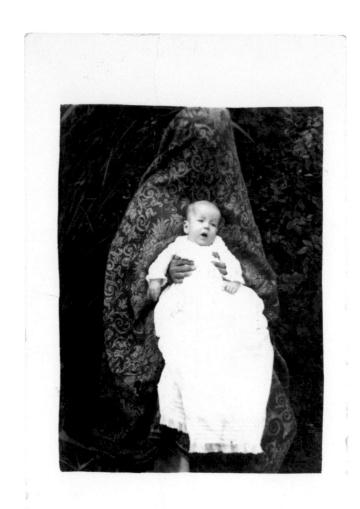

Photographers also experimented with reflections as a way of creating portraits. One woman created a self-portrait showing herself standing in front of a mirror, then inscribed it "The Artist" (see pl. 20). With her camera mounted on a tripod, she sets herself up here as a serious amateur photographer (this cyanotype, one of the easiest printing processes to master, was probably made by the photographer herself), yet smiles at her reflection in the mirror. Another photograph shows two women in identical dresses posing in front of a mirror so that both their faces and the backs of their heads are visible (see pl. 19). The male photographer taking the portrait is himself visible in the mirror with his camera mounted on a tripod. While one woman holds a hand mirror reflecting her face at yet another angle, the other cracks a slight smile.

Significantly, the snapshot not only made smiling possible in photography but made it desirable.[35] Previously considered vulgar in portraiture, the smile evolved into a means of expression. Although both of these photographs were probably consciously composed and made using a timed exposure, their setting in the home must have put the subjects at ease, which they expressed through their smiles.

Taken in the bedroom, both of the above portraits also show the camera entering an intimate space once considered off limits. Some photographers stole into bedrooms to take surreptitious snapshots of others sleeping (see pl. 33). A related subject, unique to this period but not uncommon, is the portrayal of women in the outdoors with their long hair hanging loose. In one such image a woman has her back to the camera, her hidden face creating an aura of mystery (pl. 5). The porch of the house and the distant wall suggest that she is in a backyard, anchoring her in the domestic space of the home. Only someone acquainted with her would

3
——
**gelatin silver
print,
c. 1900–1910**

4
——
**"Bess,"
gelatin silver
print,
c. 1900–1910**

likely have liberty to photograph her in this situ-
ation. In another picture labeled "Caught in the
Act!" a young woman appears outside a backdoor
to air dry her hair after washing it (fig. 1.18),
a common ritual before the twentieth-century
invention of electric hairdryers. The hand camera
gave access to such subjects of greater intimacy
and domestic routine.

Placing the simple and affordable camera
into the hands of more Americans thus brought
new subject matter and new environments into
photography. The camera portrayed people in vari-
ous spaces that were being invented or reinvented
in the middle-class home: the bedroom, library,
dining room, and nursery as well as the porch,
front lawn, and backyard.[36] Professional and work
life did not appear often, as snapshooters preferred
celebrations like weddings, birthdays, and holi-
days. Although the previous practice of taking
postmortem photographs had produced treasured
family heirlooms, themes of death (including
funerals) largely disappeared with the arrival of
the snapshot.[37] At Kodak's urging, Americans
were beginning to favor positive, happy events
as subjects for their photographs.

"Ludicrous or Uncomely Positions"

Snapshooters also captured the staged or out-of-the-
ordinary moments of life, turning their lenses on
favorite American pastimes: groups presenting ama-
teur theatricals, dressing up to perform skits or play
parlor games, or attending costume parties. The pop-
ularity of these amusements was consonant with
growing interest in dramatic formats like vaudeville.
Notably, while Kodak emphasized childhood, family,
and leisure activities in its advertising, it rarely pro-
moted humor in the taking of photographs. Nor
did the photographic establishment: W. H. Burbank
cautioned against the "dangers of hand camera
work," in which photography might be "degraded
into a means of caricaturing one's friends by secur-
ing them in various ludicrous or uncomely positions,
than which nothing can be more contrary to the
spirit of our gentle art."[38]

Yet humor fascinated snapshooters, who pro-
duced countless trick photographs, deliberate double
exposures, silhouettes, records of high jinks, funny
captions, and doctored photographs, particularly in
relation to groups of adolescents. This playfulness
went hand in hand with a growing youth culture and
increasing freedom for young men and women to
congregate and socialize. The rise of social clubs and
other leisure organizations, the greater number
of girls and boys continuing on to secondary and
higher education, and the popularity of extracurric-
ular activities hosted by high schools and colleges
all had an impact on the social lives of American
youth. Thus snapshots show groups of young people
involved in various amusements, both spontaneous
and organized.[39]

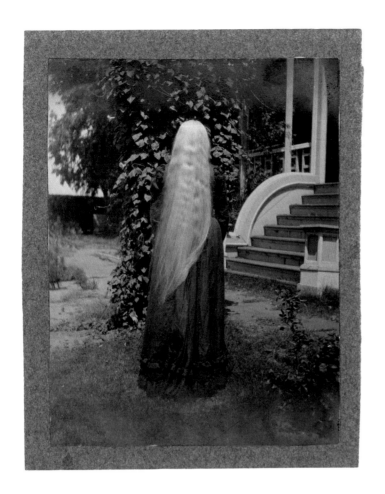

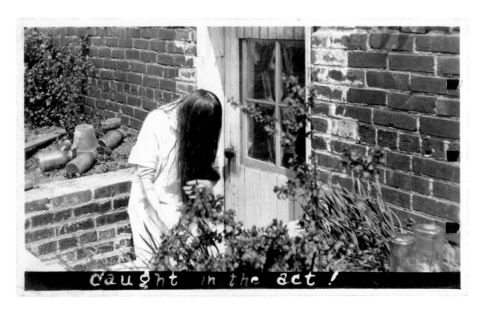

5
—
gelatin
silver print,
c. 1900

1.18
—
"Caught in
the Act!"
gelatin
silver print,
c. 1900

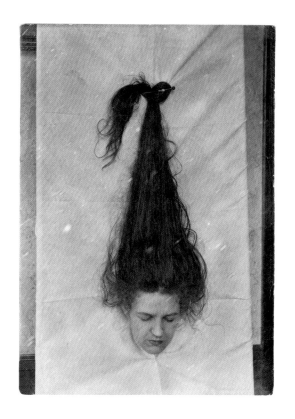

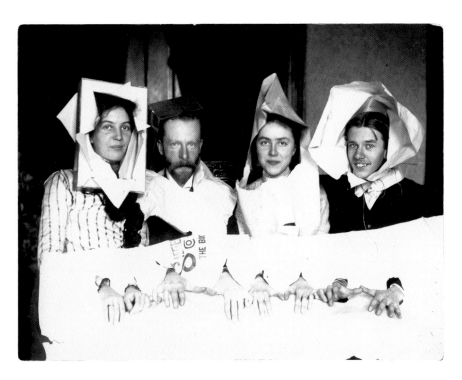

6

toned
gelatin
silver print,
c. 1910

7

gelatin
silver print,
c. 1910

1.19

"Bette, Nell,
and Leah,"
cyanotype,
c. 1900–1910

1.20

"Breaking
the News,"
New York:
Rotograph Co.,
1905. Private
collection

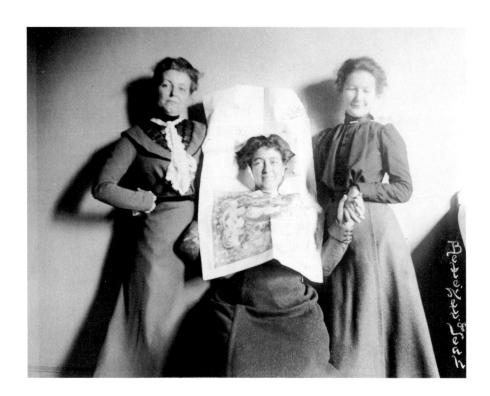

In one photograph several young adults poke their heads through holes in a sheet, with an open umbrella in the middle and the American flag at the top (see pl. 1). The exact circumstances are now lost (was this part of a skit or just a silly picture snapped at a Fourth of July picnic?), but the exuberance of the event is still plainly visible. In another photograph a woman's head inserted through a sheet has her long hair pinned up above it, as if a severed head were hanging by the hair (pl. 6). This may record an amateur theatrical of the tale of Bluebeard, who kept a room in his castle with the bodies of his dead wives strung up on the wall. In another image four young men and women wear paper headdresses and have pushed their hands through newspaper (pl. 7). A recurring motif of this period shows people placing their heads through torn newspaper, as in the cyanotype "Bette, Nell, and Leah" (taken by "The Artist" in pl. 20) (fig. 1.19). This motif was a favorite joke, a visual pun on the phrase "breaking the news," as spelled out in a commercial photographic postcard of kittens (fig. 1.20). It was also commonly employed in trade cards, showing a "breaking news" placard with business information.[40] Such visual wordplay was similar to the popular game of charades.

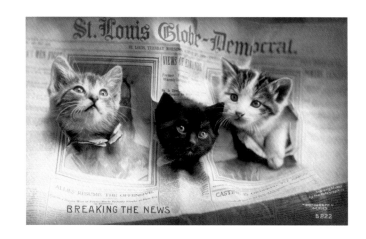

Costumes and masks of all kinds also appear frequently. One image shows two people posing in old-fashioned women's dresses, their faces covered with a stocking and a mask (see pl. 30). A contemporary book on parlor games advised holding a costume party in which guests should raid their grandparents' trunks for outfits, and this snapshot might preserve just such an occasion.[41] Cross-dressing for skits and amateur theatricals was also common, and one photograph shows the staging of a mock wedding with a cross-dressed pair pretending to be a bride and groom (see pl. 31).[42] In "Flash Light" two young men don dresses and flirt with each other in the corner of a room (pl. 8). This interior shot was taken at night, probably with the use of flash powder, as the caption suggests. Written around the photograph, more details of the spontaneous tableau are provided: "This idea was conceived about 8 PM one Sept night. The picture was *taken, developed* and printed by 10 PM the same evening. Our gowns are dreamy and are the property of Mama and sister. The picture does not express all because we had to dress you know and that is not shown in the picture tho you can imagine~? Hasn't Justin Weddell got a dainty foot? I guess nature did not want him to tumble over whilst goo-gooing at me." The inscription highlights not only the camera's absorption into the theatrical aspects of American social life but its role in inciting such light-hearted activities.[43]

Children's book author Maud Hart Lovelace gives an evocative glimpse into the active life of American young people and the camera's part in their antics during this era of confidence and prosperity. In her Betsy-Tacy books she fictionally details her own childhood, high school, and college years in the small midwestern town of Mankato, Minnesota, in the first two decades of the twentieth cen-

tury. In one passage her fictional alter ego, seventeen-year-old Betsy Ray, takes her Brownie camera on a picnic in 1909 with her two closest friends, Tacy Kelly and Tib Muller:

Betsy focused her camera. "Get set now!" Tacy jumped up and put one hand behind her head, the other on her hip. "No! No!" cried Betsy. "You're not Carmen. You're the Irish Colleen. Remember?" "Be jabbers, that's right!" said Tacy, and put both hands on her waist, arms akimbo. Tib pushed her down. Tacy's long red braids came loose. Around her face little tendrils of hair curled like vines. She looked up at Betsy, her eyes full of laughter, the skirts of her sailor suit cascading about her. Betsy snapped. "Tacy Kelly at her silliest!" she said. She snapped Tib on a rock, holding out her skirts. Tacy snapped Betsy tilting the jug of lemonade. Tib snapped Betsy and Tacy feeding each other sandwiches. When the film was used up, they collapsed in laughter.[44]

The photograph plays a role later in the story when a young man attending an informal gathering at Betsy's parents' house peruses her Kodak album:

After a while when the music gave way to general conversation, Mr. Kerr brought up the subject of cameras. "Anybody interested in photography?" he asked. "I just bought a new Eastman." Lloyd had received an Eastman for Christmas, and he and Mr. Kerr plunged into a technical discussion. Betsy said she used a square box Brownie. "I'm so dumb I can't take pictures with any other kind." "Why, you take good pictures, Betsy," Tacy said. Mr. Kerr turned away from Lloyd abruptly. "I'll *bet* you take mighty good ones," he said, smiling persuasively at Betsy. "Won't you show me some?" Betsy brought out her bulging Kodak book, filled with pictures of the Rays [her family], of the Crowd [her group of friends], of winter and summer excursions. "Someone will have to explain this to me," Mr. Kerr said, and presently he and Tacy were sitting on the couch while she told him who was who, laughing as she turned the pages. "Betsy says this is me at my silliest," Betsy heard her remark and remembered the picnic up on the Big Hill when she had snapped Tacy acting like an Irish Colleen.[45]

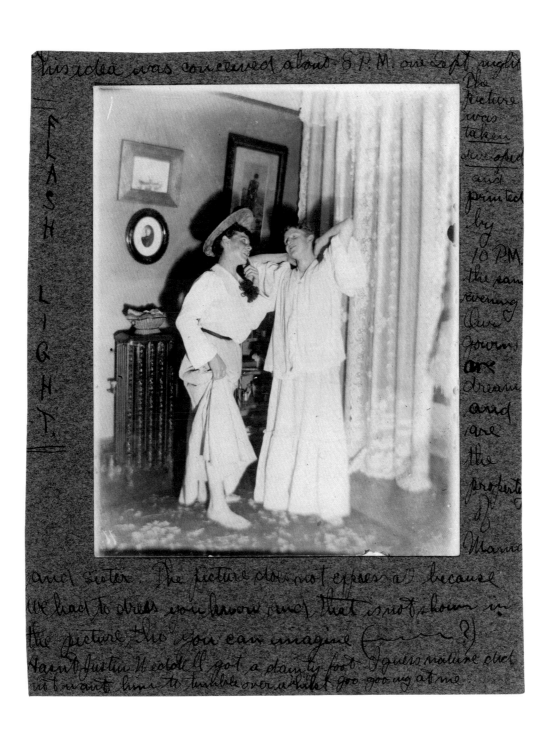

This idea was conceived about 8 P.M. one Sept night. The picture was taken, developed and printed by 10 P.M. the same evening. Our gowns are dreams and are the property of Mama and sister. The picture does not express all because we had to dress you know and that is not shown in the picture tho you can imagine (—— ?) Haint Justin Waddell got a dainty foot. I guess nature did not want him to tumble over while goo goo ing at me.

FLASH LIGHT.

1.21
—
**gelatin
silver print,
c. 1910**

Lovelace's story reflects several aspects of photography at this period: the high spirits and joking around that are common in surviving snapshots; the distinction between Betsy, who snaps photographs for fun with her easy-to-use Brownie camera, and the sophisticated amateur such as Lloyd and Mr. Kerr; the album "bulging" with snapshots of family, friends, and outings; and the need for someone with intimate knowledge of the subjects to explain the snapshots to the outsider, as Tacy does for Mr. Kerr.

Photographic amusements did not always derive from "snapping" a boisterous social life. Prints themselves were often manipulated. They were cut and pasted into albums in collages, surrounded by watercolor borders, or given different meaning by captions or inscriptions on the images. The amateur photographer experimented freely with his or her prints to create hybrid objects that held personal meaning and could also be funny. This intricate framing of snapshots had a precedent not only in the elaborate collages of earlier photograph albums but also in the practice of assembling

"commonplace books" (scrapbooks of meaningful quotations, jokes, meditations, and verses). As in the two intact Kodak albums in this exhibition (pls. 16a – b, 17a – b), many of the snapshots shown here once resided in albums or were part of larger collections of loose snapshots.

In addition, heavy, colored card stock was available for individual mounting, and arrangements of mounted photographs were displayed in people's homes (fig. 1.21). One handmade compilation of trimmed photographs, titled "Snap Shots" and probably dating from around 1910 has the heading, borders, and captions all created freehand (see pl. 24). On either side of the title are drawings of a box camera and a folding camera. Among the snapshots of the diversions and camaraderie of college life, several are portraits, captioned with the subject's name. Others are group photographs, in many cases showing students clowning around. In "Cack" two men hold another man upside down, while in "(?)" a man crouches inside a barrel, and in "Skool Daz, Skool Daz" the photograph is drawn on with pen and ink to include music notes and blackened mouths so as to suggest that the men are singing the song.

Drawings and captions like those on the "Snap Shots" compilation were often used to add humor to photographs. Another example now orphaned from its original album is surrounded by a hand-drawn decorative border with ornate photo corners and two captions: "Some of the Goofs at Camp Phantom Wood" and "'We will make a good beginning'" (see pl. 26). The photographed faces have been obscured with cartoonish embellishments. Two flying birds are drawn in the blank sky, as are the bottoms of two feet above the water in front of the face at the far left, adding an extra layer of humor to a photograph of an excursion to a lake. Meanwhile, "Cold Modesty" is inscribed on the negative of a picture of four primly dressed adults seen from behind, seated in a row looking out at a lake (see pl. 15). And in "??" numerous handwritten phrases crisscross the photograph of a couple embracing (see pl. 25). The teasing inscriptions suggest "sweet nothings" that a couple might share in a moment of intimacy, but "Please go away and let us spoon" pokes fun at the intruding photographer.

9
—

"Coming In and
Going Out,
What do you
think of us,
The 2 Paulines,"
gelatin
silver print,
c. 1900–1910

Addressed:
*Frank P. Harmer,
Greenville,
Mich.*

10
—

gelatin
silver print,
c. 1900

11
—

gelatin
silver print,
c. 1900

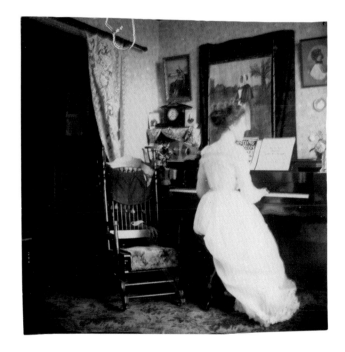

Exploring the possibilities of the camera led to some curious effects, as in a double exposure — vertical and horizontal — from the 1890s of an indoor gathering (see pl. 23). Many illusions were deliberately and humorously staged for the camera. Trick photography, as encouraged in *Photographic Amusements,* was the impetus for "Coming In and Going Out," which placed the same two men on either side within a single photograph, once facing the camera, once facing away (pl. 9). An intriguing pair of double exposures depicts a man and a woman in a parlor, each appearing in the same spots — seated at the piano and a neighboring chair — but with each taking turns as "ghosts" haunting the other (pls. 10 and 11). In this case the man's ghost was not as successful an apparition as the woman's. A different kind of trick photograph shows a couple from the back, snuggling on a boat, while behind them and gazing out at the viewer are added five smaller "passengers" (pl. 12). Another favorite motif in this period was the play on perspective achieved by placing the bottoms of a man's shoes in the extreme foreground of the photograph. This "wide-angle study," as it was called in *Photographic Amusements,* was illustrated in a line drawing with the punning caption "A Photographic Feat" to show the desired effect (fig. 1.22). A similar composition appears in a snapshot from around 1900, mounted on gray card stock with a decorative border (pl. 13), which attests to the photographer's pride in its realization. Most of these trick photographs would have required a carefully controlled exposure, with the camera mounted on a tripod, placed on a table or chair, or held in a very steady hand.

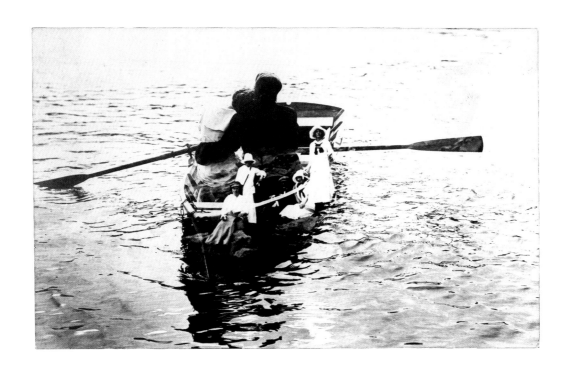

12

"Margaret,"
gelatin
silver print,
c. 1910

13

gelatin
silver print,
c. 1900

1.22

"A Photographic
Feat," in Walter E.
Woodbury, *Photo-
graphic Amuse-
ments* (New York:
The Scovill &
Adams Company,
1898), 85. National
Gallery of Art
Library

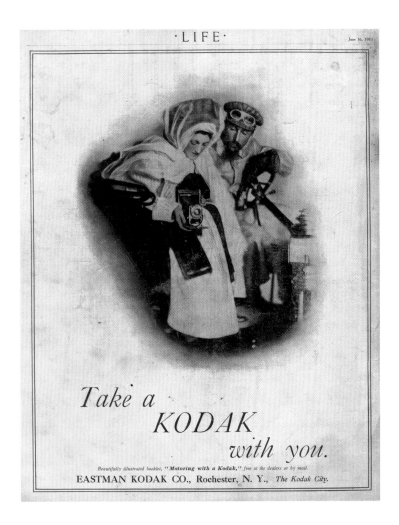

Take a *KODAK* with you.

Beautifully illustrated booklet, "Motoring with a Kodak," free at the dealers or by mail.
EASTMAN KODAK CO., Rochester, N. Y., *The Kodak City.*

1.23

—

**"Take a Kodak
with you,"
advertisement,
June 16, 1910.
Hartman
Center, Duke
University**

Get Action

In contrast to the timed exposure, the instantaneous snapshot satisfied the ambition to capture motion, particularly as the pace of life accelerated. When Stieglitz began his essay on the hand camera by claiming that photography "as a fad is well-nigh on its last legs, thanks principally to the bicycle craze," he identified a key correlation between the bicycle and the camera, both of which changed the way Americans traveled and spent their leisure time. When middle-class America increasingly enjoyed time at play and time on the go, the camera went along for the ride — quite literally, as cameras designed to hang on the bicycle were sold for convenience of travel. The safety bicycle (equipped with a chain and with tires of equal size) was introduced in the late 1880s, and by the middle to late 1890s it, like the camera, was in wide use by the middle and upper classes. One contemporary noted that amateur photographers were "as plentiful as bicyclists."[46] The bicycle took the photographer farther afield — and in turn provided a subject for the snapshooter (see fig. 1.17). Indeed, many camera clubs functioned primarily as groups to organize excursions. The Washington Camera Club, for example, was an arm of the Capital Bicycling Club.[47]

This synergy may explain the Outing Company's takeover of *The American Amateur Photographer* magazine, which it began to publish and market together with *Outing* magazine and other periodicals devoted to outdoor life. Bicycles were the first product besides photographic equipment to be advertised in *The American Amateur Photographer.* Then in the first decade of the twentieth century the magazine began to carry ads for automobiles. The same reciprocal relationship developed between the camera and the car as car ownership increased steadily dur-

ing the second decade of the twentieth century. By 1910 Kodak was promoting the pamphlet "Motoring with a Kodak" with an image of a couple seated in a car, the man at the wheel and the woman snapping a photograph (fig. 1.23).

With the rise of what has come to be called the condition of modernity, Americans experienced distances shrinking and ever-faster speeds — through the railroad, streetcar, bicycle, automobile, and airplane — and photography too became faster. Photography itself, of course, led to the moving picture, or cinema. Thomas Edison introduced the kinetoscope in the early 1890s, and motion picture film became commercially viable and available in 1896 from Eastman Kodak (which would become the major supplier for decades). Nickelodeons and movie theaters began to spring up across the country. Motion pictures even made their way into vaudeville, which showed short film programs between acts. As in early snapshots, the earliest movies were an extension of conventions drawn from the theater, with narratives told as a series of silent, serial vignettes, both comic and dramatic, that relied on gesture and expression.

Motion in early snapshots naturally registered as a blur. "The Slide for Life" depicts not only childish playfulness but also spirited movement, rendered as a blur from some distance away (see pl. 37). Likewise, in a photograph of several adults scattering on a beach, the dark forms of the men and the light forms of the women blur together in a mass of movement (see pl. 36). As camera technology improved, it became possible to record motion without blur, and more and more true "action shots" began to appear by the second decade of the twentieth century. In 1909 Kodak introduced the Speed Kodak, with exposure times of 1/1000 second. Advertising the new camera with the

slogan "Get Action," Kodak claimed that "the aeroplane in flight, the racing motorcar, the thoroughbred taking a fence, the ballplayer stealing second" were not too fast for the Speed Kodak. Processing sped up with the marketing of the Kodak Developing Machine (1902) and Tank Developer (1905), which allowed customers to print their own photographs on the spot and in daylight. The emphasis on speed, and on the speed of modern technology, existed side by side with the carefully staged tableaux of the period.

Kodakery from its first issue in 1913 included dozens of action shots taken with the Graflex (a more expensive high-speed camera, mostly used by professionals but touted by *Kodakery* to its amateur readership). They showed gymnastic feats, people leaping into the air, flying birds, jumping dogs, and sports competitions. *Kodakery* explained in a 1915 article that the Graflex could take "snapshots from moving automobiles" going twenty miles per hour. Another *Kodakery* article, "Musings of the Kodak Philosopher," drew attention to the speed of both modern life and the camera and described the capturing of motion as analogous to the condition of cinema:

Modern life crowds the moment with new opportunity, but also makes it more fleeting. The motor car, for instance, whirls us out into the great out-of-doors, where charms of landscape unfold in panoramic profusion, and scenes dissolve as quickly as they form. The aëroplane takes us aloft, where our perspective is changed entirely. The eye is unequal to the new demands and the mind can store but a fraction of its impressions. The eye of the Kodak, opening on these things, however, pictures them instantaneously on indestructible film, in lines that time cannot efface, nor the passing years dim. The Kodak makes the present ours, and preserves the past to us and to our descendants for all the future.[48]

Kodak in Camp.

From reveille to taps, each hour will bring something new into the life of every young soldier. New surroundings, new habits, new faces, and new friendships will make for him a new world—a world full of interest to him *to-day* and a world upon which he will often dwell in memory when peace has come again.

And this new world of his offers Kodak opportunities that will relieve the tedium of camp routine at the time and will afterward provide what will be to him and his friends the most interesting of all books—his Kodak album.

The parting gift, a Kodak. Wherever he goes the world over, he will find Kodak film to fit his Kodak.

EASTMAN KODAK COMPANY, Rochester, N. Y., *The Kodak City.*

As the "Kodak Philosopher" mused, the photograph caught the instantaneous and made it timeless. Whereas the distinction between timed and instantaneous exposures was always explicitly spelled out in manuals and literature at the turn of the nineteenth century, gradually the two terms dropped out of common use, as instantaneity became the dominant mode of picture taking.

In 1917, when America entered World War I, the landscape of photography shifted yet again. Humor endured as a theme, but Nancy Martha West asserts that the idea of the snapshot as a way of preserving memory came increasingly to the fore during the upheavals of the war.[49] The Autographic cameras Kodak introduced in 1914 allowed the user to write notes on the film after an exposure, underscoring the photograph's memorial function, and Kodak devised new advertising slogans and images to encourage use of the photograph to share memories of home or tell stories to absent loved ones.

"Kodak in Camp" depicts a soldier perusing an album of photographs in his tent with his folding Kodak camera on the table nearby (fig. 1.24). Kodak also urged the exchange of photographs between camp and home, suggesting: "The nation has a big job on its hands. It's only a little part, perhaps, but a genuine part of that job [is] to keep up the cheerfulness of camp life, to keep tight the bonds between camp and home. Pictures from home to the camp and from camp to the home can do their part."[50] Although not permitted to take cameras to the front (and subject to military censorship), soldiers shipped out overseas with Kodak Vest Pocket cameras and took snapshots of camp and other noncombat subjects. Photographs from home were plentiful, with patriotic themes like that of the two women draped in an American flag or a train car of soldiers preparing to depart (pl. 14 and fig. 1.25).[51]

The close of World War I marked the end of this first wave of snapshot photography. By the 1920s and 1930s ever greater numbers of Americans were purchasing faster and faster cameras, and snapshot photographers, while continuing to prefer domestic and leisure pursuits, would shift away from the experimental and staged to the "quick, casual, modern way."

1.24
—
**"Kodak in
Camp,"
advertise-
ment, c. 1917.
George
Eastman
House**

14
—
**gelatin
silver print,
late 1910s**

1.25
—
**gelatin
silver print,
c. 1917**

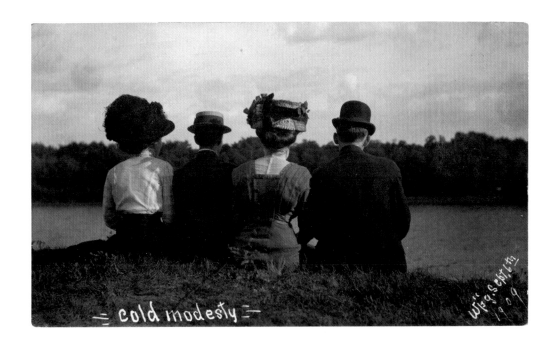

15

"Cold Modesty,"
toned
gelatin silver
print,
September 6,
1909

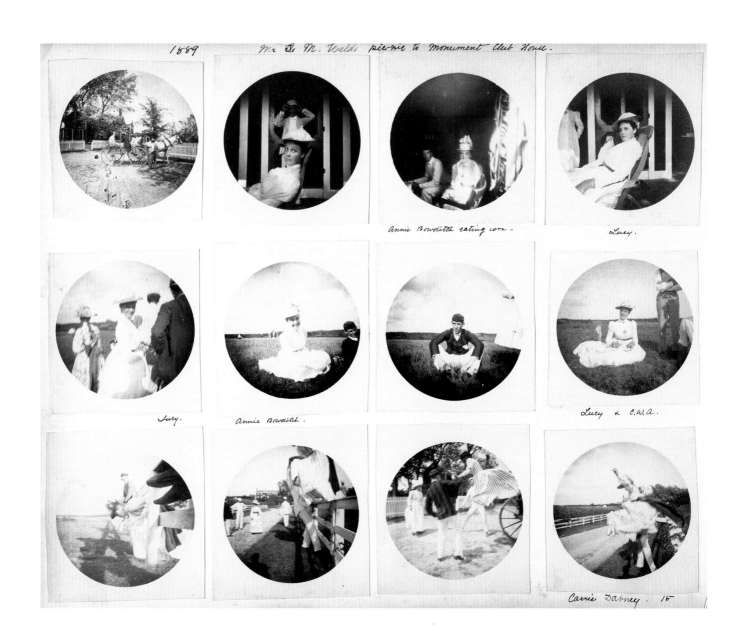

1889 Mr. & M. Weld's pic-nic to Monument Club House.

Annie Bowditch eating corn. *Lucy.*

Lucy. *Annie Bowditch.* *Lucy & C.W.A.*

Carrie Dabney. 16

16a–b

—

"**Mr. & M. Weld's picnic to Monument Club House,**" pages of albumen prints from Charles Walter Amory family album, 1889

1889.

Vinor & Bessie dancing in barn. Base ball field. " at monument.

childrens pool Plum Cove.

Looking towards greenhouse - Plum Cove. Looking east from Mr Lorings small beach. Plum. Cove. 1889. Avenue.

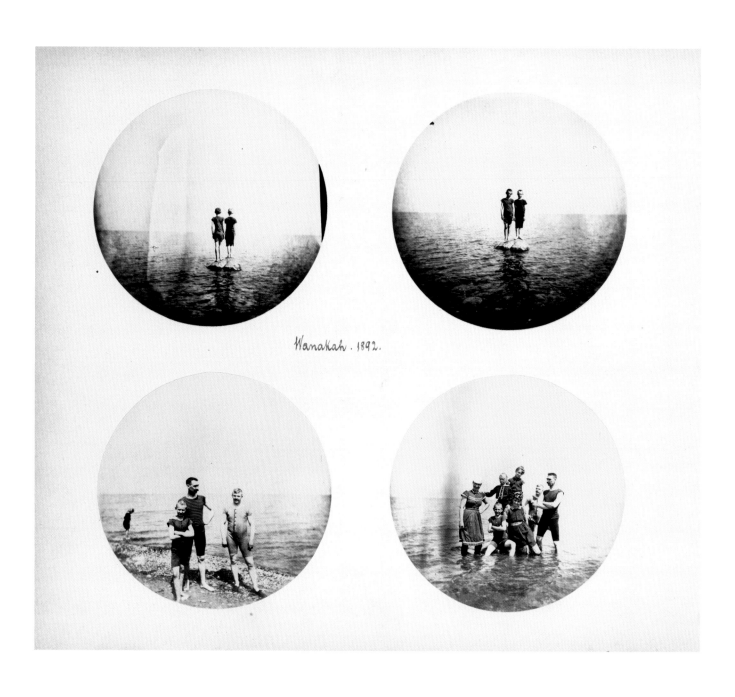

Wanakah . 1892.

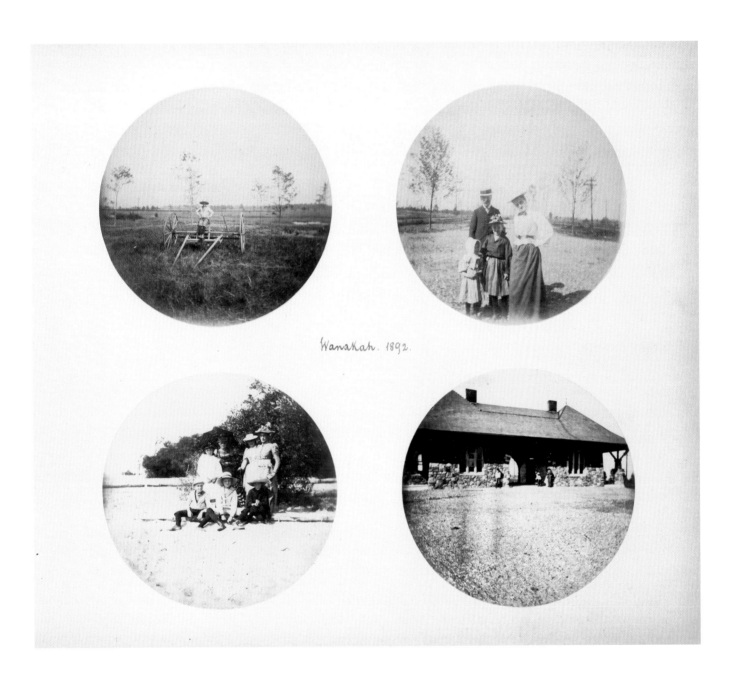

Wanakah. 1892.

17a–b

"Wanakah,"
pages of
gelatin silver
prints from
an anonymous
family album,
1892

18a–b
—
Recto and verso
of an album
page with mosaic
of cyanotypes
and gelatin silver
prints, c. 1900

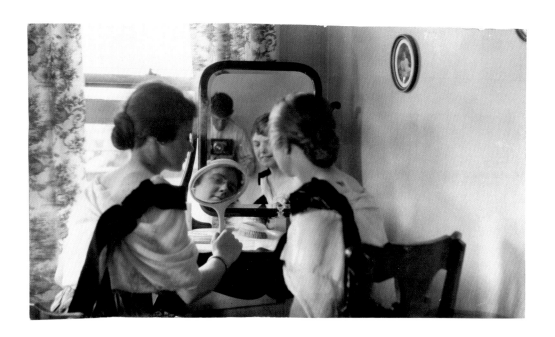

19

gelatin silver
print,
c. 1900–1910

20

"The Artist,"
cyanotype,
c. 1900–1910

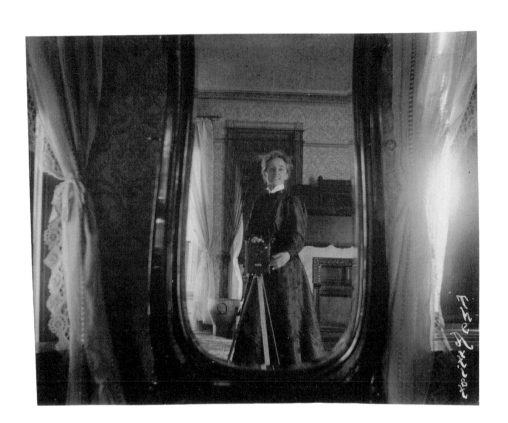

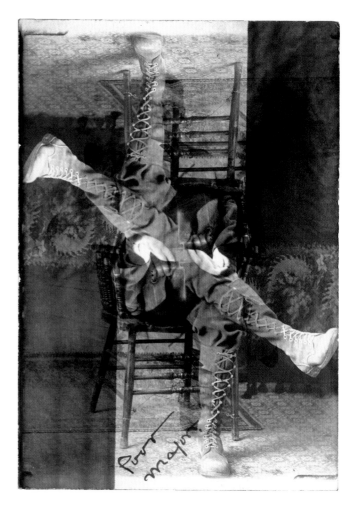

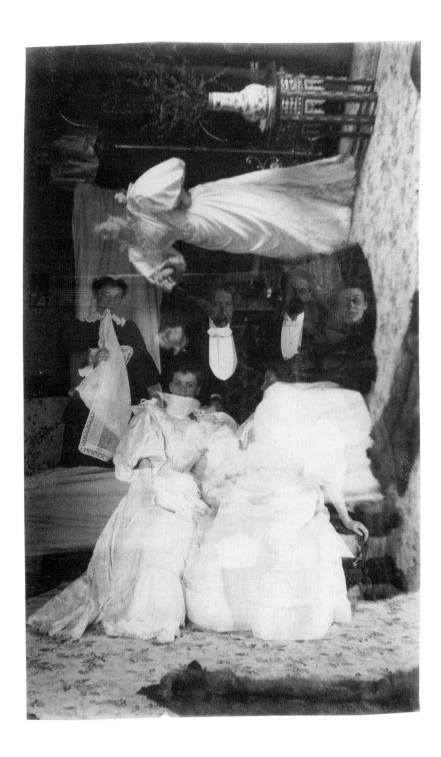

21

gelatin
silver print,
c. 1910

22

"Poor Major,"
gelatin
silver print,
late 1910s

23

cyanotype,
1890s

SNAP SHOTS

Deb

"US"

Steele

(?)

"Broterly Love"

Aggie

Prof

"Perfectly Sane"

The Kids

Steve

Jean

Tiney

Franklins Best

"Skool Daz" "Skool Daz"

Cack

Which is Which

Loafers

Shorty

Russ

Our Team

Les

On the grounds

happy

Bassett

"There's 5 of them"

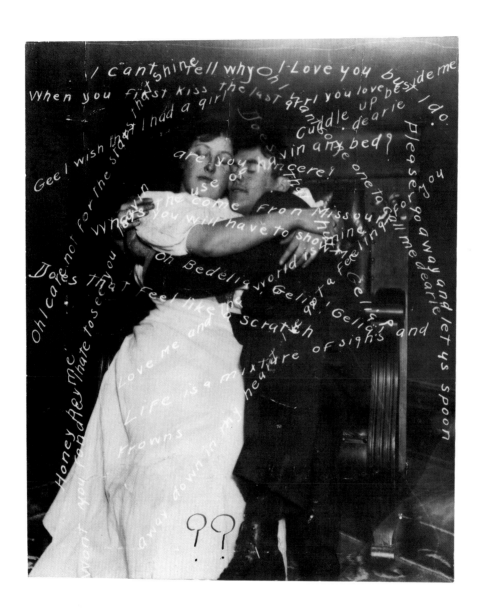

24
—
"Snap Shots,"
gelatin
silver prints,
1910s

25
—
"??"
gelatin silver
print,
c. 1900–1910

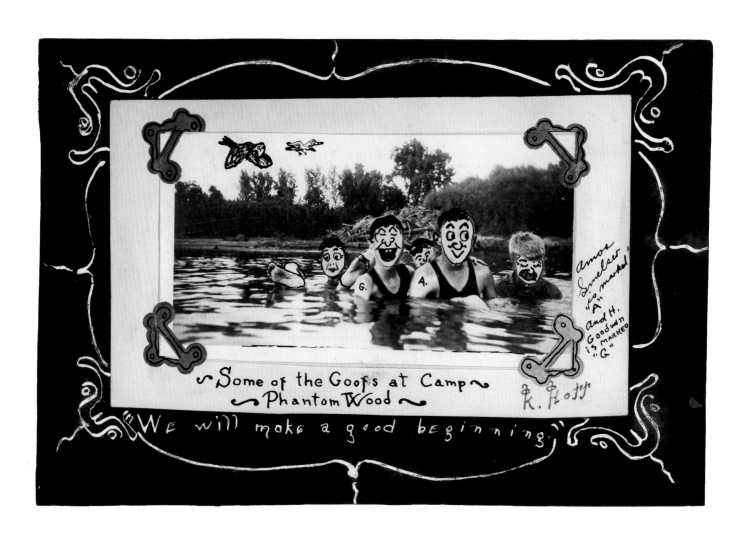

Some of the Goofs at Camp Phantom Wood

"We will make a good beginning"

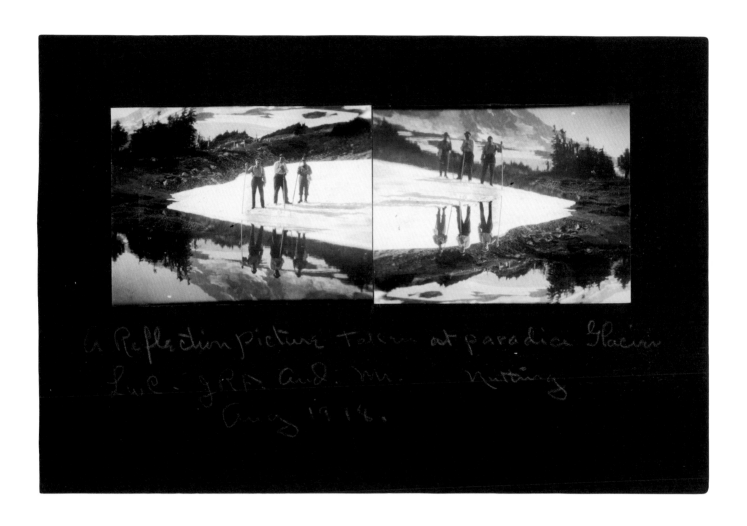

26

"Some of the
Goofs at Camp
Phantom Wood —
'We will make
a good begin-
ning,'" gelatin
silver print,
c. 1910

27

"A Reflection
Picture Taken
at Paradise
Glacier, LwC,
JRF and Mr.
Nutting," gelatin
silver print,
August 1918

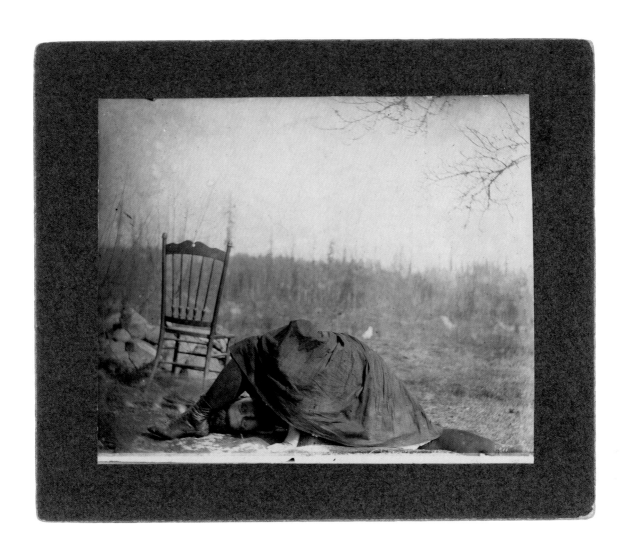

28
—
gelatin
silver print,
c. 1910

29
—
"Shirley
Holmes,"
cyanotype,
1910s

30
—
gelatin
silver print,
1913

Addressed:
*Mrs. Clara
Jackson,
412 Euclid Street,
Dayton, Ohio*

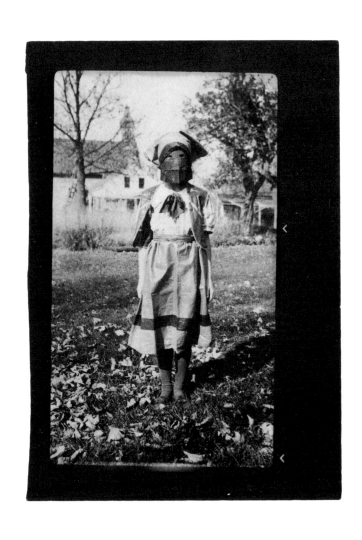

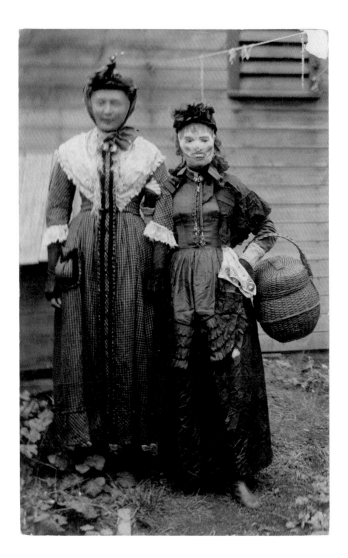

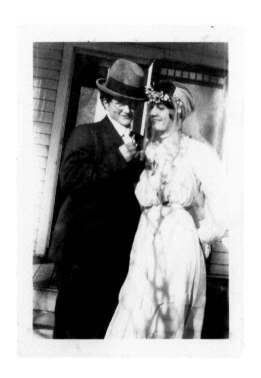

31
—
gelatin
silver print,
c. 1910

32
—
toned
gelatin
silver print,
c. 1910

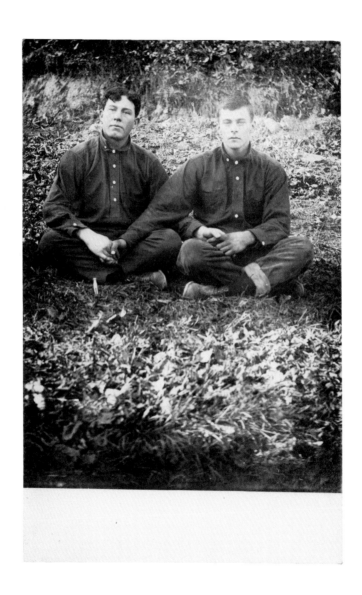

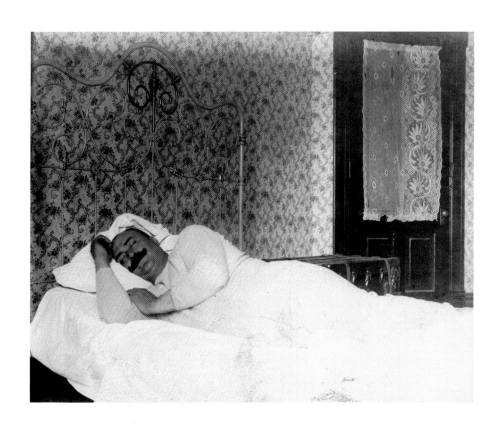

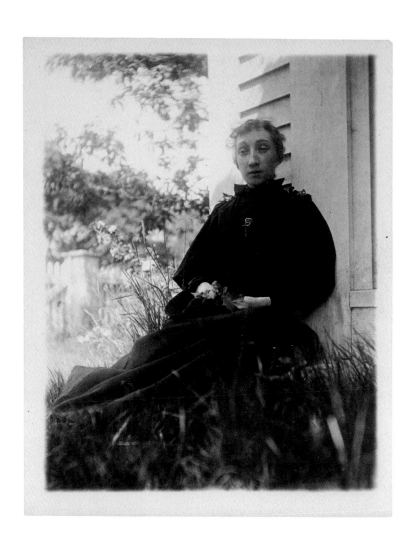

33
—
gelatin
silver print,
c. 1900–1910

34
—
cyanotype,
c. 1900

35

"Accusation,"
gelatin
silver print,
c. 1910

36

gelatin
silver print,
1910s

37

"The Slide
for Life,"
gelatin
silver print,
1910s

The Slide For Life

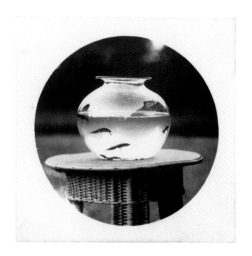

38
—

"Ellen Fullerton,
Feb. 1916 –
age 18 mo.,"
gelatin
silver print,
February
1916

39
—

gelatin
silver print,
after 1888

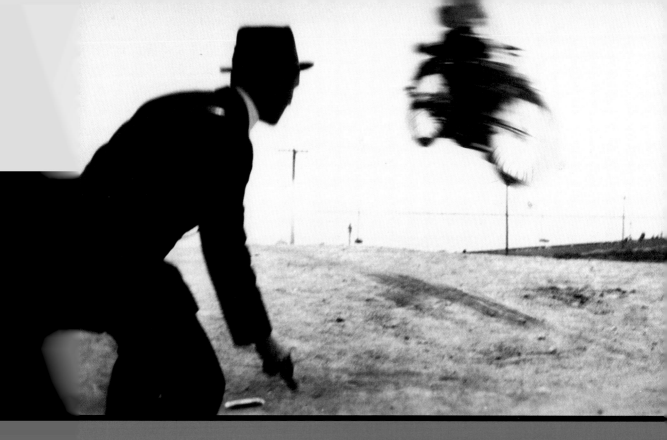

SARAH KENNEL

Quick,
Casual, Modern

1920 – 1939

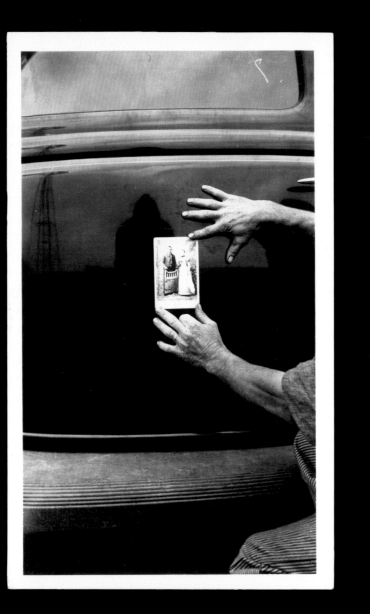

40
—
"Rosa,"
gelatin
silver print,
c. 1930

In 1922 the poet, writer, and film critic Vachel Lindsay argued that modern manifesta-tions of the image in America demanded a new form of visual literacy: "American civilization grows more hieroglyphic every day. The cartoons of Darling, the advertisements in the back of the magazines and on the bill-boards and in the street-cars, the acres of photographs in the Sunday newspapers, make us into a hieroglyphic civilization far nearer to Egypt than to England."[1] Like the great ancient civilizations of Egypt, modern American culture was to be understood and articulated not through written language but by ferreting out meaning from the seemingly chaotic system of visual signs generated daily on a massive scale. In this brave new/old world, where language was ceding power to image, snapshot photography served as an important vehicle through which Americans defined and interrogated their relationship to their rapidly changing environment.

"What an age!" marveled one columnist for *Advertising and Selling* in 1927. "Photographs by radio. Machines that think. Lights that pierce fog. . . . Vending machines that replace salesmen. . . . The list of modern marvels is practically endless."[2] Indeed, the period straddling the two world wars witnessed an impressive parade of technological achievements: the debut of home movie cameras and projectors (1923); the first feature-length "talkie," Al Jolson's *Jazz*

Singer (1927); the introduction of Technicolor (1927) and the first commercially successful color film for amateurs, Kodachrome (1936); the expansion of radio transmission to more than half of all American homes (1934); and the display of television at the New York World's Fair (1939) were just some of the innovations in media and mass culture that transformed the "Big Society" of the 1920s.[3] Such radical changes required new habits of perception that were in tune with, or even supplemented by, these new technologies. As one propagandist argued in "Musings of the Kodak Philosopher": "The eye is unequal to the new demands and the mind can store but a fraction of its impressions. The eye of the Kodak, opening on these things, however, pictures them instantaneously on indestructible film, in lines that time cannot efface."[4] The Kodak Philosopher thus identifies the two main desires that snapshots promised to fulfill: the isolation and recording of the flux of modern existence, and the preservation (indeed augmentation) of memory in a period of fragmentation and stimulus overload.

Perhaps the place to begin assessing the kinds of shifts in picture making that took place in the 1920s and 1930s is with the snapshot that opens this essay (pl. 40). The image functions as a kind of photographic palimpsest. Two truncated, work-worn hands hold against the door of a car a nineteenth-century cabinet card portrait, presumably though not necessarily representing ancestors of either the photographer or the person whose hands are photographed. The formal bearing, studio accoutrements, stiff stances, and Sunday best outfits of the couple pictured in the cabinet card conform to the standards of studio portraiture of the time. In contrast, the snapshot itself is dislodged from any stable set of photographic conventions. As portraiture, it fails to identify the subject properly. Although the verso

is inscribed "Rosa," it is unclear whether the name refers to the woman represented in the cabinet card, the pair of hands that hold it up, or the maker of the snapshot, whose reflection is just visible on the car's door. As narrative, it defies satisfying description.

Yet as a fragmentary slice of material culture, this snapshot provides other kinds of important information about the moment of its making. The reflection of an electrical tower suggests a new site for snapshooting — the rural landscape as it entered the age of industrialization — as well as the car as a new way of getting there.[5] Here, the car also functions essentially as a substitute for the domestic photograph album, where one would expect to find family pictures. More broadly, the geometry of this snapshot as a whole, with its aggressive cropping of the figure and its vertical framing of the horizontal image (an orientation emphasized by repetition of the horizontal grooves of the fender and the striped pants of the partial figure), suggests attentiveness to the abstract possibilities of photography.

It seems that what the maker of this snapshot has chosen to privilege is not the familial relationship of the couple in the cabinet card, or the maker's relationship to them, but rather the look of the old and the new together and the snapshot's role in saying something about the relation between those categories. Or perhaps the photographer simply committed the typical amateur mistake of not getting close enough to the object that he or she wished to capture. Whether intentional, accidental, or something in between, the visual particularities of this snapshot invite us to consider how the practice of snapshot photography did and did not change after the World War I.

2.1

—

"Make Silhouettes the Kodak Way," advertisement, c. 1929. George Eastman House

Make Silhouettes the Kodak Way

The Kodak Flash Sheet Holder is a handy help in providing artificial light. Price, $1.25.

Kodak Flash Sheets burn slowly, giving a broad and powerful, yet soft, light. Prices, $.35 to $.84.

KODAK Silhouettes are examples of unusual pictures—the kind that cause people to ask, "Did you really make those yourself?" They're the kind, too, that help lend variety to your album. They provide an out-of-the-ordinary element that makes any collection of pictures doubly attractive.

And yet these silhouettes are easy to make, and their cost is negligible. See your Kodak dealer. Have him show you the Kodak Flash Sheet Holder and Kodak Flash Sheets. And be sure to write for a copy of the free booklet, "Picture Taking at Night," which gives simple but complete directions for making silhouettes and other night-time pictures.

EASTMAN KODAK COMPANY
ROCHESTER, N. Y., *The Kodak City*

Postwar Photographic Amusements

Although World War I itself occasioned a historical break, picture-taking habits of most Americans did not immediately undergo a sea change upon the signing of the Treaty of Versailles in 1919. Throughout the period between the wars, the Eastman Kodak Company continued to dominate sales of cameras and film. More important, at least in the early 1920s, many Americans continued to use box-style Brownie cameras and relatively simple hand cameras, in part because they were affordable. While some cameras like the Kodak 1A Autographic with coupled rangefinder sold for as much as $60 in the early 1920s, the aluminum No. 2 Brownie introduced in 1924 cost only $2.75. A decade later Kodak introduced the Baby Brownie for $1 — the same price charged for the original Brownie in 1900.

Despite significant advancements in both camera and film technologies, such as the development of the 35mm camera, Americans adapted to changes in camera technology at different paces and in different ways. In the 1923 edition of *Hand Cameras,* Roger Bayler noted that moving from a waist-level to eye-level viewfinder could prove disconcerting:

"Those who go from one of the other forms are apt to find its use a little strange at first, but they soon get accustomed to it, and when once it is thoroughly understood, it is one of the most serviceable and satisfactory instruments made."[6] The author also cautioned the novice to use the hand camera with a tripod until the contraption had been mastered.

Americans continued to employ the camera as a pleasurable activity and as director and participant in the rituals of social life, almost as they had before the war. As described in the preceding essay, the twinning of snapshot culture and new forms of leisure, entertainment, and self-definition was established well before the outbreak of the war. What is distinctive about the practice of making snapshots in the interwar period is the ways in which older modes of self-representation and performance were increasingly inflected by use of the camera to capture, and in the process redefine, the look of intimacy, spontaneity, and a self-conscious modernity.

Throughout the 1920s and 1930s creating silhouettes, an art form that preceded the invention of photography, was a popular photographic exercise. In the 1920s Kodak promoted silhouette photography through advertisements (such as one in 1920 with the silhouette of a woman holding her camera) as well as through free pamphlets like "Make Silhouettes the Kodak Way" (fig. 2.1). Mentioned in the first edition of Walter E. Woodbury's *Photographic Amusements* (1898), silhouette making grew in popularity and was featured in many publications aimed at amateurs.[7] Although synchronized flash would not become standard until the 1940s, inexpensive flash sheets, flashbulbs (which replaced dangerous flash powders in 1930), flashlights, or even just strong sunlight could produce the desired backlit effect.

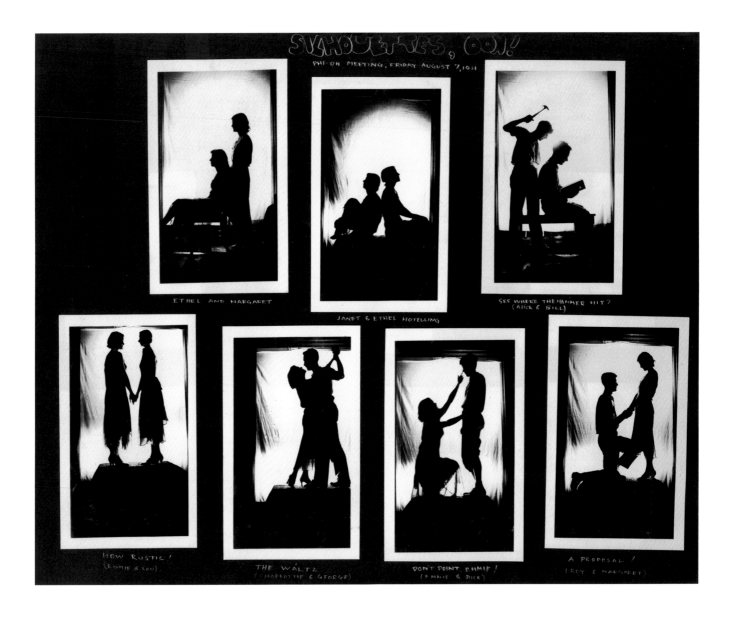

41
—

**"Silhouettes,
Ooh! Phi-Oh
Meeting,"
gelatin silver
prints,
August 7,
1931**

2.2
—

**gelatin
silver prints,
1931 (verso
of pl. 41)**

The combination of theatricality and youth-
ful sociability that characterized photographic
"amusements" in the prewar period is evident in a
double-sided album page titled "Silhouettes, Ooh!"
made by a group of young men and women for a
"Phi-Oh" meeting in 1931 (pl. 41 and fig. 2.2). The pho-
tographs, a series of vignettes involving one or two
figures (male and female), are given playful captions
such as "How Rustic!" or "A Proposal!" The carefully
staged nature of the silhouettes, with their elabor-
ate *mise-en-scène* and use of props like a Greek-style
amphora, conforms to earlier modes of theatrical
performance for the camera. Both the individual

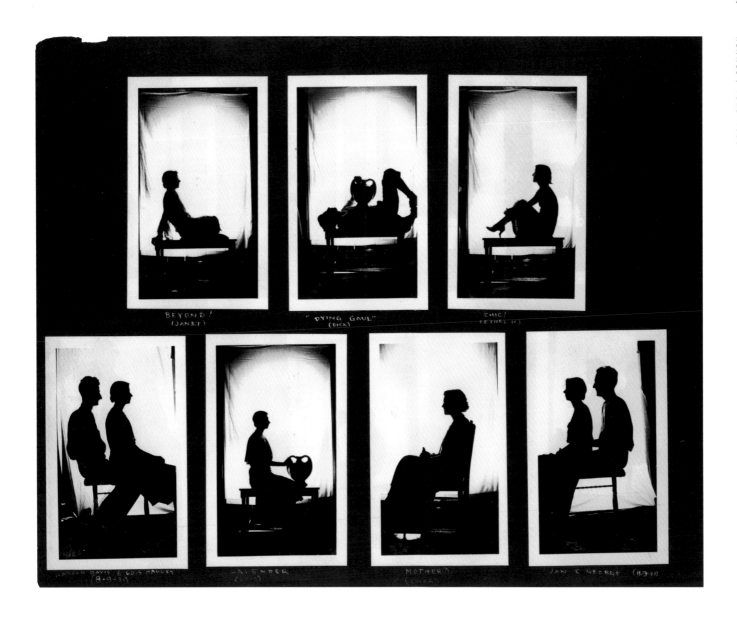

vignettes and the beautifully composed album page suggest a sophisticated knowledge of art: the silhouette of a woman seated in profile is captioned "Mother?"—in reference, no doubt, to James McNeill Whistler's nearly monochromatic *Arrangement in Grey and Black: Portrait of the Painter's Mother* ("Whistler's Mother")—while a man splayed on a bench, somewhat incongruously clutching an amphora, bears the caption "Dying Gaul."

As the practice of snapshot photography flourished and new lighter, faster, more mobile cameras came on the market in the 1920s, an expanded set of photographic amusements began to emerge that explored the inherent possibilities of camera vision itself. Jacob Deschin, one of the most prolific authors of photographic literature for the everyday camera user, summarized an extensive selection of experiments in *Photo Tricks and Effects* (1940), including multiple exposures, multiple printings, photomontage, tabletop photography, and the use of mirrors and glass to distort images. While many of these amusements are similar to those described more than twenty years earlier in pamphlets like *Photo Freaks and Helpful Hints for the Amateur Photographer* (1917), publications from the 1930s increasingly emphasized the potential for distortions and

42

gelatin
silver print,
c. 1930

2.3

gelatin
silver print,
1920s

intriguing effects created not through printing but through manipulating the camera and point of view during the act of taking the photograph. Some of these results were in fact the natural by-products of typical photographic mistakes. For example, a chapter on perspective tricks noted the common error of extreme foreshortening: "Probably every amateur desiring a 'large head' remembers his faults in this regard and how on several occasions he obtained rather weird effects for his pains.... However, intentional distortion by this means is not out of place in photographic trickery where anything goes if the result is interesting. Everyone is familiar with ... the gentleman with the big feet and diminutive head, photographed from the pedal viewpoint" (pl. 42 and fig. 2.3; see also pl. 13 and fig. 1.22 on p. 41).[8] Other interesting effects could be achieved through careful coordination of composition and extreme depth of field, as in one snapshot where a seemingly miniature woman appears to feed a giant cow (see pl. 67), or another where three men, adopting a bold, wide-legged stance connoting toughness and masculinity, "frame" three dainty women who look as if they are conveniently tucked between their legs (see pl. 69). The depth-of-field manipulation that produced the latter snapshot also iterates, in a winking way, stereotypes of gender in which big strong men protect and dominate the fairer, slighter sex.

The inadvertent inclusion of the photographer's shadow was a typical and much-lamented flaw in snapshots made by individuals who, following directives not to shoot into the sun, placed themselves between the sun (or other light source) and the intended target. Once viewed as a mistake by authorities who sought to *improve* amateur photography, the presence of the shadow photographer in the photographic event or the appearance of odd, elongated shadows were occasionally embraced in the 1920s and 1930s as expressive photographic elements that could transform the meaning of a picture. In *Photo Tricks and Effects* Deschin discusses how to photograph objects that cast long shadows, including the exaggerated silhouettes formed by figures standing at the smallest angle relative to the light. An illustration of this approach can be seen in the snapshot of a woman gingerly picking her way across a lawn of looming shadows (see pl. 98), not only that of the photographer but those of an entire lineup of other figures. A sympathetic portrait of a young girl assumes dramatic overtones, as the shadow of a man casually leaning toward her gives the impression of menace (pl. 43). And in another snapshot the silhouette of the photographer's bowler hat (echoed in the sea of hats worn by spectators in the stands) insinuates the maker's presence, and by proxy the act of photography itself, as the main subject of interest (pl. 44).

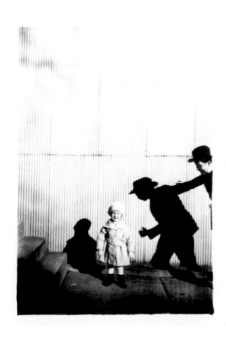

Whether these effects were intended or accidental is unknown and perhaps beside the point, for the distinctions between photographic "mistakes" and deliberate choices were increasingly blurred in the 1930s as the snapshot began to acquire its own aesthetic identity. Indeed, by 1927 a writer for *Photo-Era Magazine*, discussing what he called "the universal snapping psychosis," would acknowledge the snapshot's intrinsic, peculiar qualities: "A photograph . . . may be underexposed or out of focus, and badly composed or printed, and still possess real merit as a snapshot." According to the author, the true snapshot reveals that "the picture was snapped, not exposed." Its appeal lies in "the privilege that goes with its informality. Tricks of rendering, like tipping the camera . . . catching a subject under the checkered shadow of a lattice, including mirrors, smoke,

halation . . . all may be used with perfect appropriateness in the snapshot."[9]

If photographic "accidents" appeared with greater frequency as desirable snapshot effects, the exploration of the camera's capacity to create distorted or unusual perspectives by manipulating points of view was also promoted in amateur literature. In *The Secrets of Snapshots without Failures* (1939) William Stend writes, "the best way to snap a picture, says the rule, is naturally and as you see it . . . but what happens if we violate this rule?"[10] Stating that "the best point of view is seldom the most obvious one," the author describes how interesting pictures can be composed by changing the camera angle and viewpoint: "The camera held low tends to exaggerate and make lines longer. This is a violation of normal perspective which, incautiously used, might be distressing, but here gives a most dynamic

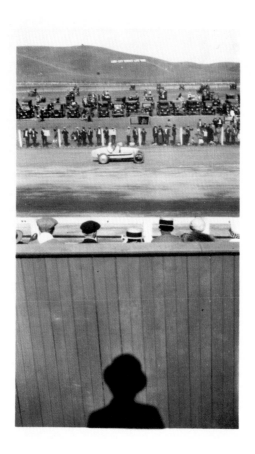

effect." Using terminology that was ever more common, Stend describes two different vantage points that can be used to achieve good pictures: the "worm's eye," which magnifies the subject, and the "bird's eye," which offers an unusual deformation of perspective and relative size.[11]

A picture of several men on a sidewalk effectively conveys the contingent nature of much snapshot photography in the 1920s and 1930s (see pl. 57). The bird's-eye view emphasizes the accidental and fragmented qualities of the scene and integrates the viewer into a complex network of glances, as two of the figures look up at the photographer, who in turn focuses on the interaction below. Like much modernist photography of the period, the unexpected point of view and the dynamic, off-kilter composition of this snapshot seem to signify both the vibrancy and the instability of modern vision.

Some picture takers were clearly aware of the modern look in their snapshots. An inscription on the back of a blurred close-up snapshot of three female faces (see pl. 54) reads: "This Modernistic point of view shows me in the center. Good?" Increasingly, snapshooters were encouraged to experiment with viewpoints that were "daring and new." Kodak's primer *How to Make Good Pictures* (1936) exhorted readers to learn from the techniques used to make advertising "bold, odd, forceful, fantastic, and withal, different!"[12]

In an article, "The March of Progress," published in *Camera Craft* in 1931, Alfons Weber linked the use of unpredictable perspectives to experiences of vision in the modern world: "Since the days when airplanes have made almost everyone familiar with bird's-eye views, which violate every rule of the absolute vertical or horizontal line standards, we

43

gelatin
silver print,
1920s

44

gelatin
silver print,
1920s

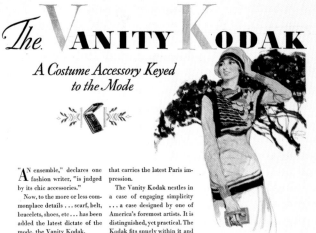

have been accustomed to seeing nothing wrong with pictures which are out of plumb. Perhaps still newer fields are open in the sometimes called worm's-eye view. Where in all the world are such grand motives as in a street lined with towers and buildings? We look up and see buildings towering skywards... every line focused on the highest point which the hand of man has constructed."[13] For Weber, as for many others writing on photography in the late 1920s and 1930s, the new physical structures and spatial experiences of modern life invited and even demanded new ways of making pictures. Snapshot photography seemed increasingly suited to meeting these demands.

Snapshots and the Modern Consumer

Many of the camera techniques described in the amateur photographic literature of time, whether as social amusements or technical experiments, formed part of a broader set of photographic prac-tices that not only were oriented toward play and self-expression but were also specifically addressed to "modern" consumers. With the introduction of the "Kodak Girl" in the 1890s, women and snapshot photography became closely aligned.[14] It was not until the mid-1920s, however, that the company brought out several cameras specifically aimed at modern female customers. The Vanity Kodak, a Vest Pocket Series II camera, appeared in 1928 (fig. 2.4). There were five color options (blue, green, brown, red, or gray), and the matching silk-lined carrying case was described as "swagger, modern, and possess-ing the rare combination of beauty and utility." That same year the Kodak Ensemble, "*The* Gift for the Modern Young Woman," was introduced. Created

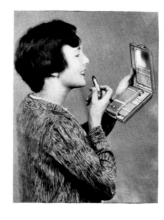

Kodak Ensemble
…*The* Gift for the Modern Young Woman

by the leading American designer Walter Dorwin Teague, it included a folding Vest Pocket Model B camera, matching case, lipstick holder, compact, mirror, and change pocket (fig. 2.5). In contrast to the Kodak promotions that featured women as mothers or homemakers for whom photography was a domestic virtue, the ads for the Vanity Kodak and the Kodak Ensemble appealed to young, dynamic women (whether "graduate or bride") who pursued photography as part of constructing a modern self-image. Indeed, the ad for the Kodak Ensemble boasted that it provided "all necessities for proper make-up and good snapshots."

Kodak also promoted its cameras as an accompaniment to contemporary forms of sociability. As one advertisement suggested around 1927, "A Modern Kodak is Part of the Party." Hawking Kodak cameras and booklets on how to take pictures at night and how to make silhouettes, the ad features a photograph of two women—both sporting costumes, one in masculine dress and a pageboy, playing "pass the apple" (fig. 2.6). The sexual frisson of this cross-dressing couple echoes that of the smaller silhouette below of a man, who adopts the same posture as the cross-dresser, propositioning a woman. In other snapshots from the 1920s and early 1930s, a willingness to explore and express physical intimacy, whether in same-sex or opposite-sex couples, is increasingly evident. While two cross-dressing men deliberately flaunt gender-bending as performance in "Practice Makes Perfect" (pl. 45), another snapshot of two men wrapped in a passionate embrace captures an unusually private moment (pl. 46), an image that would have been nearly unimaginable before the advent of the hand camera.

COLOR, style and utility are prime requisites in a gift for the modern young woman.

Kodak Ensemble—a combination of a trim little Kodak, lipstick, rouge and powder compact, all enclosed in a neat, soft fabric suede case that also contains a mirror and change pocket—capably fills all three requirements.

As to color, this unique combination is available in lovely shades of rose, beige or green. As to style, it is the last word in costume accessories. As to utility, it provides, handily, all necessities for proper make-up and good snapshots.

What a gift for graduate or bride! A gift that the recipient will treasure and use from the first. Kodak Ensemble, complete, may be secured for only $15. See this smart outfit at your nearest Kodak dealer's today.

For Graduates, for Brides, for Any Feminine Gift Purpose—KODAK ENSEMBLE

EASTMAN KODAK COMPANY
ROCHESTER, N. Y., *The Kodak City*

Today: Write for the interesting, free booklets mentioned below

A Modern Kodak is Part of the Party

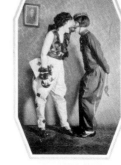

HALF the fun of the party comes with living it over in pictures. Again and again you can experience the tingling thrills, the rollicking fun, the joyful meetings—if a Kodak is part of the party. Kodak pictures become actually *priceless*, whether it's a gathering of youngsters or grown-ups.

There's new ease and economy in making Kodak party pictures

Now there's no need to miss a single picture chance at the party. Eastman scientists have designed fast, sharp-cutting lenses for the modern Kodaks that permit the making of good pictures under almost any conditions. Indoors or out. Rain or shine. Winter or summer. Daylight to dusk. With sunlight, flashlight or electric light.

And Eastman manufacturing facilities have provided these speedy lenses at prices that bring them within the reach of everyone. For example, a lens that a few years ago was available only on

No. 1A Pocket Kodak with ultra-fast Kodak Anastigmat lens f.6.3 costs only $18

cameras selling for $40 and more can now be had on a No. 1A Pocket Kodak that costs but $18.

What's more, the modern Kodak is simplicity itself. Everything possible has been made automatic. Things to adjust have been reduced to a minimum. On many models you'll find a simple Exposure Guide—a wonderful feature that almost does your thinking for you—that takes the guesswork out of making pictures.

Be sure to have a modern Kodak at the next party

Get ready now. Picture chances neither wait nor repeat. Keep all the groups, the games, the stunts, the chance happenings. Make charming silhouettes, closeups, and other unusual pictures that will lend variety to your album, win

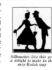
Silhouettes like this are a delight to make in the easy Kodak way

the acclaim of admiring friends, bring the good times back to you time and time again.

Step up to the nearest Kodak counter and see the modern Kodaks. Find out how science has simplified the making of pictures. You can start at once—today, tomorrow—making just the photographs you want, wherever and whenever they happen.

Have one of these modern Kodaks handy at the party. Load it with Kodak Film, the dependable, uniform kind in the yellow box. It has the wide latitude you need. It reduces the danger of under- or over-exposure. *It gets the picture.*

Get in detail the new facts about amateur photography. Write for any or all of these interesting, illustrated booklets: "The Modern Kodak—How to Make the Most of It;" "Picture-Taking at Night;" "Silhouette Making the Kodak Way." You will receive them free of charge, and without obligating yourself in any way. Eastman Kodak Company, Rochester, N. Y.

+KODAK+
Only Eastman makes the Kodak

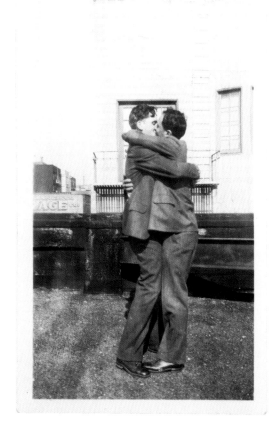

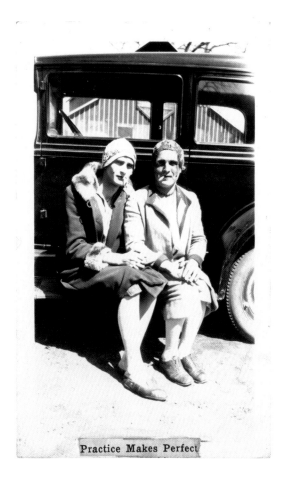

Practice Makes Perfect

45

"Practice
Makes Perfect,"
gelatin
silver print,
1920s

46

gelatin
silver print,
1920s

47

gelatin
silver print,
1930s

48

gelatin
silver print,
1930s

In other photographs theatricality and the expression of individuality and intimacy are conjoined in new and occasionally humorous ways. Two snapshots of a young woman bedecked in home-made costumes and surrounded by Halloween decorations, including a paper skeleton and black cat, show her vamping for the camera (pls. 47 and 48). The resulting images collapse two distinct genres of amateur photography — domestic amusements and home-grown pornography — into a new hybrid genre, the erotico-grotesque. We are not privy to the mode of picture taking here, but the knocked-over cat suggests that the snapshots may have been set up and hastily executed by the subject herself, perhaps with the help of a tripod and timer.

The nominal occasion for this picture-taking performance — Halloween — was, like snapshot photography, changing from a traditional activity to a commercialized one in the 1930s. The holiday has a long history, but its celebration with costumes and decorations was essentially a twentieth-century invention; by the 1930s mass-produced costumes and die-cut decorations were cheap and accessible, like the cameras used to record the new rituals of consumer culture.[15] Indeed, the emphasis on self-expression and play evident in both the taking of and subjects for snapshots harmonized with the new technological, social, and consumerist order that rose from the ravages of World War I.

As Warren Susman has described, America in the 1920s witnessed the emergence of a "culture of abundance."[16] Driven by technological developments in radio, movies, advertising, and the automobile industry and supported by rising wages for most workers, the culture of abundance fueled new ideas about what constituted happiness, satisfaction, and success. Concepts like self-expression, self-fulfillment, pleasure, personality, play, leisure,

publicity, and celebrity appeared with growing frequency in the newspapers, on the airwaves, and often in advertisements and publications that promoted photography as a hobby and an everyday activity, increasingly aligned with modernity itself. To the essayist George Brooks, writing a year before the start of the Great Depression, the expansion of leisure in the "Dollar Decade" was the by-product of the industrialization of work: "As the cities fill with routine workers, whose each day is a monotony of repetition, so fast does the desire for motor, movies, and sports increase…motoring, motion pictures, camping out, playing or watching games are merely an escape from the circumscribed routine of factory, store, or office."[17] Of the many activities Brooks enumerated in his essay, however, none had a greater impact on American culture in the 1920s and 1930s than the burgeoning role of the automobile in daily life.

The View from the Road

In 1922 Kodak sent scouts out over the country's most traveled roads in search of picturesque spots. There, among the busy highways and quiet byways, Kodak erected signs exclaiming "'Picture Ahead! Kodak as You Go!"[18] The slogan "Kodak as You Go" was not new, nor was the association of snapshots with car travel. The 1910 brochure "Motoring with a Kodak" had advertised the No. 1A Speed Kodak as fast enough to record images from a moving car and had suggested that the connection between photography and driving was not merely associative but elemental: "Every motorist feels the fascination of speed whether he indulges in it with his own car or not."[19] By the late 1920s driving had grown from the leisure pursuit of a few to the daily experience,

if not necessity, of many. During the interwar years, while railroad usage declined, automobile travel increased sixfold, and the number of registered cars jumped from less than half a million in 1910 to 8 million in 1920 and 23 million in 1930.[20] By the mid-1930s Americans spent half their entertainment budget on vacations, and 85 percent of vacations involved car travel.[21] With the birth of car culture came new ways and new venues for making pictures.

Automobile tourism and snapshooting thus went hand in hand, as motoring shaped the experience of the landscape for travelers in search of picturesque views. Like the snapshot, driving allowed one to collapse time and to explore the world both as a flow and as a series of fragments. But driving also changed what people saw and how they made pictures, for the view from the road was different from the view at the seaside, mountain, or home. In particular, the expansion of car travel necessitated a new way of approaching landscape photography. While most magazines aimed at amateur photographers still taught their readers compositional principles derived from landscape painting, several began to offer advice specifically aimed at photographers traveling through the countryside by car. For example, Wallace Nutting, photographer and editor of the enormously popular "States Beautiful Series," which included numerous photographs taken from cars or from the side of the road, suggested that photographers look for curving roads and avoid telephone poles at all costs. He also advised them on what kinds of trees were most picturesque and even suggested carrying an axe in case an errant sapling or protruding stump threatened to "spoil the scene."[22] *How to Make Good Pictures* cautioned readers to avoid taking a picture with a horizon that divides the composition in half.[23] Other publications in the Photo-Miniature series, such as "Fifty Dollars

a Week with Car and Camera" (1930) and "Camera Holidays Illustrated" (1930), instructed readers in what subjects to photograph (scenic views, old buildings, interesting trees) and how to handle unattractive intrusions into the picture. Moreover, by printing one's pictures on standard postcard stock — a practice that took root in the first decade of the century — snapshooters could make and send their own scenic postcards.

Even the development of roads in America in the 1920s and 1930s complemented this search for the photographic picturesque. The national parkway system, which expanded greatly in the this period, offered roads that were designed specifically with an aesthetic intent. Unlike the straight lines of the highways, the parkways offered curving roads with interesting scenery that directed the motorist's eye to a visual attraction beyond the road itself.[24] Despite the plethora of advice, however, many photographers included in their pictures such obtrusive elements as power lines or truncated parts of the car (fig. 2.7). In fact, an advertisement for the 1929 Reo automobile, touting the car's ability to reclaim open roads clogged by "a hundred million people seeking freedom from the drabness of daily life," borrows from

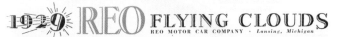
the conventions of amateur road photography (fig. 2.8). Instead of glorifying the car, the ad offers the view of an endless, gently curving open road as seen from the perspective of the driver. The inclusion of part of the car's hood in the advertisement suggests the extent to which this typical element of amateur photography had become part of the way one saw the road, and by extension, part of an American lexicon of speed and space and freedom.

Most publications addressing the amateur landscape photographer stressed the picturesque possibilities of snapshots taken from the road and reproduced illustrations with harmoniously composed, scenic landscapes devoid of industry, but a new sensitivity to the particularities of the urban landscape began to emerge in the literature and the practice of amateur photography. In distinct opposition to Wallace Nutting, Edward D. Wilson argued in an article entitled "Beauty in Ugliness" that the industrial landscape possessed its own kind of visual power, one that the camera was uniquely suited to record.[25] In one snapshot the diagonal thrust of power lines, the veering sweep of a railway bridge, and the broad, flat horizon enlivened by a cloud of smoke reveal an attentiveness to the geometric rather than picturesque qualities of the landscape (see pl. 106). Similarly, the technological exuberance of the great building projects of the 1920s and 1930s is conveyed in a snapshot of three men atop a bridge across the Colorado River (pl. 49). Defined by the geometry of industry rather than the arabesques of nature, the composition of the latter photograph, with its small figures perched precariously on iron girders, expresses the body's relation to the modern world as at once euphoric and endangered — a condition communicated even more forcefully by a snapshot of a man seemingly without arms, dangling perilously by his feet from a telephone pole (pl. 50).

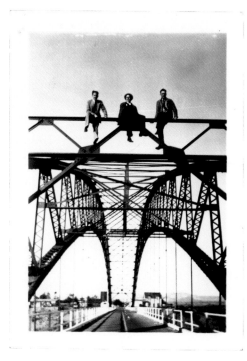

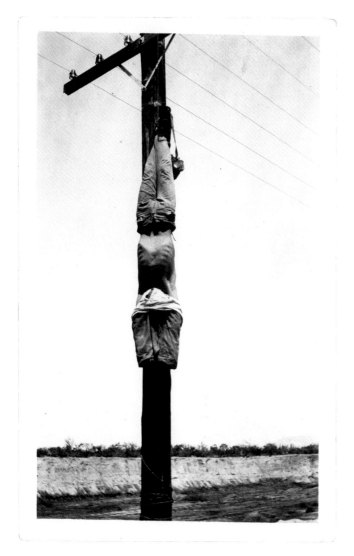

2.8

"1929 Reo
Flying Clouds,"
automobile
advertisement,
*The Saturday
Evening Post*
(June 9, 1928):
69. Library
of Congress

49

"The bridge across
the Colorado
River — the state
line is right in
the center,
Arizona & Calif.
Below Needles,
Calif. Walter.
Baker, Curtis,
Ward," gelatin
silver print,
c. 1930

50

gelatin
silver print,
c. 1930

Speed, Sports, and Spontaneity:
The Modern Kodak

In 1927 Eastman Kodak began to advertise "the modern Kodak." This appellation was not linked to a particular line of cameras but to a set of improvements to both cameras and film technology. More sensitive film emulsions, including full-spectrum panchromatic film such as Ilford Pan (1929) and Kodak Super Sensitive Pan film (1933), combined with cameras capable of faster shutter speeds enabled snapshooters to make pictures under a broader range of conditions than had been possible before the war: indoors, in poor lighting or variable weather, and so forth. Although reductions in the size of cameras and in the corresponding spooled film resulted in smaller negatives, advances in film and lenses meant that even small negatives could yield high-quality pictures. As advertisements for the modern Kodak insisted, the price of such improvements was not prohibitive. For example, in 1927 Kodak sold the pocket 1A camera with an "ultra-fast" anastigmatic lens for $18, which was pitched to amateurs. Cameras with faster lenses, viewfinders, and eventually automatic exposure were available for a moderate price. Everyone, Kodak proclaimed, could now make snapshots "the quick, casual, modern way."[26]

Instruction manuals such as "The Modern Kodak: How to Make the Most of It" (c. 1928) offered tips for using the cameras, including an exposure guide to correlate speed and f-stop with lighting conditions so that "everyone can make good snapshots now…in the shade…indoors…on rainy days." Although Kodak effectively promoted the ease and instantaneity of the new cameras, claiming that "the modern Kodak is simplicity itself" and "everything possible has been made automatic," it took some adjustment for amateurs to become comfortable with the changes. Although some cameras, including several Brownie models, continued to feature waist-level viewfinders through the 1950s, the increased production of cameras with eye-level viewfinders throughout the 1920s and 1930s necessitated a new way of handling the camera. Viewfinders held at eye level were not only easier to see through and thus reduced the time needed to compose a picture but also created greater coherence between what the lens and the eye registered.[27] Together these improvements enabled photographers to make pictures that seemed more fluid and immediate. Perhaps as a result of these developments, candid photography grew increasingly desirable: "Snap, snap, snap, no posing—see how alive they are!" exclaimed one Kodak ad from the 1930s.

Kodak's marketing of its "modern" cameras was in part a response to the 1925 introduction of the German-made Leica, the first practical and popular 35mm camera.[28] The small, highly portable Leica offered many new features that made it ideal for action and candid shots, including controls on the top of the camera, variable shutter speeds, a faster 35mm lens, and, of course, 35mm roll film. Because it seemed to function as both an extension of the hand and an integral part of the eye, the ultra-lightweight Leica was pivotal in the history of twentieth-century photography, especially for photojournalism. And it proved that a negative as small as 24mm × 36mm could produce professional-quality prints. Its impact on amateur photography was less immediate, however. The price of the Leica and other 35mm cameras such as the Contax, first sold in 1932, remained out of reach for most Americans. Thus

throughout two decades following the war many amateurs continued to use folding or box-style cameras like the Brownie, which was issued in many styles, such as the Bakelite art deco Beau Brownie (1930). It was not until the mid-1930s, with the introduction of the Kodak Retina and Argus Model A, that owning a 35mm camera was viable for the average American. The Kodak Retina, available in 1934 for $57.50, boasted a daylight-loading (light-tight) 35mm film cartridge that could be used in other 35mm cameras, including the Leica. Up to that point, photographers generally had to trim short lengths from long rolls of 35mm movie film and load them into special cartridges for use in a still camera. Two years later the Argus appeared on the market, priced at $12.50. Inexpensive and easy to use, this camera rapidly gained extensive popularity.

Even before the widespread use of 35mm cameras, the development of lighter equipment, superior lenses, and more sensitive film emulsions made possible new subjects for photography, in particular the depiction of movement and speed. Although the camera had long been linked to the freedom of locomotion, represented first by the bicycle in the 1890s, then by the car after 1910, the ability to capture the arc of motion itself had remained the province of professional photographers like Eadweard Muybridge and Jules-Etienne Marey. By about 1910, however, even the casual snapshooter could achieve an "action snap," transforming an airborne bicycle or motorbike into a flying miasma (see pl. 53) through the film's registration of the blur of motion. The figure on the left here, who seems to hold something in his hand

(perhaps a starting gun), stands in for the new type of snapshooter: crouched, tense, about to spring on a moving target.

In other action shots the impetus to "get the snap" and the ability to take a fast picture may have overridden older, slower habits of composition. One image made in the Grand Canyon shows a man from the torso down, leaping across a steep crevasse, one foot in midair, far from the safety of the other side (see pl. 56). Whether the photographer deliberately sacrificed the subject's head in order to record the full depth of the chasm or whether it was an accidental cropping caused by the speed of picture taking is unknown. In either case, this photograph signals the new fascination with the camera's potential for recording the fast and fragmented pace of modern life. Of course, the preeminent medium for recording movement was moving pictures. But although Kodak had introduced home movie cameras in 1923, their high cost and the relative difficulty of operating them restricted their use to a small number of enthusiasts until the middle to late 1930s.

As part of the general enthrallment with speed, flow, and motion, blurriness, no longer considered a photographic error, was increasingly prized for its capacity to convey movement. By the time *Secrets of Snapshots without Failures* was published in 1939, blur — though evidently avoidable — was instead actively cultivated: "More and more in modern photography, the tendency has been away from photographing moving objects so that their motion is not apparent. It is now considered excellent photography to shoot somewhat more slowly and to indicate motion through a slight blurring of the image."[29]

The ability to photograph stop-action movement was the result of technological developments, but the drive to photograph the body in action —

swimming, diving, running, leaping — stemmed from broader cultural changes in America that transformed the 1920s into what essayist Robert Duffus has called the "Age of Play."[30] Rejoicing in the body's health and vitality in the wake of the war's carnage, young men and women flocked to pools, gyms, beaches, dance halls, stadiums, and running tracks. Of the many leisure activities that defined the new cultural and social realities of the 1920s, sports most aptly expressed the promise of the postwar period. At the same time, photographing sports, thanks to the ability as well as the desire to capture the figure in motion, gave rise to a new vision of the body: propelled by energy, yet recorded in fragments. In one snapshot, the thrust of a nude figure diving into a lake, leaving pale buttocks and inward-turned legs visible above the water, seems to celebrate the body's physicality while also depicting its awkward and humorous vulnerability (pl. 51). The perspective positions the viewer in a similarly ambiguous place: are we resting in a boat, or swimming in the lake? We may be tempted to detect references to modernist representations of the fragmented body in this and other diving or action snapshots, but the photograph reveals less about a shared modernist aesthetic than about a collective embrace of a new form of camera vision: the "snapshot aesthetic" that progressively cut across the boundaries of art, journalism, and the imaging of daily life.

Memory and the Family

As in the prewar years, recording the family for posterity remained one of the most common forms of snapshot photography during the interwar period. The significant change concerned ways in which snapshots of the family were increasingly entwined with discussions of memory and forgetfulness. In the 1930s Kodak began to stress use of the camera to counter the truancy of memory, particularly with regard to family stability. Most advertisements with this theme targeted women, including a series showing mothers photographing their children with the tagline "Let Kodak keep the story" (fig. 2.9). These promotions emphasized the storytelling function of the camera, which gave childhood (and by extension the family) a structured, visual narrative. Other marketing strategies played on fears of familial disintegration and loss. A 1930 advertisement featuring snapshots of children at different ages encouraged frequent picture taking, not merely because "they change so quickly" but also because "memory fades so soon."

Kodak advertisements aimed at men generally touted photography as a means to record activities such as camping, sports, and fishing (men posing triumphantly with their fishing catch were especially favored). But by the mid-1930s a few ads portrayed photography as a way of securing the man's role in the family as provider and protector. One depicted two men perusing snapshots of one of the men's children (fig. 2.10). The text described how the other man "felt ashamed" that he did not have photographs of his own children: "While he showed *pictures* of his youngsters, I could only *talk* about mine. Without snapshots, though, I couldn't seem to find much to say." Pictures, the ad implies, are worth much more than a thousand

51

gelatin
silver print,
Poland,
Maine, 1930s

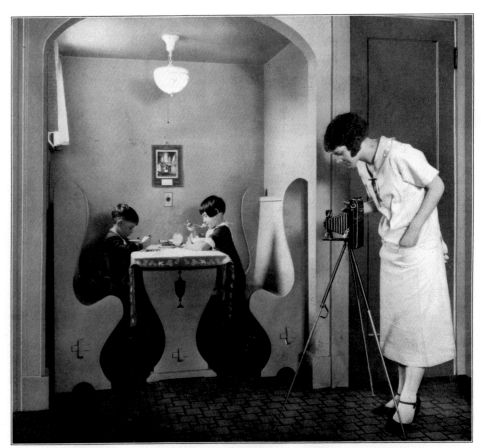

Let Kodak keep the story

In the house or out of doors, whenever there's a home story you want to save, your Kodak saves it. Children are always little, and the scenes just as they used to be —in your Kodak album.

Any Kodak is easy to work, and
the prices start at $5

Eastman Kodak Company, Rochester, N. Y., *The Kodak City*

I Felt Ashamed

HE was so proud of his children; why hadn't I taken snapshots of mine?

JOHNSON took an envelope out of his pocket and handed me some snapshots.

"Just got these," he said. "Don't the kids look wonderful!"

"Look at Betty there," he rattled on, "isn't she cute in that dress? Her mother made it. Betty's crazy about dolls, but Buddy is strong for dogs. See here—this picture—"

I felt ashamed. While he showed *pictures* of his youngsters, I could only *talk* about mine. Without snapshots, though, I couldn't seem to find much to say. So my friend did most of the talking. A jealous pang ran through me. Why, *his* children couldn't compare with mine.

Often, because of mere thoughtlessness, a father fails to take snapshots of his children. As years pass he begins to regret this failure more

and more. By the time he realizes how quickly he is forgetting the way his youngsters *used to look*, it is often too late. Don't let this happen to you. Take snapshots of them as they are today, as they never will be again.

As for not owning a Kodak . . . really, there's no excuse for it. Every day of your life, probably, you pass stores that sell them. The cost is whatever you want to pay. There's a genuine Eastman camera, the Brownie, as low as $2, and Kodaks from $5 up.

And every Eastman camera makes excellent snapshots. Particularly the Modern Kodaks. Many have lenses so fast that you don't have to wait for sunshine. Rain or shine, Winter or Summer, indoors or out, everyone

can take good pictures with these marvelous new Kodaks.

Kodak Film in the familiar yellow box is dependably uniform. It has speed and wide latitude. Which simply means that it reduces the danger of under- and over-exposure. It gets the picture. Expert photo finishers are ready in every community to develop and print your films quickly and skilfully. So begin —or continue—taking the pictures that will mean so much to you later on.

EASTMAN KODAK CO., Dept. AF-6
Rochester, N. Y.

Please send me FREE and without obligation your interesting booklet about the Modern Kodaks.

Name

Address28

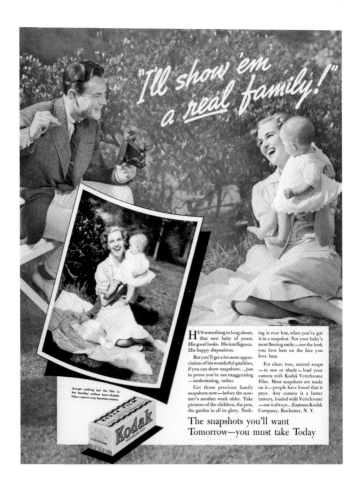

"I'll show 'em a *real* family!"

HE'S something to brag about, that new baby of yours. His good looks. His intelligence. His happy disposition.

But you'll get a lot more appreciation of his wonderful qualities, if you can show snapshots . . . just to prove you're not exaggerating —understating, rather.

Get those precious family snapshots now—before the summer's another week older. Take pictures of the children, the pets, the garden in all its glory. Noth-

ing is ever lost, when you've got it in a snapshot. Not your baby's most fleeting smile—nor the look you love best on the face you love best.

For clear, true, natural snaps —in sun or shade—load your camera with Kodak Verichrome Film. Most snapshots are made on it—people have found that it pays. Any camera is a better camera, loaded with Verichrome —use it always...Eastman Kodak Company, Rochester, N. Y.

The snapshots you'll want Tomorrow—you must take Today

Accept nothing but the film in the familiar yellow box—Kodak Film—which only Eastman makes.

Kodak

words — they are signifiers of moral responsibility. Another advertisement for Kodak, again directed at the anxious male customer, shows a man photographing his wife and baby with the caption "I'll show 'em a *real* family!" — thus reiterating the power of the snapshot to define and sustain the nuclear family (fig. 2.11).

The camera's role in documenting childhood and family rituals was of prime importance to most amateur photographers. In a series of photographs of a young boy, Edward Book, made each year on his birthday, we observe such a tradition in the making. The photographs, which all measure 2 × 3 inches (suggesting that the family continued to use the same camera) and are inscribed with the date and sometimes the age of the subject, function as a partial, serial record of one boy's childhood. In the first photograph of this group (see pls. 77–83) — although not necessarily the first one made —

a nine-year-old Edward shyly holds a large birthday cake; two years later he stands, somewhat more confidently, with a tray of cake slices. At thirteen, he holds a large cake decorated with his name; and at fifteen, following a growth spurt, he is transformed into a tall and slightly awkward teenager. Despite Kodak's exhortation to let the camera "keep the story," these photographs are essentially without narrative. While two of the photographs are inscribed with the location ("Kodiak, Alaska," 1932, and "Seward, Alaska," 1935), the details of the celebrations, the other guests for whom the cake is intended and offered, and the identity of the picture taker are unknown. What matters is the documentation of the occasion; the act of picture taking itself has become ritualized, inseparable from the ritual of the birthday festivities.

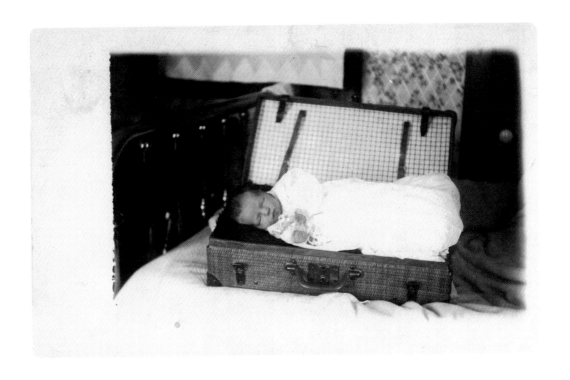

52

gelatin
silver print,
1920s

Celebratory events such as holidays, birth-days, and weddings (see pls. 73–76) remained the preferred themes for picture taking, but several snapshots from this period reveal that the camera occasionally witnessed more serious forms of ritual and even death. Many nineteenth-century special-ists in postmortem photography portrayed their subjects as if sleeping rather than deceased. But with rare exceptions, early twentieth-century pro-fessionals had stopped photographing the dead and instead focused on recording narrative scenes of grief or conventionalized half-length views of the deceased in a casket.[31] Indeed, what appears to be a postmortem photograph of a baby swaddled in fancy clothes and placed in a small valise (pl. 52) is unusual, for it at once points to the continuity between snapshot protocols and earlier forms of photographic memorialization, yet it stands apart from the more popular use of the snapshot, which was to record life and its pleasures. Another photo-graph of a casket being carried down the steps during a funeral, taken in a direct, almost confron-tational manner, seems to function less as memori-alization than as a form of reportage (see pl. 102). These unorthodox images show what many snap-shooters preferred not to depict, perhaps because it was all too present: death. But with the awakening concept of the "candid camera" in the 1930s, the proper subjects for snapshot photography seemed to be ever expanding.

Candid Camera Capers

By the early 1930s the economic impact of the Depression forced many Americans to curtail their leisure activities drastically, yet picture taking did not diminish. In fact, interest in photography virtu-ally exploded at all levels, from amateur and photo-journalist activities to books on the topic, hugely popular nationwide exhibitions, and the embrace of photography as an art form by the museum world.[32] The "democratization" of photography stemmed largely from the reproducibility of its images, which made "the daily world of modern man a pictorial world to a degree beyond anything in human experi-ence," according to an editorial in the *New York Herald Tribune*.[33] Most Americans experienced this pictorial world through magazines or their own snapshots. Thanks to cheaper modes of reproduc-tion and increased use of smaller, handheld cameras, the European picture industry boomed in the 1920s. Subsequently, with the launching of magazines like *Life* (1936) and *Look* (1937), photojournalism in America evolved into a sophisticated visual form. By the late 1930s photojournalists were recording pro-fessionally what had been nearly the sole province of the snapshot twenty years earlier, with special atten-tion directed toward stories of everyday life. New publications like *US Camera* (1935), *Minicam* (1937), and *Popular Photography* (1937) disseminated tech-nical advice as well as photographs of all subjects, by both professionals and amateurs, to a rapidly grow-ing public hungry for pictures.

The greater prominence of photojournalism combined with high levels of unemployment may in part have spawned a new breed of amateur, seek-ing to make money from his or her photographs. Pamphlets and books like *Ten Million Salable Camera Shots* (1938) and *Making Amateur Photography Pay* (1937), edited by Willard D. Morgan of *Life*, offered guidelines on publishing work in magazines and on selling to picture agencies. These authors provided specific information on how to submit photo-graphs to major picture agencies (including mailing addresses). Yet the major insight that emerges is

the conviction that the entire world, not simply one's own family, was ripe for photographic exploration. As *How to Make Good Pictures* put it, "the scope of photography has broadened tremendously and…the usefulness of the camera has increased a hundredfold…picture making today is a more intriguing hobby than ever."[34]

The belief that even the most mundane aspects of everyday life were worthy of photographic representation was in part nurtured by the widespread interest in and publication of documentary photographs in the 1930s. Photographs made for the Farm Security Administration (FSA) appeared in mainstream magazines like *Life* and in large-scale traveling exhibitions at popular and accessible venues like Rockefeller Center and Grand Central Palace.[35] One might speculate that the rise of documentary photography in the commercial and art worlds inspired amateurs by seeming to demystify photography, but photojournalism in turn drew much of its inspiration from the aesthetics and techniques of the snapshot. In particular, both were indebted to the development of "minicams," the small, lightweight cameras like the Leica and the Retina that ushered in the era of the candid photograph. It was increasingly possible and, it seems, desirable in the late 1920s and 1930s to take pictures of people caught unaware of the camera's lens. From Walker Evans's "subway portraits," made with a camera hidden under his coat, to casual snapshots of a woman sleeping in the back seat of a car or in a hospital bed (see pls. 91 and 93), candid photographs revealed their subjects unposed, unadorned, and vulnerable.

The snapshot's spontaneity had long been an acknowledged part of its appeal, and with the dominance of minicams in the 1930s, a new emphasis on candid photography arose, as well as a debate over its merits. In *New Ways for Photography* Jacob Deschin vaunted the popularity of the candid camera: "The 'candid,' so-called miniature camera is one of the strangest phenomena of this decade. It has given new life and new trends to the photographic industry, inspired some remarkable scientific and mechanical achievements in the general field of photography, attracted hosts of new devotees to the ranks of the 'snapshotters.' And through exhibitions and reproductions of its works, it has raised the standards of the art."[36] Though it may possess technical flaws, the strength of the candid photograph, according to Deschin, was its ability to "produce records of human experience unmatched by any other medium."[37]

One particularly avid supporter of the minicam, Horace Bristol, went as far as to claim in a 1937 issue of *Camera Craft* that the device was "Social Dynamite" that could function as everyman's tool for truth telling at moments of social strife and conflict. Marshalling the average snapshooter to the ranks of the social documentarian, the author proclaims:

In a world of strikes and lynchings, towering bridges, tumbling slums, child-labor and society weddings, where it is all but impossible to point a camera without including significant documentary evidence of contemporary civilization, the average snap-shooter packs his Kodak beside the pickles of the picnic lunch, all unaware that ounce for ounce, his piece of glass, leather and steel is more potent than TNT.…At a time when powerful forces are active in the world in the suppression of free expression…the cheapest box Brownie can serve…in the fight against oppression.[38]

While Bristol championed the activist potential of the minicam to reveal the world's conflicts and struggles, others regarded its influence as pernicious. Coursin Black, writing in the journal *Photography*, cautioned: "candid photography is making us human goldfish."[39] With the new candid cameras that were "mostly all lenses — that is, eyes," no one was safe from their prurient gaze. Not only were "we apt any day to open a magazine and find ourselves the models for an epic of a citizen's day," but the sanctity of public figures was undermined: we found "our statesmen in the act of munching corn on the cob ... or sound asleep during the eulogistic speech being made in their honor."

Echoing these sentiments, William Mortensen characterized the 1930s as the age of "the Collapse of Privacy,"[40] and the "most important instrument in this concerted invasion" was the miniature camera. Mortensen distinguished between the "healthy and harmless" pastimes of minicam owners trying to get a few "record shots" and those who use the camera to catch people off guard and intrude upon the very "privacy of their thoughts," a phenomenon that he felt had developed into "a morbid mass mania." Rehearsing the long-standing argument that snapshooters lacked skill and discrimination, Mortenson continued: "Most ... are mere button-pushers. They push one button and the elevator stops for them, they push another button and the radio plays, they push a third button and they secure a sort of replica of whatever they had their camera pointed at."[41]

Thus using harsh rhetoric, Mortensen articulates anxiety over the ease with which miniature cameras challenged the status of the accomplished amateur and professional photographer and produced a ceaseless barrage of "cheap and nasty little picture magazines."[42] Mortensen was not unbiased. A professional who specialized in highly manipulated, sentimental, mildly erotic studio photographs, he was the antithesis of both the untutored snapshot photographer and the minicam-wielding photojournalist. And as an entrepreneur who aggressively marketed his publications and school devoted to studio photography, he may have felt threatened by the increasing acceptance and popularity of the miniature camera within the photographic and journalistic establishments.

Despite these biases, Mortensen's emphasis on button pushing as modern way of life registers a keen discomfort over new forms of technology and mass culture as well as the perceived alienation between human intentionality and the mechanization that they produced. Moreover, his alarm over automation had some resonance. Mortensen's article was published 1938, the same year that Kodak introduced the first automatic exposure camera, the Super Kodak Six-20, and the first color transparency film, each making the world ever more, and more faithfully, reproducible. Little did Mortensen know that in less than a year, at the wildly popular New York World's Fair, alongside giant color transparencies and the display of the special World's Fair model of the Baby Brownie exhibited in Kodak's hall, the newest form of mass media — television — requiring nothing but the push of a button to reveal the texture of the world, would soon eclipse picture taking as Americans' favorite means of visual communication.

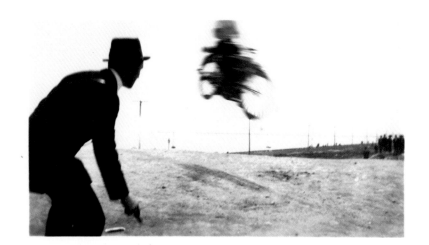

53

**gelatin
silver print,
c. 1930**

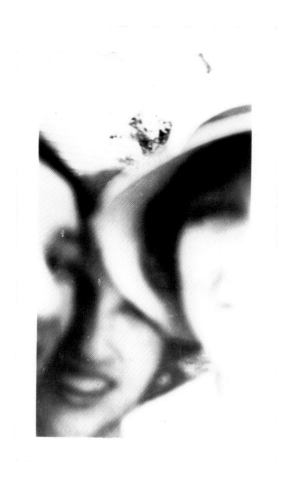

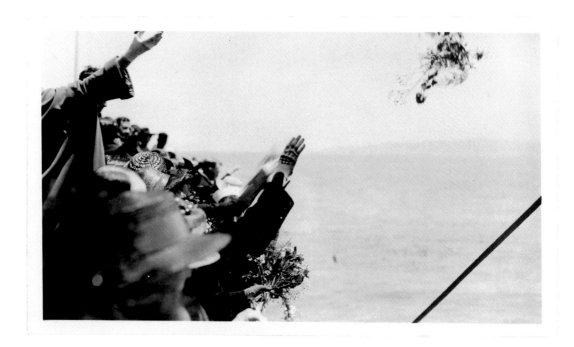

54
—

"This Modern-
istic point
of view shows
me in the
center. Good?"
gelatin
silver print,
1930s

55
—

gelatin
silver print,
1920s

56
—
"Taken at
Grand Canyon
Arizona.
2000 ft below.
Vern Albred
Grand Canyon,"
gelatin
silver print,
November 24,
1927

57
—
gelatin
silver print,
1920s

58
—
gelatin
silver print,
1920s

59
—
gelatin
silver print,
1920s

60
—
gelatin
silver print,
1930s

61
—
gelatin
silver print,
1920s

62
—
gelatin
silver print,
1930s

63
—
gelatin
silver print,
1930s

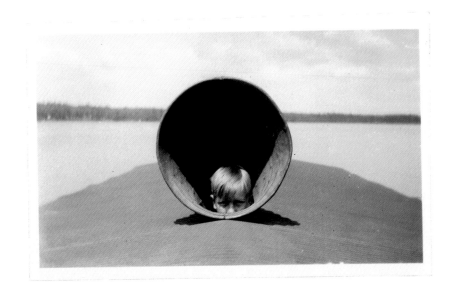

64

gelatin
silver print,
La Crosse,
Wisconsin,
1920s

65

gelatin
silver print,
c. 1930

66

gelatin
silver print,
c. 1930

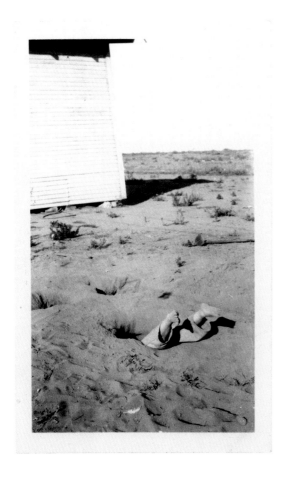

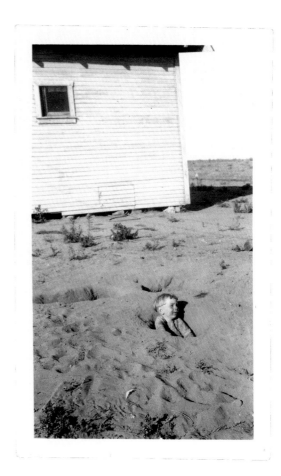

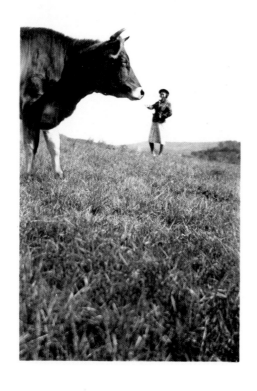

67

gelatin
silver print,
1920s

68

gelatin
silver print,
1930s

69

gelatin
silver print,
1930s

70

gelatin
silver print,
1920s

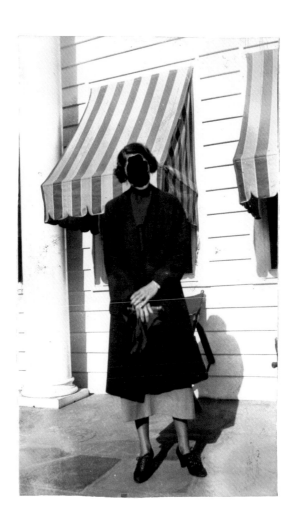

71
—
"?!!"
gelatin
silver print,
1930s

72
—
gelatin
silver print,
1930s

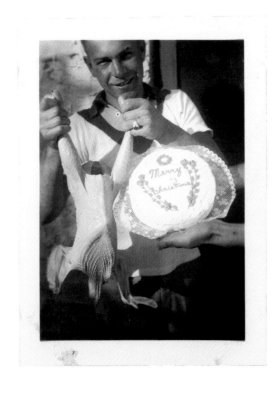

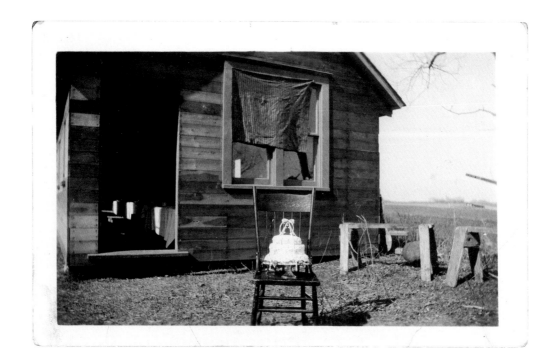

73

"Hollywood
Florida,
Xmas Turkey,
Russell
Schnoyer,"
gelatin
silver print,
December
1937

74

gelatin
silver print,
1930s

75

gelatin
silver print,
1920s

76

gelatin
silver print,
1920s

april 14, 1929.

APRIL 14 1930
10 YEARS

13 yrs old. april 14, 1933

april 14, 1934.

April 14, 1931.

Kodiak Alaska.

Seward Alaska April 14, 1935

77
—
"April 14,
1929,"
gelatin silver
print

78
—
"April 14,
1930, 10 Years,"
gelatin
silver print

79
—
"April 14,
1931,"
gelatin silver
print

80
—
"Kodiak Alaska,"
gelatin
silver print,
April 14,
1932

81
—
"13 yrs old.
April 14,
1933,"
gelatin
silver print

82
—
"April 14,
1934,"
gelatin silver
print

83
—
"Seward Alaska,
April 14,
1935,"
gelatin silver
print

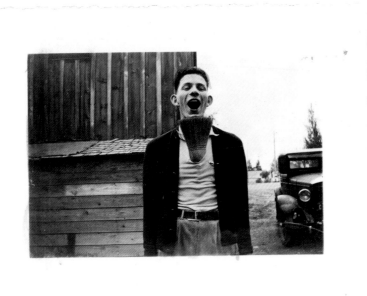

84
—
hand-colored
gelatin
silver print,
Septem-
ber 12, 1938

85
—
gelatin silver
print, Pierre,
South Dakota,
July 20, 1939

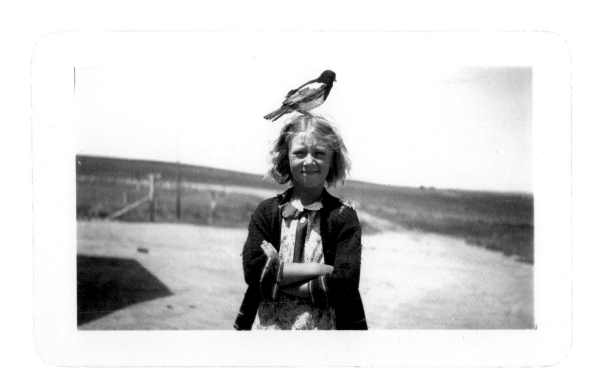

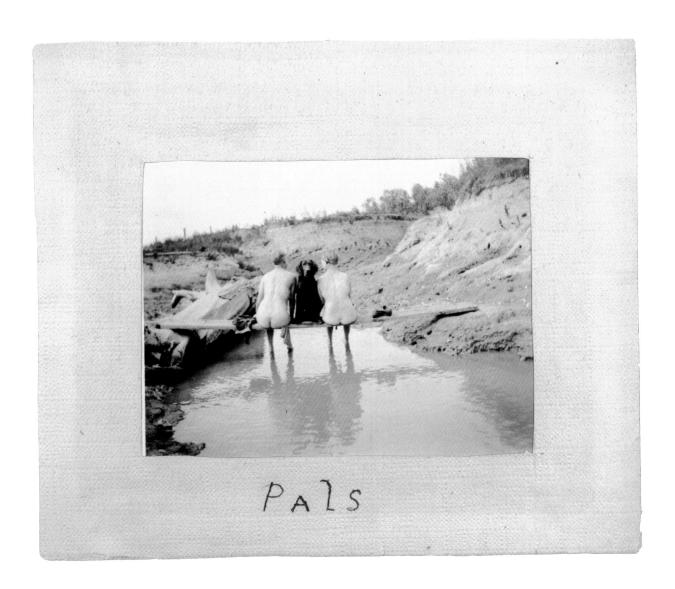

Pals

86
—
"Pals,"
gelatin
silver print,
1920s

87
—
gelatin
silver print,
1930s

88
—
gelatin
silver print,
1920s

89
—
gelatin
silver print,
c. 1930

90
—
"Charlie and
rooster
crowing,"
gelatin
silver print,
1930s

91
—
"Going home
& Still
Sleeping,"
gelatin
silver print,
July 17,
1938

92
—
gelatin
silver print,
1930s

93

"This is the one when I was asleep. I had been in the hospital almost a month so I look kind of worn down. This picture does not do my room justice. It was all in pink and blue. I had a French telephone beside my bed on the radio that doesn't show up here. Really it is wonderful the way the hospital rooms are so cheerful and look so little like a hospital and so much like a hotel room," gelatin silver print, 1930s

94

gelatin silver print, c. 1930

95
—
gelatin
silver print,
c. 1930

96
—
"Ellwood
Hollbrook,
Watson-
ville, Calif.,"
gelatin
silver print,
1930s

97

gelatin
silver print,
1930s

98

"Mom didn't
even notice
me taking
this. Wonder
what she
saw on the
ground? ha
ha!" gelatin
silver print,
1930s

Mom didn't even notice me taking this. Wonder what she saw on the ground? ha'ha!

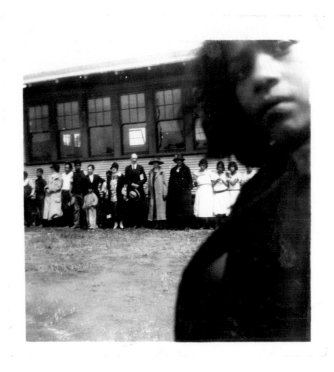

99
—

**gelatin
silver print,
c. 1930**

100
—

**gelatin
silver print,
c. 1930**

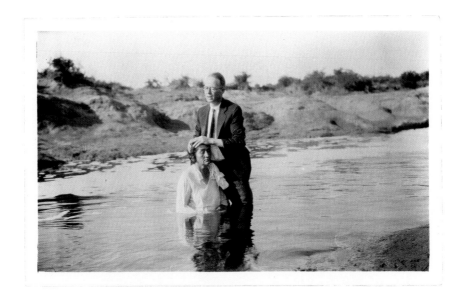

101

gelatin
silver print,
1930s

102

gelatin
silver print,
1930s

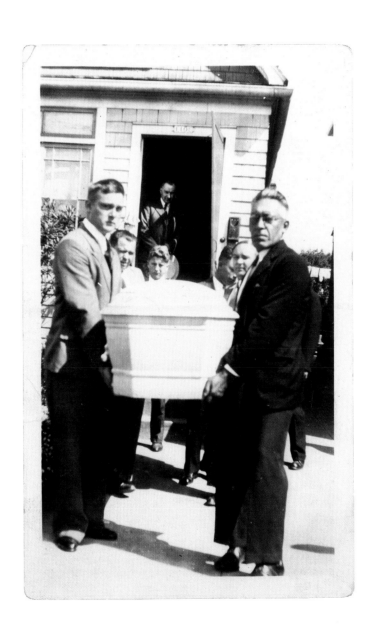

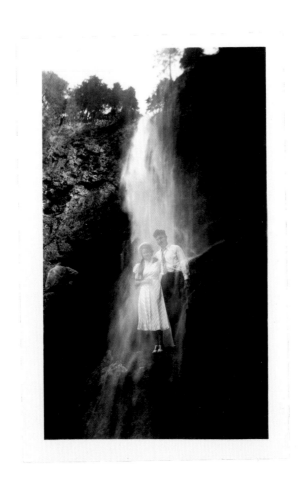

103
———

"Double Expose
—Snapshot
Showing Zim
& Rita in
Multnomah
Falls, Old
Oregon Trail
7/16–29/37
Oregon 7/25/37
Portland,
Fleet-Week,"
gelatin
silver print,
July 25, 1937

104
———

gelatin
silver print,
1930s

105
—
gelatin
silver print,
1930s

106
—
gelatin
silver print,
1920s

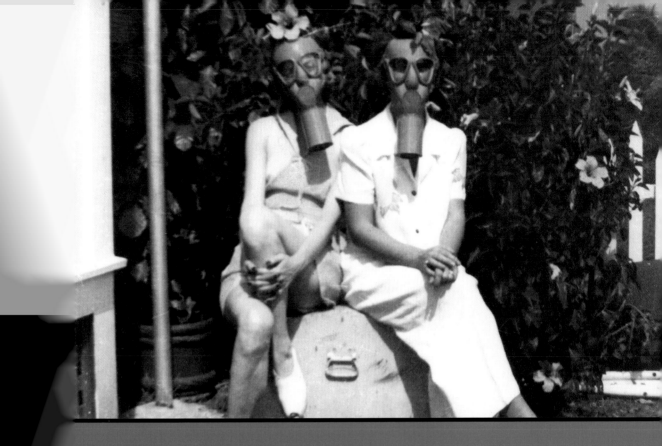

SARAH GREENOUGH

Fun under the
Shade of the
Mushroom Cloud

1940–1959

107
—

**Flo, "Dorie,"
gelatin
silver print,
July 1957**

In 1955 Flo, a young Midwestern woman, perhaps in her early twenties, somewhat plain in looks but fierce in determination, moved into a drab but respectable YWCA in Milwaukee. She had briefly attended college, but with little possibility of a professional career, she, like so many other women in the 1950s, quit school and reluctantly accepted a series of menial jobs. After working as a cook at the YWCA, she found a position in a local office of IBM, but although her new employers repeatedly told her that computers would revolutionize the workplace, she saw scant evidence of that and was consigned to the monotonous drudgery of working in the file room. Flo dearly wanted to marry, move to the suburbs, and raise a family, but, awkward around men, she was not even going steady, and unlike almost all of the other young women who lived at the Y, there was no one, as they would say, that she "dug the most." Truth be told, with her clumsy ways, lack of social graces, and inability to join in the girl talk her housemates adored, they regarded her as "square," even a bit of an "oddball." Perhaps most painful for her, she watched longingly every Friday and Saturday night as the other girls went off to any one of the number of local "hops," where they danced the Hokey Pokey or the Bunny Hop, and, of course, Walked the Dog. When the music turned slow and Elvis crooned from the jukebox to "Love Me Tender," they even occasionally dirty danced with their guys. This behavior and especially this new rock 'n' roll music,

108

Flo, "Dorie,"
gelatin
silver print,
July 1957

109

Flo, "Dorie,"
gelatin
silver print,
July 1957

110

Flo,
"C. Gaikowski,"
gelatin
silver print,
August or
July 1956

which so obviously derived from rhythm and blues, worried the parents of Flo's housemates, all of whom were white, but it thrilled and titillated their daughters. And when the girls got home from their evenings out, they squealed with excitement as they recounted what they referred to as the "backseat bingo" they had played in their dates' cars in the darkened city streets and alleys.

Yet Flo sat at home, watching an immense amount of TV on the one small set in the common living room while she idly flipped through the numerous magazines strewn on the tables. Inundated by their seemingly endless advertisements, which extolled the good life and suggested that with easy credit it was now within reach of all Americans, she began to dream of herself, if not as "Queen for a Day," then certainly, as the media so frequently intoned, as a "Queen of Domesticity."[1] She had seen the "Homes of the Future" that toured the country earlier in the 1950s, but she preferred something a little less flashy — perhaps a ranch or split-level house with a large picture window, not one of those Cape Cods that had been so popular right after the war.[2] There she and her dream family would enjoy cookouts, as they were now called, in the backyard with one of those new kettle grills that had first appeared on the market only a few years earlier. She knew her husband would lavish attention on their car, making sure it was an accurate reflection of their status and family life, but she would devote herself to their

home. Envisioning herself less like the new starlet Marilyn Monroe and more like Harriet Nelson from the TV show "The Adventures of Ozzie and Harriet," she pictured herself in her airy, sparklingly new kitchen, impeccably coiffed and dressed, wearing heels, a neatly ironed apron, and a cheery, unflappable nature. Easily seduced by slick advertising, she wanted one of those new ovens with the window that allowed you to look inside without opening the door, for the idea of cooking as entertainment, indeed cooking as television, greatly appealed to her. And she wanted one of those new refrigerators bedecked with chrome, just like the car that would sit in their neatly attached garage. When most lonely, Flo even fantasized that the new advertising sensation Mr. Clean, with his heavenly muscles, would help her clean her turquoise blue appliances. And despite the Jolly Green Giant's annoying "Ho-ho-ho," she knew she would serve her family his frozen vegetables, as they represented the height of modern time-saving conveniences.

After several weeks of such behavior, Flo was smart enough to realize that her fantasies were bordering on obsessions and, most likely, only increasing her unhappiness. Recognizing that she needed something productive — a hobby — to fill her empty hours, she bought a cheap camera. Appreciating that she also needed a way to get closer to her housemates, she started to photograph them (pls. 107–110, 133–136, 177–200).

Flo did indeed live in Milwaukee and appears to have worked at IBM, but the preceding story of her life — her character, education, and social standing; her dreams, her aspirations, and her slights — has been entirely fabricated, based on an examination of her snapshots as well as critical studies of American popular culture in the 1950s.[3] Like so many other snapshots now abandoned by their makers or their makers' immediate family and friends, Flo's photographs invite such speculation because they have been cut loose from the personal narrative that originally gave them meaning. Rich with suggestive hints but lacking in definitive details, they entice us with their visual creativity and tempt us to imagine the lives that created them, precisely because as documents they remain so elusive and unsatisfactory. We know almost nothing, in fact, about these photographs: about the person who made them, the circumstances that inspired their creation, the people or events they depict, or the significance they had to their maker. In today's culture where everything is explained — on television or the Internet, in newspapers or books — Flo's photographs remain stubbornly mute. And it is their very muteness, coupled with their partial, fragmentary nature and our undeniably voyeuristic feelings as we look at them, that makes such photographs so compelling and gives them their obvious authenticity. From our own experiences, we instinctively know when viewing snapshots like these that they, unlike many carefully crafted works of art or fully articulated documents, possess a kind of truth that is both profound and unassailable. But what that truth is precisely remains forever unknown.

The ordinariness of Flo's snapshots and her desire to make them is also touching, for in that banal act she was no different from countless other Americans in the late 1940s and 1950s. During the war the government had poured millions of dollars into American businesses, filling their coffers and giving them great incentive to modernize their infrastructures. After the war, as the economy continued to boom, commerce thrived, spurred on by hundreds of thousands of soldiers returning home and a world sorely in need of American products. With Europe and much of Asia in ruins, the United States quickly became the most powerful nation on earth. The explosion of the nuclear bombs "Little Boy" and "Fat Man" over Hiroshima and Nagasaki in August 1945 and the Soviet Union's detonation of a hydrogen bomb in 1949 patently demonstrated that both this country and the world faced grave and imminent dangers, but Americans at first were largely unconcerned. Instead, as a collective amnesia settled over the nation, erasing or at least minimizing the most painful memories of the war, the veterans and the young women they had left behind quickly set about having families, buying homes and cars, and establishing roots, eager to partake of the American dream they had worked so hard to secure. With the Depression behind them, unemployment low, and a forty-hour, five-day-a-week work schedule now the norm, Americans in the years immediately after the war had more leisure time than at any other point in the country's history and more discretionary cash: "Never have so many people had so much time on their hands — with pay," *Business Week* declared in 1953.[4]

Americans had pursued hobbies since the nineteenth-century, but after World War II, with significantly more free time and disposable income, they embraced them with a passion, even a moral fervor, unknown in earlier decades. Because they valued both work and living within prescribed boundaries, the idea of spending one's spare time in a directed pursuit seemed highly commendable.[5]

111
—
gelatin
silver print,
January 12,
1942

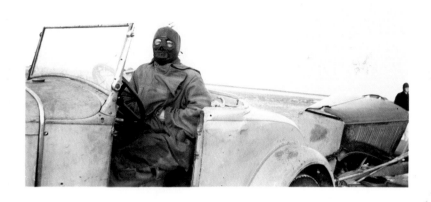

Thus men, women, and children explored all kinds of hobbies: they collected stamps, coins, and trading cards; they mastered crafts like sewing, toleware (lacquered or enameled metalware), mosaic sets, or woodworking; and they eagerly undertook do-it-yourself home improvement projects as they sought to renovate an attic, put down a new linoleum floor, or otherwise perfect their portion of the American dream. Fads for making Revell plastic models of airplanes, ships, trains, and other objects swept the country in the 1950s, as did one for paint-by-number picture kits — even President Eisenhower was known to paint such pictures while watching television.[6]

Praised as a "worthwhile recreation" that teaches "observation, alertness, and patience," photography was also an extremely popular diversion in the late 1940s and 1950s.[7] During the war, when the military had first claim on all available cameras, film, and equipment, it was soldiers, not civilians, who had ready access to photographic materials (pls. 111 and 138).[8] But by late 1944 and early 1945, as those shortages evaporated, more Americans from all walks of life began to make more photographs than ever before.[9] Kodak estimated that in 1941 amateurs in this country took 1.1 million snapshots, a little more than twice the number taken in 1935. During the war the number was so negligible it was not worth recording, yet in the first full year after the end of the war, when commercial activities resumed, Americans took more than 1.5 million snapshots. In the next several years that number continued to soar, so that by the middle of the 1950s more than 2 billion snapshots were made annually in the United States; by 1954 around 38 million of the country's 53 million families — more than 70 percent — owned cameras.[10]

American snapshots changed significantly in the 1940s and 1950s, propelled by the technological improvements made as a direct consequence of the war and by the rapidly evolving visual sophistication of the American public. As the preceding essays make clear, American snapshot habits before World War II had been intimately related to new forms of leisure and recreation, coupled with a desire to use the process as a means of self-definition. These traditions continued after the war, but they were subsumed into even broader practices. What separates the postwar years from earlier periods is the ubiquity of photography. As photographic images seeped into every aspect of daily life — from snapshots to reproductions in newspapers and magazines, to movies and television, and to the billboards that lined city streets and rural highways — people no longer needed an excuse to make photographs. As everything and anything became a worthy target for their cameras, amateurs not only photographed what was close at hand, personal, and meaningful to them, as they had always done, but they also infused old subjects with fresh vitality and pioneered new ones. In the process they began to address areas of American life that had previously been beyond the frame of their cameras, examining themes that had been ignored or deemed inappropriate. And as the power of photography in modern life became ever more apparent, amateurs began to see their snapshots not merely as a way of defining themselves, their families, and their customs and traditions, but as a vehicle to mold, even transform themselves.

Kodak was a primary agent of this change. During the war it, like other American companies, had benefited enormously from the government's demand for its products. In 1936 Kodak had invented and released a color slide film, Kodachrome, the first truly viable color process. But because it

was slow, complicated, and ill-suited for not only amateur but military needs, the Air Force, which extensively used photography for aerial recognizance during the war, urged Kodak to hasten the discovery of a negative-positive color process. In 1942 Kodak released Kodacolor, the first color negative film, and hailed it as "the greatest achievement in photography since George Eastman pioneered and introduced the first black-and-white roll film in 1889."[11] Once Kodacolor became available to the general public after the war, Americans in ever increasing numbers began to take color snapshots. Although Kodak admitted that very few color slides and prints were made by civilians in 1941, it estimated that in 1951 more than 170 million were made.[12] Nevertheless, because color slides were awkward to view and Kodacolor prints were expensive — each print cost 37 cents in 1953 — color film did not become the dominant way of taking snapshots until the 1960s.[13]

Kodak also continued to dominate the market for reliable inexpensive cameras, with German and Japanese companies unable to produce competitive models until the mid-1950s. Its Brownie Hawkeye camera, a simple plastic box with chrome detailing and a large handle, looked like little more than a 1950s version of the earliest Kodaks. Lightweight and durable, it was even more popular when it was first released in 1949, especially among children, than the Brownies manufactured at the turn of the century. In 1951 Kodak produced an improved model with a synchronized flash attachment that screwed onto the side of camera. Perfected in the late 1930s, the synchronized flash made it possible to photograph in any lighting condition and promised, as Kodak assured its customers, "new indoor thrills."[14] Capitalizing on the success of these cameras, Kodak released updated styles of the Brownie in the 1950s,

their names often signaling their special attributes: the Baby Brownie and Brownie Holiday were lightweight, compact, and suitable for travel; the Brownie Starflash and the Brownie Starlet, capable of photographing under the stars, had built-in flash; while the Brownie Bull's-Eye and Brownie Bullet assured customers that they would hit their intended targets.[15] Some were available in different colors — the Starflash came in red, white, or blue for patriotic amateurs — while the Six-20 Brownie was available in "sporty versions," with tan coverings and brass trim. Their focus and exposure controls were minimal to nonexistent. Most had one setting for color and another for black and white, a fixed focus (usually from five feet to infinity), a set shutter speed (1/25 or 1/50 second was most common), and all were inexpensive, ranging in price from $2.85 to $15.[16]

Kodak was not the only American company to supply easy-to-use, economical cameras. Sears sold its Tower Camera — "so simple a child can operate," with "everything needed to take good pictures indoors and out" — in a convenient carrying case, all for $11.50, while its durable Spartacus Camera sold for only $5.85.[17] Fashion-conscious women could sport the gold-plated Pixie Camera, so small it could be attached to the wrist, for only $7.50 (fig. 3.1). During this time, as companies grew increasingly savvy about the ability of one product to sell another, they produced many specialty cameras that were specifically aimed at children and teenagers, such as those marketed for Boy Scouts and Camp Fire Girls or the Seymore Products' Dick Tracy Candid Camera, which, befitting its namesake, was compact, seemingly rugged, and no-nonsense. Nor was the serious amateur overlooked. The Argus 35mm camera, especially its Model C3, which was made of Bakelite and nick-

3.1
—
"New! Pixie Flash Camera," advertisement, 1949. National Gallery of Art, Washington

named "the Brick" because of its shape, weight, and durability, was an immediate success. *Fortune* magazine declared in 1945 that "the Brick," with its small size and economical price, had "overnight changed candid photography in the United States from a class hobby to a mass pastime."[18] By the mid-1950s many 35mm cameras, previously considered the "Cadillacs" of cameras, were transformed, as one camera magazine noted in 1957, into "the Chevrolets of today."[19] Numerous 35mm cameras cost less than $100, most had light meters, many had interchangeable lenses, and some were even equipped with built-in flash.

Black-and-white film was also improved during the 1950s. Kodak introduced its highly popular Tri-X film in 1954. Dramatically faster than earlier films, although with a noticeable grain, Tri-X made it possible to photograph in dim light without a flash

and to use a faster shutter speed to capture movement without blur. Although film in cassettes gained in favor for 35mm cameras, almost all of the 1950s Brownies used roll film, which had to be loaded and unloaded in low light and was awkward to handle. Roll film was far from foolproof: careless amateurs could improperly load the film so that it did not advance correctly, or they could expose it to light, ruining some or even all of the pictures. In addition, cameras had no safeguards to remind the absent-minded operator to advance the film, thus double exposures were still common (pl. 112). Yet because film, processing, and prints were now so cheap — an eight-exposure roll of film could be developed and printed in 1953 for 35 cents[20] — and the average American was now so prosperous, the customer could simply throw away any photographs that did not turn out.

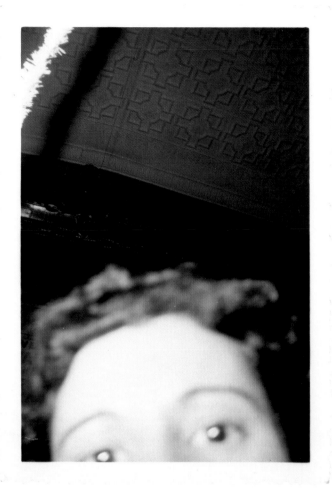

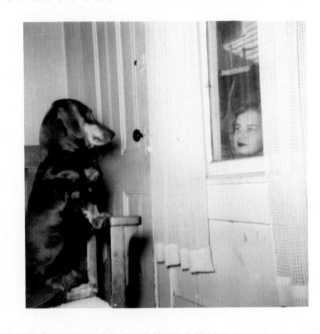

Without doubt, the most sensational photographic invention of the period was the Polaroid, created in 1947 by Edwin Land, so the story goes, because his daughter was frustrated that she had to wait so long to see her finished prints.[21] In the earliest models a black-and-white negative was exposed in the camera, and as it was pulled out, it was first pressed against a positive receiving layer, and both then passed through a reservoir of processing chemicals. Sixty seconds later the final print, sepia in color with a deckled edge, could be peeled away from the negative. The photographer then coated the print to protect it from fading and damage. The camera and its film were not inexpensive — early models sold for $89.75, and a pack of film cost $1.75 — but they were an instant success. When they first appeared in a Boston department store before Christmas 1948, they sold out immediately, and sales the

following year exceeded $5 million. The Polaroid perfectly suited the 1950s spirit. Like the Jolly Green Giant's frozen vegetables, it was convenient and fast. Although the results, as with frozen vegetables, were often mixed and the prints far from stable, that did not matter because the process of making them was so much fun.

The new cameras, films, and processes were responsible, at least in part, for the changing look of American snapshots in the 1940s and 1950s. Because many cameras now had flash attachments, more photographs were taken inside or at night (pls 113, 114, and 142). Because fewer cameras had viewfinders that required operators to hold them at waist level and more were brought to the eye, and because film was more sensitive, the resulting photographs

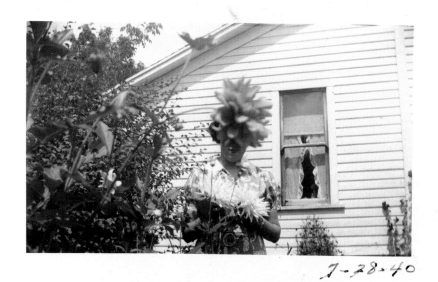

115

gelatin
silver print,
July 28,
1940

116

gelatin
silver print,
1950s

117

"Mary Girow's
Cadillac,"
chromogenic
print, September 9, 1956,
2:45pm

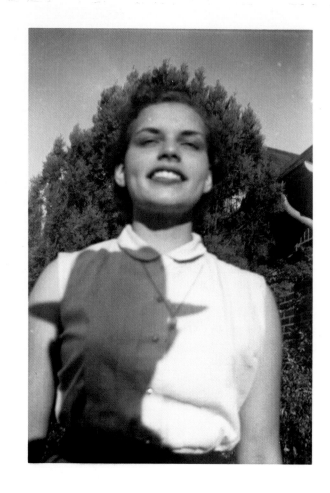

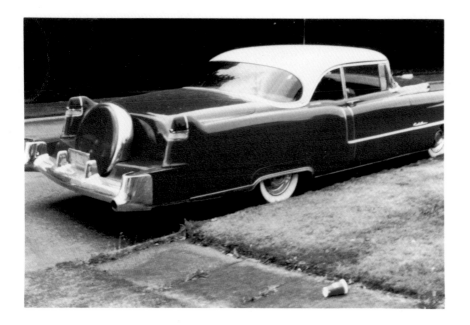

were more fluid and immediate, less posed or static. But the optics on inexpensive cameras remained less than optimal, and viewfinders provided only limited approximations of what was actually being recorded. It was still difficult to see, for example, that a branch was covering Grandma's face (pl. 115) or that bushes appeared to be growing out of a friend's head (pl. 116). Thus most snapshooters continued to use a hit-or-miss strategy, placing the primary object of interest at the center of the composition, with little concern for whatever else was captured around the edges (see pl. 164).

Color posed both new possibilities and new challenges. Once limited to documenting their world in the more subdued tonal range of black and white, amateurs in the late 1940s and 1950s who could afford the cost were able to reproduce the full palette of "living color," as the NBC television commercial first announced in 1957. For the first time snapshooters could easily record scenes where color was integral to meaning or emotion, like the red of a shiny new Cadillac (pl. 117). But they soon discovered that black and white was more forgiving: in color an unforeseen, trivial element, like the red paper cup discarded on the sidewalk in front of the gleaming Cadillac, assumed almost as much prominence as the car itself. Moreover, because the stability of the dyes used in color prints of the 1940s and 1950s was far from perfect, amateurs just as quickly learned to look at their precious memories in less-than-accurate "living color."

Many of the new cameras created different pictorial formats for amateurs to explore and exploit. In some cameras the long, thin format of the negatives and their wide-angle lenses, which splayed forms at the edges of the frame, made

especially dynamic and often distorted composi-
tions. When oriented horizontally, as in "So happy,"
the proportions emphasized the tendency of all
horizontal photographs to be read in a narrative,
filmic manner, while the wide-angle lens often pro-
duced striking contrasts between foreground and
background (see pls. 145 and 146). When turned
vertically, it stacked disparate forms on top of one
another, so that a wailing baby in a carriage — eerily
evoking the celebrated scene in Sergei Eisenstein's
film *Battleship Potemkin* (1925) of a loose pram careen-
ing down a flight of stairs — seems on a collision
course with a car directly above it (pl. 118). The wide-
angle lens also distorted scale so that one hapless
photographer, who no doubt intended to record his
wife or girlfriend asleep on the sofa, also captured
his own shoe in the foreground, looking gigantic and
phallic, pointing directly at the sleeping figure (pl. 119).
The square format of the photographs made by the
Starlet and other cameras had a chunky, static ap-
pearance when all the elements were gathered in the
middle (pl. 120) and a centrifugal effect when they
were scattered at the edges (pl. 121). Professional
photographers had mastered this format beginning
in the late 1920s when using the popular Rolleiflex
camera, which made 2¼ × 2¼ inch negatives, but
amateurs had not. Yet because it so closely mim-
icked the proportions of many television sets of the
time, they had little trouble adapting to it.

Most other changes in American snapshots
at this time, however, were a direct result of the
rapidly increasing visual sophistication of the culture.
The amount of information Americans received
about the world — its news, people, places, and his-
tory; its sports, fashion, politics, and business;
and especially its human relationships — through
images (on film, television, and in reproductions
in magazines and newspapers), exploded in the
years immediately after World War II. *Confidential,
Family Circle, Galaxy, Glamour, Good Housekeeping,
Harper's Bazaar, Holiday, Jet, Junior Bazaar, Ladies'
Home Journal, Life, Look, Mademoiselle, McCall's,
Modern Screen, Newsweek, Popular Mechanics, The
Saturday Evening Post, Time, Town & Country, Vogue,*
and *Women's Weekly* were just a few of the many
magazines published in these decades. There were
others devoted to crafts: *The Work Basket;* sports:
*Car and Driver, Golf Digest, Road and Track, Sports
Illustrated,* and *Sports World;* soft porn: *Playboy* and
Spam; children: *Boy's Life* or *Children's Playmate;*
and teens: *Seventeen* and *Young Miss.* Some of these
publications were founded in the years before the
war, but many more were launched in the 1940s and
1950s. After the war, all drew inspiration from the
remarkable success of the European illustrated peri-
odicals of the 1920s and 1930s as well as *Life,* which
began publication in 1936. These magazines had
used photographs not just as illustrations but as a
primary means for telling stories. Newspapers, too,
became more profusely illustrated with photographs
during these years, in an attempt to compete with
both popular magazines and television. And adver-
tisers, always keen to find the most effective way
to promote their products, were quick to pick up on
the power of eye-catching photographs and gradu-
ally abandoned drawings or long verbal descriptions,
which had been fashionable in the preceding
decades. Hollywood continued to saturate the Amer-
ican public with as many visual images as ever, but
now it offered such technical innovations as three-
dimensional and wide-screen movies and drive-ins
as a way of luring people out of their homes and
back to the theaters.

None of these media, however, could com-
pete with television, which enjoyed a rapid rise and
widespread acceptance and use in the 1950s. At

118
—
gelatin
silver print,
1940s

119

gelatin
silver print,
1940s

120

gelatin
silver print,
1955

121

 gelatin
silver print,
October 7,
1947

1955

the beginning of the decade 9 percent of American households owned a television set; by the end of the decade 86 percent did.[22] Studies conducted at the time noted that once American communities received television reception between 1948 and 1952, fewer people went to movies, libraries, restaurants, and sporting events.[23] Instead, they stayed at home and watched television, viewing variety, comedy, crime, sports, and quiz shows as well as soap operas, westerns, and news programs. Because the early sets were small—at first only eleven or twelve inches across—and usually located in the living room, entire families huddled around them, watching programs together. This made the act of viewing television especially personal and intimate, and it also increased its influence. Embraced and sanctified by the family, the images seen on television were physically much closer to the viewer than those on a movie screen and were therefore much more powerfully hypnotic. Karal Ann Marling has argued that because of the profound impact of television on American culture, seeing—not reading, hearing, or experiencing—"is absolutely central to the meaning of the 1950s.... Seeing, looking, appraising, exercising one's own taste.... It's all about what people looked at, and what there was to see."[24] Seeing became believing in the 1950s, and, more than at any other earlier time in American history, people saw through the filter of photography.

Inundated with visual, and specifically photographic images, snapshooters in "the Picture Age" of the 1950s, as it was hailed at the time, continued to focus on the same subjects their predecessors had: sports, leisure activities, and travel; birthdays and holidays, especially Christmas and Halloween; as well as the arrival of a new child, visits of family and friends, a day at the beach, or a trip to the zoo (see pls. 120, 126, 131, and 170).[25] But they also stopped

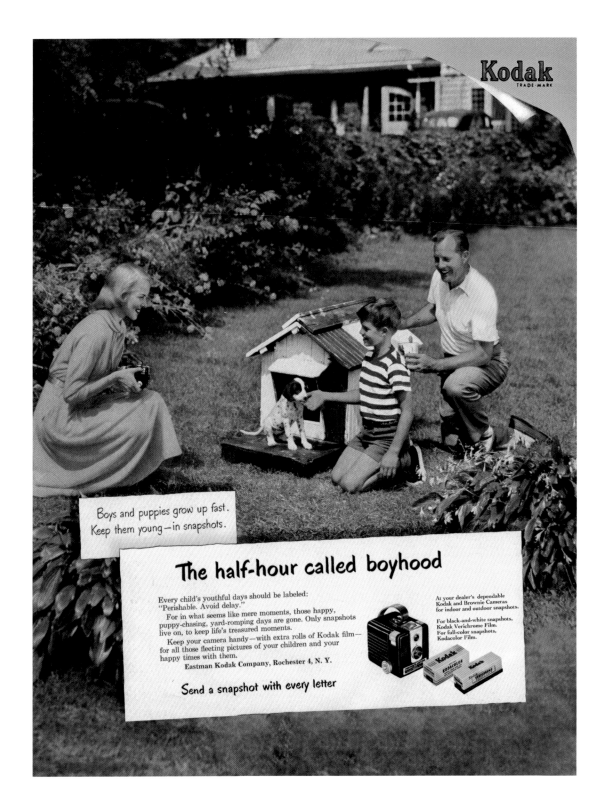

making certain kinds of photographs and began to record different subjects than their predecessors had — and in a different way. Camera clubs, which had thrived at the turn of the century and taught neophytes the rules of composition and technical processes as well as appropriate subject matter, faded in the years after the war, a victim of the new-found ease and affordability of the medium. As photography gained in popularity, amateurs no longer turned to fellow camera club members, "how-to" pamphlets, or books like "Fun Things to Do with Your Camera." Thus the number of trick photographs began to diminish. Instead, articles in amateur photography magazines in the 1940s and 1950s implored their readers, as one author insisted in 1953, to "learn to SEE." Noting that "we have come to look at things like everybody else does, or as outside influences have taught us to look," the writer urged photographers to depend less on their tools or tricks and more on their "inner vision." Each must learn to "see as nobody else does."[26]

Kodak's advertising echoed the primacy of seeing and the vital role of photography within the media culture of the late 1940s and 1950s. Because the idea of the family was central to the myth of American life perpetuated in the media at the time, Kodak abandoned its trademark drawing of the adventurous, globe-trotting "Kodak Girl" in her striped dress, replacing her with a photograph of a 1950s woman who could have stepped out of a Norman Rockwell painting; she holds a camera, ready to take a snap of her husband, son, and dog (fig. 3.2).[27] Overlooking the selectivity of photography, which records only discrete moments and subjects, Kodak continued to insist that the snapshot was far superior to human memory: it "remembers — when you forget," and it remembers "*every bit of it.*"[28] Customers were assured that

snapshots "tell the story best," better than any oral or written family history, and they were encouraged to photograph not only special occasions but anything, anywhere, and at any time: "Have your camera with you everywhere — for that's where great snapshots are.... Wherever you are, wherever you go. Then you'll *save* all those wonderful memories instead of *wishing* you had."[29]

Kodak was not the only company to charge women with the task of preserving domestic memories or to target women specifically as the makers of snapshots. In an article titled "What Happened to the Snapshot?" published in *Popular Photography* in May 1956, Dorothy Fields noted that "even the most amateur of amateur photographers would reel under a pride-crushing blow if his pictures are referred to as snapshots or having a 'snapshot-ish' quality."[30] Observing that in recent years "cameras were firmly removed from the hands of women by those mechanical and mathematical geniuses of the household — men," she addressed her "plea" to the "photographers' wives," asking them "how many of you have a pictorial record of your children?" She urged them to "remember the 'good old days' [when] it used to be the women who carried the cameras and took the pictures." After advising the wives to buy hamburger instead of steak when they shopped for the family's meals, she told them to use the money they had saved to buy an inexpensive camera. Keep it handy, she concluded, "on a kitchen shelf or in a dresser drawer and when the occasion arises, take it out...put the sun over your shoulder, and snap, snap, snap."[31]

Far more than in previous decades, amateurs in the 1940s and 1950s did indeed take their cameras everywhere and photographed everything, creating an almost visual stream-of-consciousness record of their lives. Nothing was off limits. As life imitated

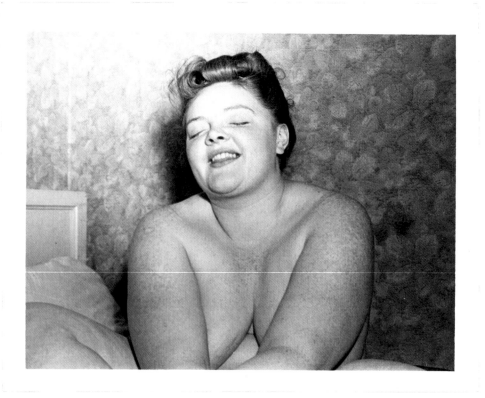

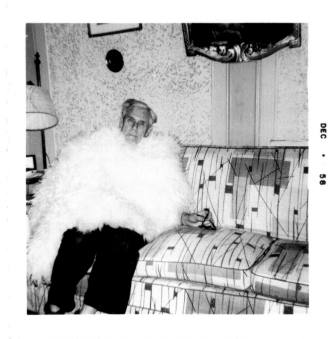

DEC • 58

122
—
gelatin
silver print,
1940s

123
—
gelatin
silver print,
December
1958

124
—
"This is the
only way
Sara would
pose for
a picture,
being dressed
in this
disguise,"
gelatin
silver print,
March 1957

125
—
gelatin
silver print,
1950s

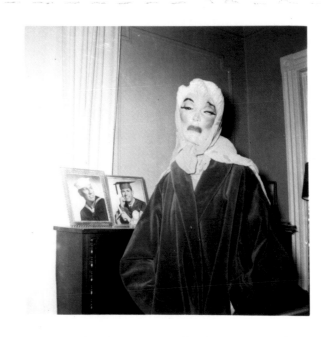

art and moviegoers saw the intense physical intimacy displayed by stars like Elizabeth Taylor and Montgomery Clift in Hollywood movies such as *A Place in the Sun* (1951), their own snapshots began to reveal far more personal moments, even ones showing great passion, than they had in previous decades (see pls. 142, 143, and 144). As they saw the sizzling seductiveness of Rita Hayworth in the 1940s or the playful, frank sexuality of Marilyn Monroe in the 1950s, they more freely expressed their own sexuality (pl. 122). And as Hollywood opened the door to the bedroom, snapshooters also began to share some of their secrets with their cameras, giving glimpses of what they did in the privacy of their homes (see pls. 123 and 124). Earlier in the century some amateurs portrayed cross-dressing and male-to-male or female-to-female intimacy (see pls. 8, 31, 32, 45, and 46), but these activities usually took place as part of games or theatricals. Although the buttoned-down culture of the 1950s did not allow for open displays of same-sex affection or cross-dressing, people like the man standing on the chair in one snapshot (pl. 125) privately reveled in the ability that photography gave them to defy gender stereotypes and try on other identities.[32]

As the consumer culture raced forward in the 1950s, propelled by television and the advertising media eager to encourage Americans to want ever more possessions, amateurs made many more photographs of their hard-won trophies, showing off, for example, their new car or new refrigerator (see pls. 117 and 168). Inspired by the urban images they saw in newspapers, in magazines, and on television, casual snapshooters began to embrace the visual cacophony of the street itself as a subject (pls. 127 and 128). Incited by the rapacious media and swept up in the fads of the time, they also made

photographs showing that their young daughters could dream "I Went Shopping in My Maidenform Bra" or that their best friend rode in a flying saucer (pls. 129 and 130).[33] But amateurs at this time also became more self-conscious about the very act of taking a photograph. Sometimes they playfully captured each other in the midst of aiming their cameras, or they craned their necks to look into the camera, even while kissing a loved one (pls. 131 and 132). Often the process of making a photograph, or the desire to see, as Garry Winogrand later stated, "what something will look like photographed," became more important than the event itself.[34]

The audience for snapshots grew exponentially from the late 1940s through the 1950s. Once confined to more private enjoyment in family albums or discreetly placed in frames on side tables, amateur photography assumed greater prominence after the war and became a popular form of entertainment. First introduced in the 1930s, home movie cameras became much more affordable in the late 1940s and early 1950s, especially after Kodak released its Brownie 8mm movie camera in 1951. Home movies, like color slides, had to be seen through projection, thus they invited public performances. Throughout the 1950s amateurs subjected their family and friends to endless hours of "the best home movies" or "the greatest slide show on earth."[35] Not wanting to be left out of this profitable market, Polaroid advertised how it "Perks up a Party" and suggested to hostesses that they throw a "Polaroid picture party" by personalizing guests' drinking glasses with their snapshots. Sylvania, a large distributor of flashbulbs, advertised "hilarious photo-fun" for the "brightest, gayest party idea in years" by using the "Photo-Prop Kit."[36]

As more aspects of personal life became fodder for public consumption, amateurs increasingly sought ways to use their snapshots to make money.

126

gelatin
silver print,
1940s

127

gelatin
silver print,
September
1956

128

gelatin
silver print,
1950s

129
—
**gelatin
silver print,
1950s**

130
—
**gelatin
silver print,
1950s**

Authors in magazines and books urged readers to remember that "the editor of the richest publication in the world doesn't care a hoot who gets the check for the photograph he likes. If you make a better picture than the next fellow, he'll grab it — but fast."[37] Amateurs did not need to look far for proof of this assertion. In 1947 a Georgia Tech student, Arnold E. Hardy, "caught a lucky shot" of a woman plummeting from the tenth floor of a raging inferno at the Winecoff Hotel in Atlanta. He not only received $500 from the Associated Press but was awarded the Pulitzer Prize for best news photograph of the year.[38] Throughout the 1940s and 1950s *Life* published a series of articles featured at the front of each issue, titled "Speaking of Pictures," which often reproduced humorous or striking photographs by unknown amateurs. Breaking down all barriers of privacy or propriety, publishers and contest pro-

moters repeatedly suggested to snapshooters that any one of their "dozens of snapshots" of their youngsters "may be worth $5,000."[39] Tempting them with the prospect of fame, these marketers prodded: "think what it would mean . . . if famous directors, outstanding artists, and the world's leading photographers" were to honor their photographs.[40]

In the late 1940s and 1950s the snapshot also began to assume greater prominence in American cultural institutions. The Museum of Modern Art in New York mounted an exhibition of 350 photographs in 1944 called *The American Snapshot*. In his introduction Willard Morgan — photographer, publisher, and the organizer of the exhibition — patriotically asserted that snapshots have "become a real factor in maintaining the unity of the American family, the solidity of the nation [for] they tie the family together more effectively than written

131

gelatin
silver print,
1940s

132

gelatin
silver print,
Bellingham,
Washington,
Septem-
ber 22, 1953

words."[41] These photographs, however, were far from ordinary snapshots. Instead, they had been selected from those submitted to earlier snapshot competitions and exhibitions sponsored by Kodak and subsequently purchased by the company. Later they were carefully reprinted and recropped, "by someone," as critics noted at the time, "who agrees quite closely with the compositional ideas of most salonists."[42] While most reviewers asserted that the exhibition was severely compromised, they also insisted that the pictures "constitute[d] the most vital, most dynamic, most interesting and worthwhile photographic exhibition ever assembled by the Museum of Modern Art." Praised as being "without artistic pretensions" and coming "nearer to achieving the stature of true art than any of the inbred preciosities in the museum's permanent collection of in any of its previous shows," the

photographs were applauded as "honest, realistic, human and articulate."[43]

A far more public example of the prominence of photography in American life — and the snapshot's preeminent position within that hierarchy — was the dramatic presentation of the Kodak "Colorama," a rear-lighted color transparency, in Grand Central Terminal.[44] In the late 1940s, as railroads began to lose ridership to airplanes, long-distance buses, and especially automobiles, the operators of Grand Central tried other ways to raise revenues and entice customers back aboard. In 1949 they piped music into the terminal interspersed with commercials, and when that met with howls of protest, they leased a large portion of one balcony to Kodak for an exhibition space and the display of what was billed as the world's largest color photograph, the 18 × 60 foot Colorama.[45] Although differ-

3.3
—
Wes Wooden,
Kodak Colorama
(#28, Birthday
Party), 1951.
George Eastman
House

ent kinds of photographs were presented over the forty-year span of the Colorama — alpine vistas, airplanes, farm scenes, fields of flowers — many featured people in the process of taking snapshots of friends and family enjoying the views. One of the early Coloramas from 1951, by Wes Wooden, was a picture of a mother photographing a child's birthday party, with some of "her" snapshots depicted at either side (fig. 3.3). Adolph Stuber, one of the two Kodak executives who conceived of the Colorama, told the *New York Times* reporter that Kodak wanted "men who have had a hard day at the office to look up at it on their way to catch the 5:28, and like their wives and children the better for it when they get home."[46] Less altruistically, he admitted that "everyone who sees the Colorama should be able to visualize themselves as being able to make the same wonderful photograph."[47]

Fine art photographers also began to embrace some of the stylistic attributes of the snapshot. Influential teachers in New York, such as the photographers Sid Grossman and Lisette Model along with the art director of *Harper's Bazaar* Alexey Brodovitch, encouraged those who studied with them to investigate all of the novice's common "mistakes." They urged their students to shoot into the light; explore blurred, out-of-focus forms, off-kilter compositions, and tilted horizons; and experiment with camera movement, multiple exposures, and apparently random subjects. Breaking all of the traditional rules of photography, their disciples — including Ted Croner, Louis Stettner, Louis Faurer, and most notably Robert Frank, as well as other photographers such as William Klein — sought to open themselves to chance and accident, as the amateur routinely did, in order to infuse their photographs with the energy and immediacy, the authenticity and veracity of snapshots (fig. 3.4).

Edward Steichen, who had been impressed by an installation of photographs he had seen at Grand Central Terminal in the late 1930s, drew on the accessibility of this more casual, loose style of photography and the shared experiences of everyone who had ever looked through a family album of photographs when he organized his 1955 exhibition *The Family of Man* at the Museum of Modern Art in New York.[48] One of the most popular photography exhibitions of all time, it was viewed by tens of thousands of visitors both in New York and elsewhere as it traveled around the world; millions more came to know it through the best-selling book that accompanied the show. Steichen conceived of the exhibition not as a tribute to photography itself — its history or connoisseurship — but as a paean to

the shared humanity of the world and an urgent warning about its possible imminent annihilation through nuclear holocaust. (The only color photograph in the presentation and the only photograph to be given an entire room to itself was a 6 × 8 foot transparency of a glowing red and orange hydrogen bomb explosion.) Although works by celebrated photographers from around the world were shown, so too were those by unknown makers, for Steichen solicited photographs from everywhere — picture archives, libraries, and museum storerooms; amateurs and professionals. He and his staff examined more than 2 million photographs from which they selected more than five hundred images that were then reprinted, cropped, and enlarged to sizes ranging from 8 × 10 inches to 8 × 10 feet. The prints were hung not only on the walls of the museum but also on panels suspended from the ceiling and on clear Lucite partitions; in one instance two photographs of couples on swings were even mounted back to back and hung from the ceiling, as if to tempt viewers to push them. Critics likened the installation to a Cecil B. DeMille extravaganza, but for many viewers the experience must have been somewhat similar to walking into their own snapshot albums, although admittedly more ethnically diverse ones. Like many amateur albums, Steichen's show contained photographs in a range of sizes made by different people — both professionals and amateurs — that were carefully arranged and sequenced by a single guiding hand and eye. And like most amateur albums, the progression of images attempted to represent, as Steichen wrote in the introductory text, "the gamut of life from birth to death with emphasis on the daily relationships of man to himself, his family, to the community and to the world we live in."[49] As Eric Sandeen notes, visitors frequently took snapshots of friends and

family in the exhibition posing in front of photographs that were especially meaningful to them, thus literally making themselves a part of *The Family of Man.* We have to assume that at least some of these snapshots were subsequently incorporated into the visitors' own photographic albums, thereby completing the cycle of inspiration from life to art and back to life again.[50]

We should return to Flo's photographs, for they are telling signs of both the shifts in the American psyche in the late 1950s and the direction many American snapshots took in the 1960s (see pls. 107–110, 133–136, and 177–200). When Flo began to take this series of photographs in 1955, she clearly intended to record not the rooming house itself or its neighborhood, but her housemates and coworkers. Yet if we look beyond the people in her photographs to observe the details of her environment, we see, not surprisingly, a striking disparity between the world described by the American media at the time — the one Flo may have seen in her dreams — and her real life. It is not simply that no husband or children exist in her photographs, that Flo had to work instead of stay at home and take care of her family, but that her surroundings are so bare, dreary, and distinctly old-fashioned. With its dark, heavy wood accents, flowered wallpaper, lace tablecloths, and leftover furniture from the 1920s and 1930s, her rooming house had none of the sleekness or allure of modern living extolled by media in the 1950s and few of its gadgets or amenities. The small television set with its rabbit ears is the only sign of the modern life.

More striking, though, is that none of Flo's housemates — Carol, Luci, and Mary; Betty, Donna, Ellie, and Virgie; Berta, Lois, Sally, Sandy,

and Ruth — wanted to have their pictures taken by her. They covered their faces with their hands or magazines; they turned and walked away or closed their doors in her face; they stuck their tongues out at her unwelcome intrusions. Yet Flo, undaunted, continued to snap their pictures. When we do see their faces, Flo has captured them off-guard, with startled expressions — washing their hair in the kitchen sink, for example. She even waited for them outside the bathroom door. Unlike most amateurs of the time, Flo also took her camera to work, but her coworkers — Florence, Carol, Marianne, and the two Joans — were no more accommodating and tried to dodge both her and her impudent camera. Only her sister Doris would stand still and face the camera, perhaps to keep some semblance of family harmony. But at times even she hid her face or turned away to continue dressing for a party.

Many American snapshots of the 1940s and 1950s, especially those depicting intimate interactions, have a voyeuristic quality: not only do we, as outsiders, witness a profoundly private moment, but we know that the person making the snapshot also intruded on the event. But Flo's photographs often go beyond that voyeurism. Aggressive and seemingly oblivious to the discomfort she caused, she displayed few of the sensitivities of a friend who wants to preserve happy memories of the people closest to her. Wielding the camera not as a means to ingratiate herself or even to assert her presence, she frequently acted more like the paparazzi, intent on capturing her prey.

The tone of American life shifted in the late 1950s and early 1960s, as did the character of many American snapshots. As the Cold War intensified and the reality of nuclear obliteration became ever more apparent, as McCarthyism poisoned the country with fear and suspicion and the painful reality

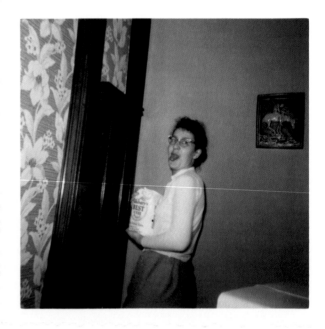

of racial segregation became a progressively more brutal and unavoidable fact, the cracks in the myth of postwar peace and prosperity broke wide open. Thus it is not surprising that a palpable sense of uncertainty and malaise crept into many snapshots. Flo's snapshots, made between 1955 and 1958, are an admittedly extreme example of this angst, but it was present in movies such as *The Wild One* (1953) or *Rebel without a Cause* (1955), and even in television programs such as *Father Knows Best* or *Leave It to Beaver,* which occasionally dealt with themes of anxiety and dysfunctionality.[51] It would become far more prevalent in amateur photographs made in the early 1960s (see pls. 206, 230, and 231).

Early in 1958 Flo and Doris moved out of the rooming house and into an apartment on West Kilbourn Avenue in Milwaukee. With no one but her sister to photograph, Flo's interest in this project seems to have waned. Years later either Flo or her heirs must have looked at the photographs she had made in her early twenties, perhaps in anticipation of a move or on the occasion of her death. We have to hope that some of her other photographs, with their almost quaint reflection of life in the 1950s, had assumed the patina of time and been transformed into precious relics of a life long past. But those from her days in the rooming house apparently had not. Concluding they were not worth saving, Flo or her heirs appear to have piled them up with other once treasured, now forsaken mementos and sold them.

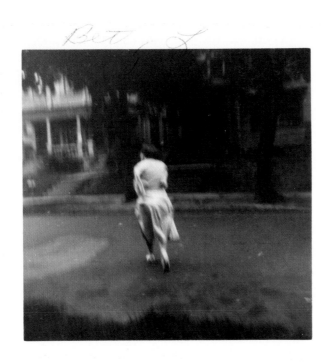

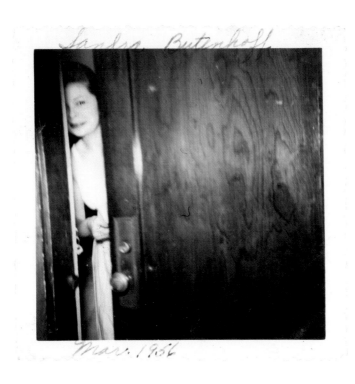

133
—
Flo,
gelatin
silver print,
July 1957

134
—
Flo,
gelatin
silver print,
late 1950s

135
—
Flo, "Betty
Lundamo,"
gelatin
silver print,
August
1956

136
—
Flo, "Sandra
Butenhoff,"
gelatin
silver print,
March
1956

137
—
**hand-colored
gelatin
silver print,
1940s**

138
—
gelatin
silver print,
1940s

139
—
gelatin
silver print,
1940s

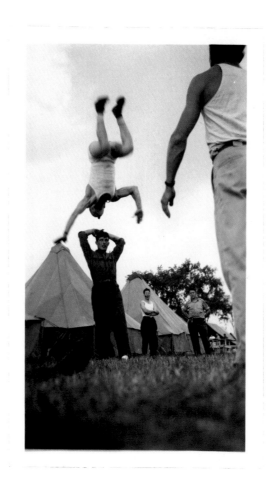

140
—
gelatin
silver print,
1940s

141
—
gelatin
silver print,
1940s

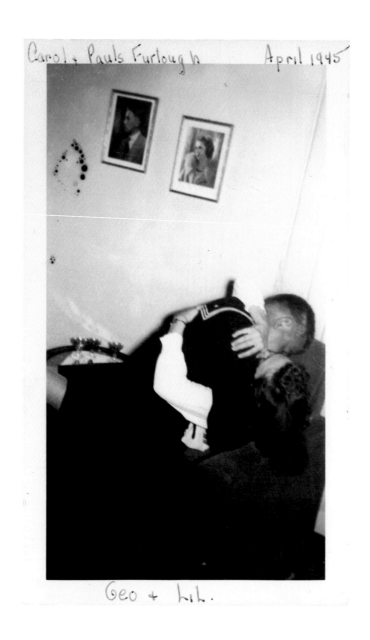

Carol + Pauls Furlough April 1945

Geo + Lil.

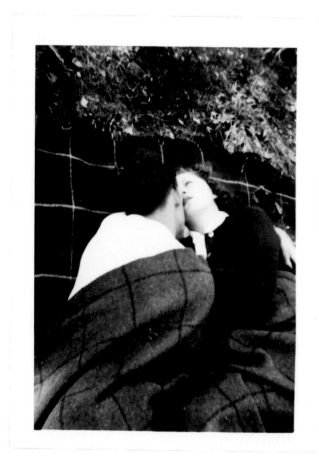

142
—
"Carol & Paul's
Furlough,
Geo & Lil,"
gelatin
silver print,
April 1945

143
—
gelatin
silver print,
La Crosse,
Wisconsin,
1940s

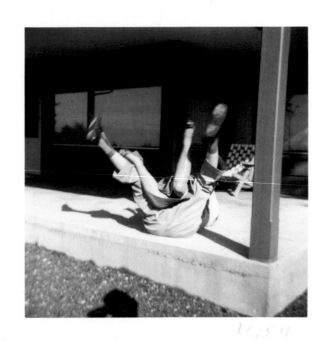

144
—
gelatin
silver print,
October
1954

145
—
"So happy,"
gelatin
silver print,
1940s

146
—
gelatin
silver print,
1940s

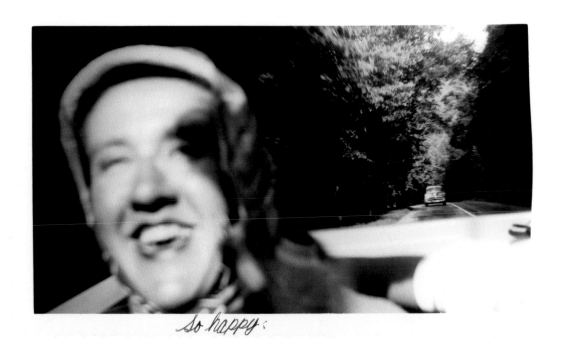

So happy

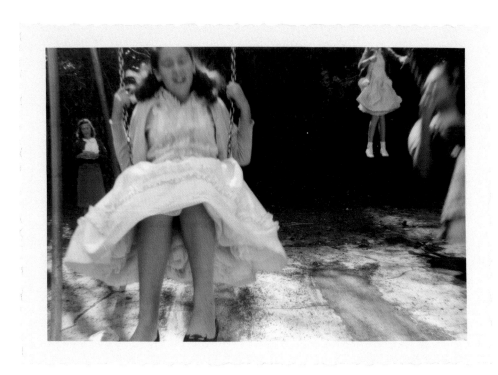

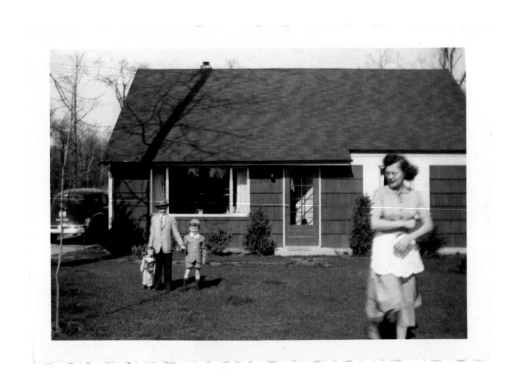

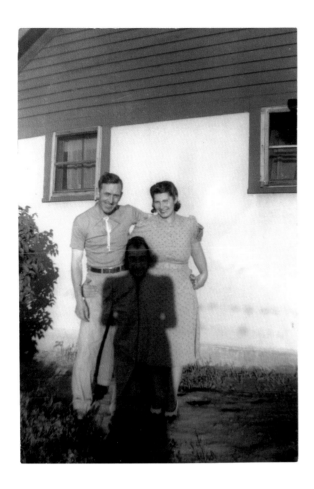

147
—
gelatin
silver print,
1940s

148
—
gelatin
silver print,
1940s

149
—
gelatin
silver print,
1940s

150
—

"Oakland Bay
Bridge,"
gelatin silver
print, 1940s

151
—

gelatin silver
print,
September 1,
1940

152
—
gelatin
silver print,
1940s

153
—
gelatin
silver print,
1940s

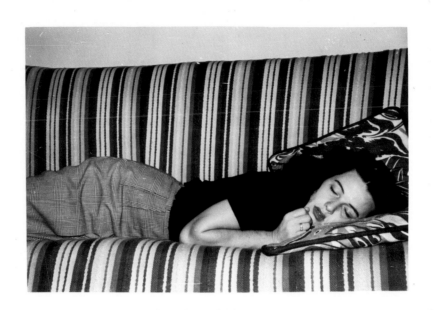

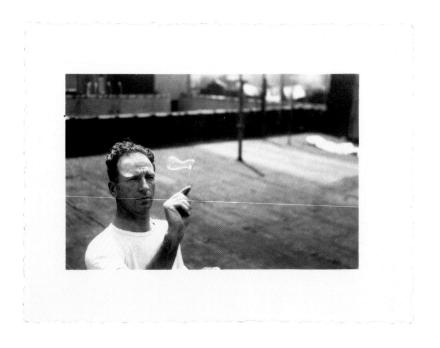

154

"Making soap
bubbles,"
gelatin silver
print,
August 1950

155

gelatin
silver print,
1950s

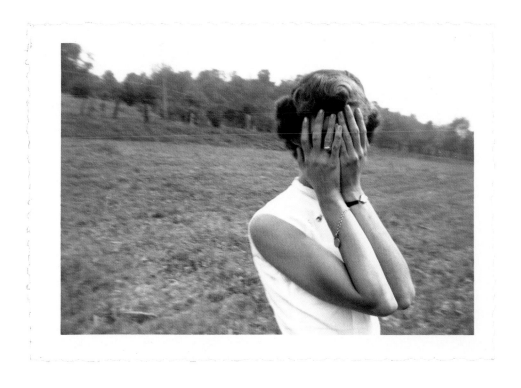

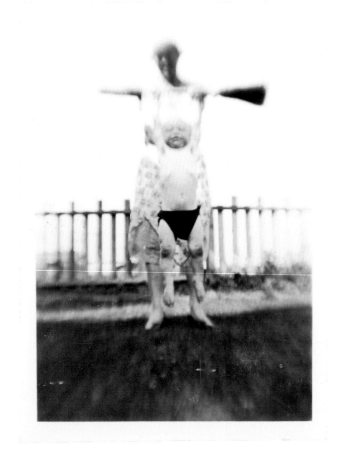

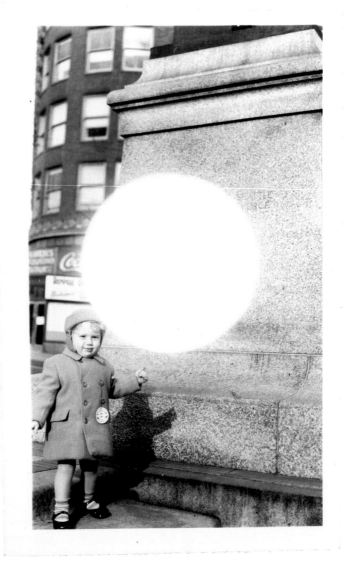

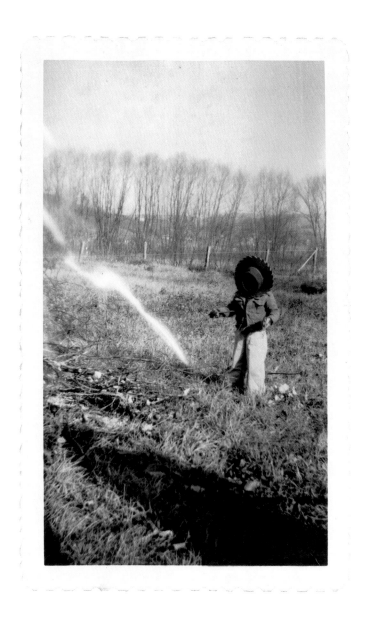

156
—
"Jerry,"
gelatin
silver print,
1940s

157
—
"Carole,
Seattle,
Washington,"
gelatin
silver print,
November 22,
1945

158
—
gelatin
silver print,
1950s

159

—

gelatin
silver print,
1940s

160

—

"Patsie
the day we
bought her.
Taken
at Ann's,"
gelatin
silver print,
July 10,
1943,

161

—

"Cookie,
about
4 mos. old,"
gelatin
silver print,
November
1952

162

—

gelatin
silver print,
Portland,
Oregon,
1940s

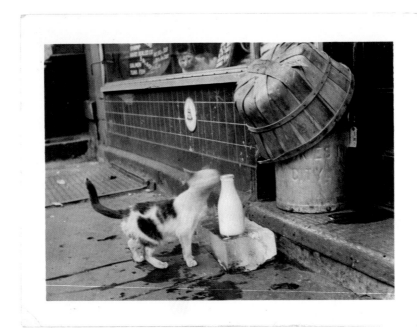

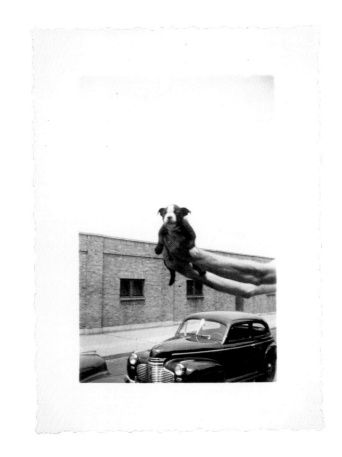

163
—
"Hey Big Boy,
Come up
and see me
some time!"
gelatin
silver print,
1940s

164
—
gelatin
silver print,
1950s

165
—
gelatin
silver print,
1950s

166

gelatin
silver print,
July 1956

167

"Looking down
the barrel
of a '155 M.M.'
'Schofield
Barracks'
Oahu, Hawaii,"
gelatin
silver print,
1940s

168

gelatin
silver print,
May 20,
1956

169

gelatin
silver print,
July 1951

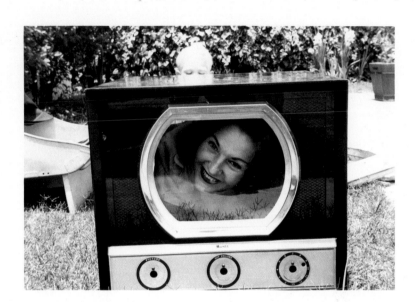

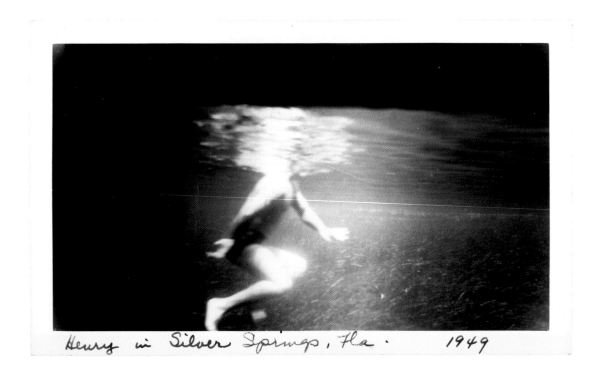

Henry in Silver Springs, Fla.　　　1949

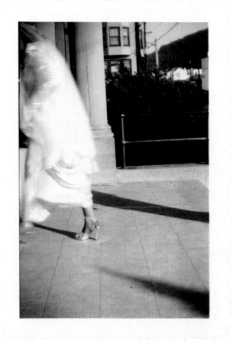

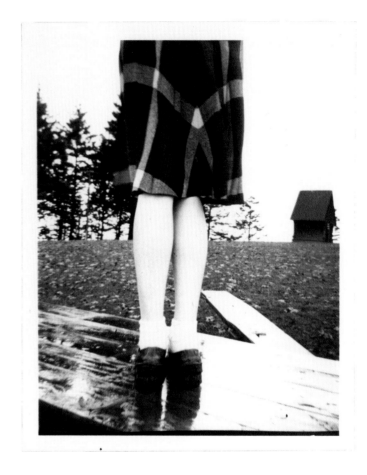

170
—
"Henry in
Silver
Springs, Fla.,"
gelatin
silver print,
1949

171
—
gelatin
silver print,
1940s

172
—
gelatin
silver print,
1940s

173
—
gelatin
silver print,
July 1955

174
—
gelatin
silver print,
1940s

175
———
gelatin
silver print,
1940s

176
———
"Debbie &
Jim taken
before Easter.
She was scared.
Ernie took
it with his flash
camera,"
gelatin silver
print, 1950s

picture in my bedroom

Mar. 1956

177

Flo,
"Picture in
my bedroom,"
gelatin
silver print,
March 1956

178

Flo, "Ruth
Nelson,"
gelatin
silver print,
July 1956

179

Flo, "Lois
Weiker,"
gelatin
silver print,
November 26,
1955

180
—

Flo, "Dorie,"
gelatin
silver print,
May 1957

181
—

Flo, "Xmas,
Dorie
'Bottoms Up!'"
gelatin
silver print,
December
1956

182
—

Flo, "Berta
Weiker,"
gelatin
silver print,
November 26,
1955

183
—

Flo, "Dorie,"
gelatin
silver print,
July 1956

184

Flo, "Dorie,"
gelatin
silver print,
July 1957

185

Flo, "Dorie,"
gelatin
silver print,
Novem-
ber 24, 1955

186

Flo, "Dorie,"
gelatin
silver print,
May 1956

187

Flo, "Dorie,"
gelatin
silver print,
April 1,
1956

188

Flo,
"Eleanor,"
gelatin
silver print,
August
1956

189

Flo, "Donna—
Virgie,"
gelatin silver
print,
July 1956

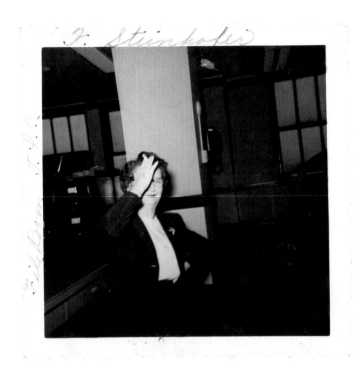

190
—
**Flo,
"F. Steinhofer,
File Room
T.L.C.," gelatin
silver print,
March 1956**

191
—
**Flo,
gelatin silver
print,
July 1957**

192
—
**"Me,"
gelatin silver
print,
July 1957**

193
—
**Flo, "Donna,"
gelatin
silver print,
July 1957**

194
—
Flo, "Joan
Hensel,
I.B.M.-T.L.C.,"
gelatin
silver print,
March 1956

195
—
Flo, "Carol
Clements,
T.L.C. File
Room," gelatin
silver print,
March 1956

196
—
Flo, "Joan Greco,
T.L.C. File
Room," gelatin
silver print,
March 1956

197
—
Flo, "Marianne
Festerling,
I.B.M.-T.L.C.,"
gelatin
silver print,
March 1956

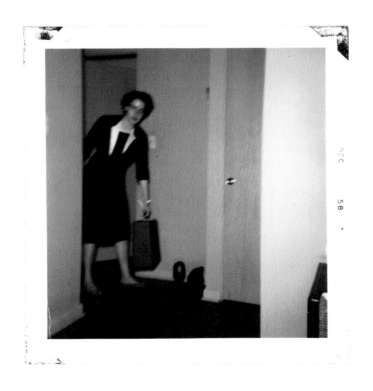

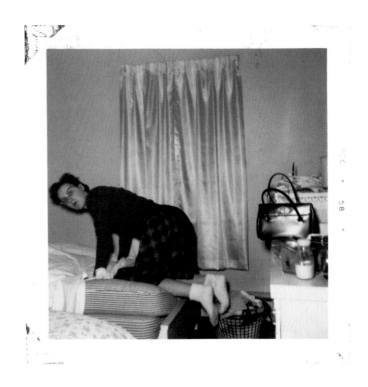

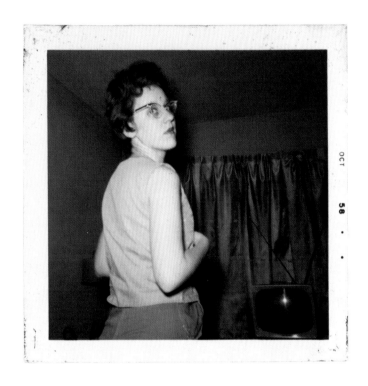

198
—
Flo,
"3620 W. Kilbourn,
Apt. 27,"
chromogenic
print,
December
1958

199
—
Flo,
"3620 W. Kilbourn,
Apt. 27 Do 44,"
chromogenic
print,
December
1958

200
—
Flo,
"3620 W. Kilbourn
Apt. 1,"
chromogenic
print,
October
1958

MATTHEW S. WITKOVSKY

When the
Earth Was Square

1960 – 1978

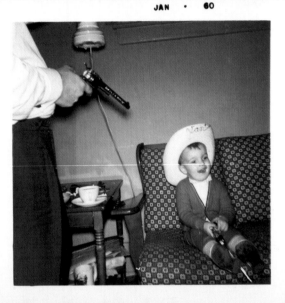

JAN • 60

201
—

"Taken Dec. 20
at home 1959.
Bud and
Jeff," gelatin
silver print,
printed
January 1960

The decade or so from the mid-1960s to the mid-1970s may be considered the fourth generation of snapshot photography. The first generation, born in 1888 with the Kodak, matures when Kodak manufactures its $1 Brownie camera in 1900. Not only does routine photography greatly expand in popularity, serious amateurs take note of this expansion and respond, whether by demonstratively shunning or protesting the new vogue or by cleverly redefining its terms. Alfred Stieglitz, leading champion of fine art photography in America, manages to do both, inveighing against the blurring of boundaries between snapshots and serious amateur work while taking up hand cameras himself and even applying the word "snapshot" to a suite of artfully made holiday views in 1911.[1] These multiple levels of action and reaction elucidate what makes something in photography a phenomenon. It is not technology alone, nor sheer sales, but rather the cumulative interest (whether positive or negative) shown by manufacturers, a market, and both low and high practitioners that etches a commercial innovation into historical consciousness.

The second generation, which comes of age in the later 1920s, finds its emblem (though by no means its most common instrument) in the 35mm Leica, which sells 50,000 units during the five years following its introduction in 1925. A new technology spurs a new craze, then

as in 1900, yet in both cases it is a technologically inflected understanding of the world in pictures that truly excites the collective imagination. This is the era of *Life* and *Fortune*, of the photobook,[2] of photography's embrace by government, museums, and mass media as well as by thousands upon thousands of new hobbyists in Europe and the United States. During this second period theoreticians and practitioners of the avant-garde become fascinated with photography, and many of the strategies they celebrate — compositional "mistakes," truths told serially or in fragments, proximity to the living instant — draw their inspiration from snapshots.

The third and fourth generations span the half-century of American dominance after World War II and might well be written about together, for they have much in common (shifts in society and innovations in technology are both overdetermined and inadequate as markers per se of a generational change in snapshooting). A new pervasiveness to photographic imagery characterizes these decades, spurred by widening affluence and the advent of television as well as a perhaps unprecedentedly casual attitude toward picture making. Yet if the first postwar decade establishes the dominant technological forms — television, cartridge-loading and instant cameras, color film — the cultural potential (or curse) of these technologies becomes manifest only in the mid-1960s and after. This fourth generation is essentially the period when private and public images collide, even as the shrinking public sphere begins to lose its cohesive hold on society. It is the period when daily life, turned by a nation of consumers into an unending succession of narcissistic photo ops, becomes fodder for media spectacle,

creating the lottery-like promise of instant but evanescent celebrity for anyone. These are the years when nothing is sacred yet everything is ritualized; when no one and everyone is special, and all things are made potentially interesting in pictures; and when amnesia, which thrives on prosperity, takes hold, leaving memory to scatter and fade in billions of little prints.

In 1963 Kodak brought out the Instamatic, an inexpensive camera ($16 and up) designed to house a film cartridge that snapped into the camera body, simplifying loading and removal of film for users and reducing costs for the manufacturer. The success of this new product greatly outstripped that of earlier offerings, with unit sales measured not in tens or hundreds of thousands but in tens of millions: 50 million Instamatics of various models were sold by 1970. Kodak engineered processing machines capable of printing 2,000–3,000 prints *per hour,* and they ensured that the greatest American technological feat of that time, the Apollo moon landing, would be recorded with Kodak equipment. Meanwhile, Kodak's nearest rival, the Polaroid Corporation, which had been making instant cameras since the late 1940s (meaning cameras that enabled customers to develop their own positive prints), vastly expanded its market niche in 1972 with the sx-70, also a cartridge-loading camera, which no longer required even the relatively simple act of peeling sheets apart or sticking them together. One could forget the competition's once-famous offer to "do the rest"; it was enough now to "press the button." Far more expensive than the Instamatics, sx-70 cameras sold "only" in the millions, yet they and other Polaroids indisputably captured the American imagination. The company estimated that more

than one billion instant pictures were made in 1974. Collaborations with artists gave Polaroid cachet and made its long-standing rivalry with Kodak analogous to that between the Macintosh and the PC today.

One arresting feature of most Instamatics and the SX-70 is that these cameras generated square prints; another popular Polaroid model was even called the "square shooter." This curious format, while anomalous in the history of visual culture, was certainly not unique to the period. Various companies had manufactured square-format cameras since the early 1910s, and as pointed out in the previous essay, the popular Starlet and other cameras made square pictures relatively widespread beginning in the mid-1950s, perhaps in imitation of screens on the newfangled television. Still, the sheer quantity of such prints generated in the 1960s and 1970s — more than half the photographs reproduced in the present essay are square — lends the period an identifiable "look."

The effect of a square format, neither portrait nor landscape, on habits of ordinary picture taking is impossible to assess, although its implicit resistance to storytelling makes it a singular choice for snapshots. (While professional photographers often worked with square-format cameras, most would crop the results so that the prints appeared vertical or horizontal.) The square shape supplants narrative flow with iconic stasis, and it tends to draw attention away from the picture toward the object as such. Square images have a lineage in modern painting that stretches from Kazimir Malevich's *Black Square* (1915) to Josef Albers' Homage to the Square series

(1950–1976) and the mature canvases of Ad Reinhardt. More than in any previous period, high art in the 1960s embraced this shape and its cubic permutations. Art historian Benjamin Buchloh recounts the rise of conceptual art, for instance, as "A Tale of Many Squares."[3] One thread in that "tale" is the widespread and significant turn to photography and, more particularly, to snapshots. This connection resides mainly in the subject matter of the new art or in its strategies of production and distribution. Additionally, however, a variety of projects within and beyond conceptual art literally use (square-format) snapshot cameras: Ed Ruscha's first books, William Wegman's early concept pieces, "photo-exercises" by Vito Acconci, or Lucas Samaras's *Photo-Transformations,* to name a few.

Thanks largely to the new offerings from Kodak and Polaroid, making one's own pictures in these years might be said for the first time to match in its breadth and banality the daily experience of seeing pictures by others. After an initial half-century in which photographs were more commonly viewed in the original (in family albums, for instance, or at World's Fairs) than in print, followed by nearly a century in which the reproduction of still and moving images in the public sphere came to outstrip by far their production for private uses, the 1960s and 1970s probably saw parity achieved between making and viewing private originals and public reproductions. Nor were the two streams of imagery, the one individual and unique, the other collective and mass-reproduced, unrelated. To an unprecedented degree, the amateur and corporate image worlds converged in America during these two decades.

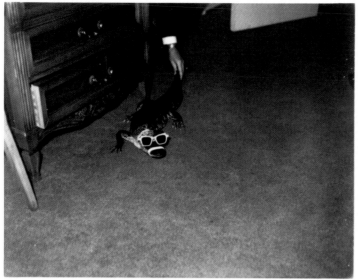

1969

202
—
chromogenic
print, 1969

203
—
chromogenic
print, 1960s

To give one germinal example: in 1963, the "year of the Instamatic," a Ukrainian-born retailer of women's clothing, Abraham Zapruder, inadvertently caught the assassination of President John F. Kennedy while filming his visit to Dallas, Texas (he used an 8mm film camera; two years later Kodak introduced its "Super 8" format and sent interest in home movies to new heights). Within two hours of the event Zapruder was on local television to discuss the view through his lens; three days later he sold the rights to his less than thirty seconds of footage to *Life* magazine for $150,000.[4] In lieu of a screening, Zapruder's serendipitously recorded disaster imagery reached the public soon afterward in the form of photographic stills (the full film clip would be shown on national television only twelve years later, not in any solemn setting but under the distinctly carnivalesque auspices of Geraldo Rivera on *Good Night America*). Press photographers had for decades upheld the importance of being in the right place at the right time. Yet here was a precedent-setting case of history being captured by Everyman and, more intriguingly still, of Everyman achieving instant fame and fortune as a result, thereby making history in his own right.

Ordinary citizens soon became constant media subjects, as the Vietnam War devolved into what would now be called a reality television show, with live broadcasts from the "theater of operations" and increasingly candid interviews with individual soldiers. Years of this daily spectacle permanently altered the American media landscape, culminating in what many recall as the most captivating live television of the age, the Watergate hearings, which kept viewers glued to the screen from May until August of 1973. Also in that year WNET, the precursor to public television, broadcast the first bona fide reality show, *An American Family*, in which the seven-member household of Bill and Pat Loud allowed cameras and microphones to record every facet of their lives for seven months. Produced with the more-or-less explicit intent of corroding the once ironclad myth of a nuclear family living the patriarchal American dream, the series, which soon drew 11 million viewers weekly, exceeded its own creators' expectations. Over the course of a dozen hour-long episodes, Pat left her husband, Bill's wildly successful business in strip-mining manufacture practically collapsed, and their son Lance became a drag queen.[5] An extended snapshot of previously unknown existences thus made for instant celebrity spectacle, but the instant was truly brief, and like Zapruder's home movie, it succeeded by

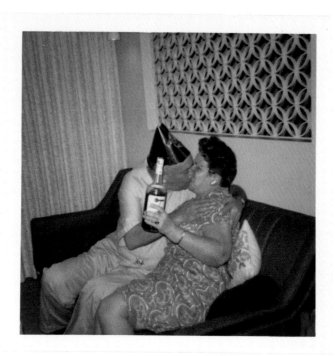

cashing in on cataclysm. This is, after all, the era defined by Andy Warhol's prediction of quarter-hour fame, a fleeting celebrity that, as Warhol's own works obsessively showed, lifted up the anonymous most often through death and disaster. Lance Loud acknowledged the rightness of Warhol's dictum, and he offered a charming epigram of his own: "Television ate my family."[6]

These and other grand themes of American culture do not "leap out" of the pictures reproduced in these pages, about whose makers, unlike the Louds or Abraham Zapruder, we know nothing specific. In addition, the snapshots chosen for this exhibition, which largely depict a family-oriented, rural or urban lower middle class, cannot stand for all America in the 1960s and 1970s; one sees here, for example, no African Americans (or other people of color), no signs of women's liberation or of the alternative lifestyles for which the two decades are best remembered. Limitations thus become evident in the use of such pictures to construct a History, whether of American society or of American snapshots.

At the same time, there are several "period" features to the group. One such telltale feature is color, an aspect grown so familiar that we have difficulty registering its presence. Color images had appeared in photography since the 1890s, in cinema and print since the 1920s, and in television since the early 1950s, but it rapidly became the norm in all media around 1965. This relatively sudden change in standards seems to have been impelled by manufacturers, who developed increasingly affordable means of processing or broadcasting color, rather than by an overwhelming preference on the part of audiences or users. Nevertheless, one readily imagines that the public greeted the triumph of color as a definitive indication that film and photography finally looked "just like life," an assumption that would logically feed into the increasingly "life-like" informality of snapshots from this era.

The most basic element common to these pictures, one that is in fact visible in snapshots across time, is a propensity for theatrics. Against the perhaps commonsense assertion that snapshots are candid or transparent representations, the photographs throughout this book demonstrate a self-conscious delight taken by ordinary people in staging scenes of play. The man pushing an alligator in sunglasses around the floor, or the older couple kissing on a couch, she with her bottle of booze and he in his verdant party hat, enjoy having the camera turned upon them, even if they did not necessarily set themselves up for its presence (pls. 202 and 203). Children, too, quickly become accustomed to the

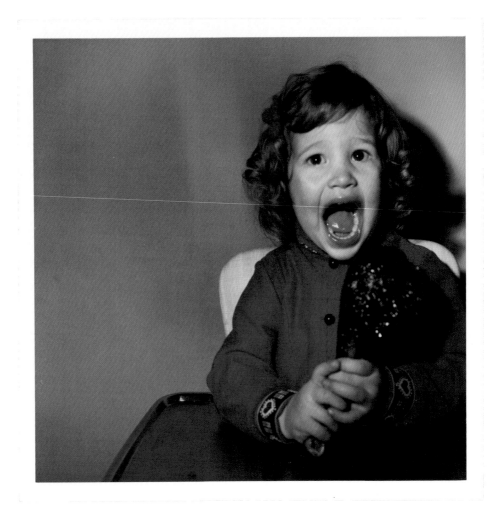

204

chromogenic
print, 1970s

205

chromogenic
print,
September
1969

206

chromogenic
print,
January
1965

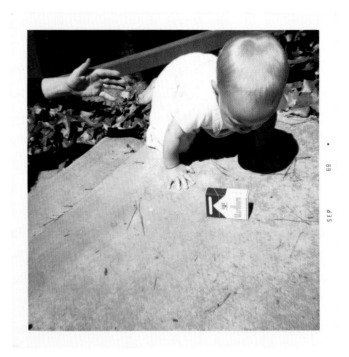

camera, particularly in this era when the number of
snapshots per household increases exponentially.[7]
Even the toddler in a red dress, snapped while con-
suming a turkey leg larger than her face, brandishes
the drumstick with as much aplomb as her inex-
perienced digits can muster (pl. 204). The hallmark
"cuteness" of a good kiddie photo derives supposedly
from the gap in consciousness between photogra-
pher and subject; yet it is infantile innocence com-
bined with precocious self-awareness, or with
playacting, that makes a scene photogenic, for the
audience that witnesses its making and for those
who flip through the resulting pictures later in
albums.

If photographing children involves a peren-
nial mix of guilelessness and posing, some of the
pictures of little ones here reveal a perhaps unaccus-
tomed level of nonchalance that separates them
from earlier family snapshots and potentially from
those made more recently as well. The baby left (or
encouraged?) to pursue a pack of Marlboros or the
youngster pictured in bloomers on the floor with
his or her upper body stuck inside a green shopping
bag (pls. 205 and 206) suggest a remarkable, even
disconcerting privileging of humor over safety, in
what they show and also how they show it: the shoot-
from-the-hip look of the baby and cigarette box,
the carpet in the "bagged child" photo made bleached
and tawdry by an unsubtle camera flash. Overall,
many of these pictures seem insistently mundane
and emotionally awkward. The discolored portrait
of a young man, smiling but looking almost dead,
and above all the one of a blankly staring woman
in a headscarf, her careworn face caught in a stark
sidelight, carry a particularly saddening effect
(pls. 207 and 231).

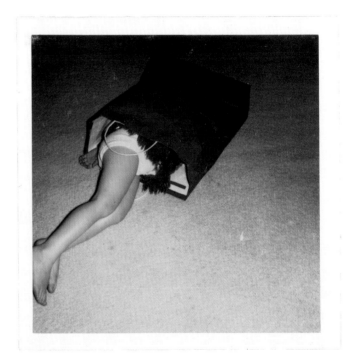

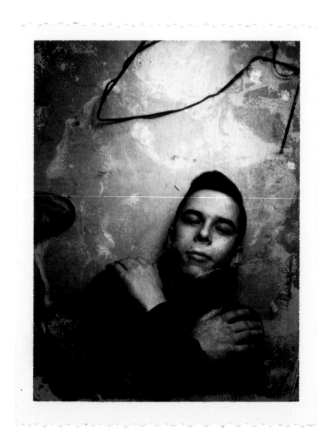

Certain photographs, like the Polaroid of a woman giving the finger as a cake, presumably for her own birthday, is presented to the camera, move from nonchalance to vulgarity (pl. 208). We see the same aesthetics of inelegance at work in the boy's-eye view of "Bud and Jeff" (per the inscription on the reverse) playing with guns in what seems like the family den, in the too-close shot of a woman smoking in her car, and in the self-portrait of a woman in what could be a motel room positioning her camera at her crotch (pls. 201, 209, and 227).

The offhanded gestures in these snapshots might be interpreted as a sign of increasing social recklessness, part of "sixties culture," its echoes and aftermath. Similarly, the two pictures in the exhibition that show public reports of historic moments — a newspaper headline of Kennedy's assassination and television news of the moon landing — suggest consciousness of the broader circuit linking amateurs to the mass media in this time (pls. 210 and 211). Such inferential judgments would likely be misplaced. If certain photographs here seem to be "engaging" history or to have shown outré candor in staging sex and violence — vernacular favorites in photography since the medium's invention — that speaks above all to the increased pervasiveness of the photographic image. The one thing grown demonstrably casual all across America beginning in the 1950s is the technology of picture making, which becomes an extension of daily living, accompanying people not just on birthdays or family trips but to the bathroom, to the store — in short, everywhere.

Pointed countercultural impulses can, however, be identified in the work of many who turned to snapshots for inspiration during this period, including writers, career photographers, artists taken with photography, and filmmakers. The list of such people in North America and Europe is

207

Polaroid
silver print,
1960s

208

Polaroid
SX-70 print,
May 13,
1978

209

chromogenic
print, 1960s

210
—

gelatin
silver print,
November
1963

211
—

gelatin silver
print,
July 1969

4.1

William Eggleston,
Memphis, **dye
transfer print,
c. 1970. National
Gallery of Art,
Washington,
Pepita Milmore
Memorial Fund
and Diana and
Mallory Walker
Fund**

remarkably long and varied and suggests the broad promise offered by snapshot photography for critical reflection and artistic renewal. One motivation was simply a variant of a long-standing modernist preoccupation with the overlooked or marginal in society, which since the nineteenth century often means the downtrodden or demonstrably "other." William Eggleston, Lee Friedlander, and Garry Winogrand consider the overlooked to mean the commonplace and the local: the insides of trailer homes, views framed in car mirrors or reflected in pawnshop windows, scenes glimpsed while walking down the street.

The preference for unglamorous subject matter, which retains a tinge of exoticism in the work of these photographers, takes a turn toward unremediated — and therefore highly provocative — banality when treated by avant-garde artists such as Acconci, John Baldessari, and Dan Graham, all of whom use photography (or so they claim) as a mute and inexpressive tool. Their common interest in the brute thingness of the photographic image, and of the language and the objects (including in many cases their own bodies) to which they attend with cameras in hand, takes as inspiration the unemotional prose of the French "new novelists," such as Alain Robbe-Grillet, whose collection of short stories, *Snapshots (Instantanés),* appeared in English in 1962. Their performances and projects are calibrated to the camera's presence and echo the ritualization of daily life effected through vernacular photography. In the television era that process entails voyeurism, alienation, and transient stardom on an unprecedented scale. It is life lived as small-screen ritual theater. This is the kind of life that interests Diane Arbus, a photographer attuned with rare refinement to the postwar media age, with its bizarre circuits that loop from anonymity to celebrity to has-been or jump from instant "feedback" to total disconnection.

Grand talk of photography as a means to democratize art, characteristic of intellectuals who embraced snapshot photography in the 1920s and 1930s, was supplanted in the 1960s and 1970s by depictions of the unvarnished *demos*. William Eggleston, who likened fingering a Leica to polishing a gun, poeticized humdrum details of apparently ramshackle lives in his native Mississippi and Tennessee: dirty dishes, fences overgrown with wisteria, old shoes under the bed, jerry-built wiring on the ceiling (fig. 4.1). The color glows in these works, just as in earlier Hollywood films, and it makes potentially despondent scenes seem luridly upbeat. This amazing use of color, made possible through the expensive and (in the 1970s) nostalgically laden dye-transfer process,[8] sets Eggleston's prints at a far remove from regular snapshots, but the ethos of snapshot photography is vital to their intended effect. Rock musician David Byrne later explained his affection for Eggleston's pictures in terms that resonate with the aesthetic impact commonly perceived in amateur snaps: "I find [them] very pleasantly disorienting. Some look like accidents, like somebody accidentally pressed the shutter button on the camera while examining the strap, or something."[9]

"Accident," a word equally open to happiness and hurt, is one of the descriptors most frequently—if erroneously—attached to snapshots, and the careful cultivation of its appearance (a deliberate paradox) guides much photographic work of this time. Eggleston's close contemporaries Friedlander and Winogrand made photographs that seemed haphazard, and Winogrand made them by the boatload: unproofed and even undeveloped film numbered in the thousands of rolls at his death.[10] Having claimed that he photographed simply to see what the results looked like as photographs, his produc-

tion came to exceed so vastly his own capacity for viewing that he might have been mistaken for a snapshooter run amok.[11] Yet Winogrand angrily dismissed the equation of his photographs with snapshots. He refuted the comparison not because it suggested his own work lacked polish or control but precisely for the opposite reason; snapshots, he commented perspicaciously, were posed and too rigidly controlled, at least in their conception.[12]

Snapshot photography is in reality rather less constituted by "accidents" than is artistic or other professional work, particularly work that courts the unexpected, as was the case for Winogrand and much street photography or for experimental photography. The "happy" or "lucky" accident that photography lovers prize in snapshots amounts to a surplus value conferred upon these images. The term "accidental masterpiece" transfers the moment of aesthetic decision from the original maker to a later, presumably more sophisticated viewer; it can therefore help specify the potential for photography as a form of modern folk art, but it does not explain much about the aims or function of snapshots themselves. Furthermore, the visual complexity sought by Eggleston, Winogrand, and their contemporaries —the syncopated rhythms and multilayered harmonies—operate at the furthest remove from snapshots. In a parallel to "documentary style," the phrase coined by Walker Evans, father of vernacular modernism in American photography, the photographic artists of the 1960s were said not to be making snapshots per se but to be fashioning a "snapshot aesthetic" (whether they liked the term or not).

ECON-O-WASH
14 TH AND HIGHLAND
NATIONAL CITY CALIF.

Those less invested in an actual history of photography, in precursors such as Evans or Robert Frank, could attend to the form of the snapshot more directly. John Baldessari's first mature pieces, for example, depended on pocket cameras and the uses to which they are commonly put (fig. 4.2). Like many conceptual artists, Baldessari likened his work with the camera to photojournalism, not to snapshots, and he dwelled once again on the inspirational role of chance or accident: "rather than framing [the photographs]," he recalled in a later interview, "I just drove around clicking out of the car window not really looking...using life like it really is."[13] The works themselves belie this suggestion of spontaneity and straightforward truthfulness to reality at every level: they seem purposive rather than random in their dullness, demonstrative in their great size, ruminative not unmediated in their mix of hand-lettering and mechanically generated image. But they look homemade, and they frame ordinary places with a slackness that nevertheless suggests an affective pull on their maker — all the chosen sites, indeed, are in Baldessari's hometown, National City, California.

The embrace of photography here to drain formal interest, to de-skill the creative process, generates an aesthetic that many at the time called "neutral" or "affectless" but which seems more accurately described as somewhere between kitsch and tedium. Dan Graham's landmark magazine project "Homes for America" (1966–1967), for instance, reproduces color slide views of postwar tract housing and shopping mall sundries, titled in ink underneath and interspersed with pasted snippets of text (fig. 4.3). Understood as a sequence of discrete rectangles filled with words or images, the original layout for the essay[14] suggests a modernist matrix, but at a more prosaic level it looks like a scrapbook; one could easily imagine these pages commemorating a family's relocation to one of the newly built units. With "Homes for America," Graham commented ironically on the high art of his time, minimalism, by discovering in prefabricated real estate and cheap consumer goods the modular, repetitive geometries favored in minimal art. At the same time, his essay opens downward onto a much broader field of action. In shooting views of people, kitchen trays, and washtubs rather than exclusively depopulated buildings; in framing most of his shots with apparent offhandedness; and in suggesting, however abstractly, a narrative of home buying — first distanced views and a plan of the house, then front doors, then an interior, and lastly cleaning, shopping, and starting one's commute to work — Graham plays off the amateur vernacular form of the family album.

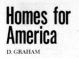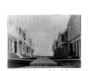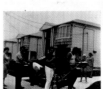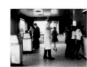

4.2

John Baldessari,
*Econ-O-Wash,
14th and High-
land, National
City Calif.,*
acrylic and
photoemulsion
on canvas,
1966–1968.
Courtesy John
Baldessari,
Santa Monica,
California

4.3

Dan Graham,
*Homes for
America,* maquette
for article in
Arts Magazine
(December
1966–January
1967), printed
matter, ink, and
chromogenic
prints. Daled
Collection,
Brussels, cour-
tesy Marian
Goodman Gallery,
New York

Vito Acconci, meanwhile, accented the ritual character of existence in a series of auto-documentary pieces staged in 1969–1970 using a Kodak 124 Instamatic (fig. 4.4). *Toe-Touch, Spin, Blinks, Jumps, Pick-Up, Bend* are the self-referential titles to short exercises that entailed snapping pictures for the duration of a specific motion or activity. In *Bend (Arm-Bending Piece),* for instance, Acconci moved his arm back and forth while pressing the button continuously. These private performances for and with the camera initiated for Acconci years of staging his body and his physical relations with others: a "presentation of a self" grounded in the conviction that a "mediated landscape…provides the controlling and constitutive factor in the development of the individual self."[15] His Instamatic, and in other works his video equipment, accordingly did not

merely document or disseminate live actions but became one with those actions, as their theme or as their material support. The early "photo-exercises" used the camera to set limits, to mark the beginning and end of a piece or to measure its spatial reach. They also suggested that cameras are extensions of our bodies and are clicking away everywhere, an assertion of tremendous relevance in the age of nascent closed-circuit technology, miniature "bugs," and multiple cameras in every household.

Acconci enacted or orchestrated many situations of voyeurism, surveillance, and sadism in these years, casting the mediation of interpersonal relations in the harshest possible light. A sense of invasiveness likewise attended the photographs of Diane Arbus, who came to prominence with Friedlander and Winogrand in the 1967 exhibition

4.4

Vito Acconci,
Bend (Arm-
Bending Piece),
gelatin
silver prints,
1970.
National
Gallery of Art,
Washington,
Anonymous
Gift

4.4

Diane Arbus,
A Child Crying,
N.J., **gelatin**
silver print,
1967, printed
later. National
Gallery of Art,
Washington,
Gift of the R.K.
Mellon Family
Foundation

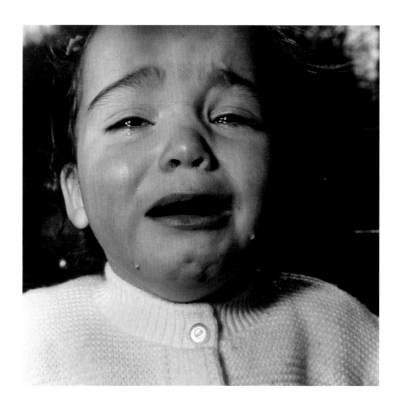

New Documents. Arbus intended no imposition upon or assertion of control over her subjects, but her choice of subcultures, from the very wealthy to nudists, midgets, and transvestites, brought with it accusations of a prying eye, or a loss of dignity. In their cumulative power, ironically, this collection of anomalies came to seem normative, emblematic of American society in the 1960s and 1970s.

Like her fellow artists in *New Documents,* Arbus cultivated a "snapshot aesthetic" that existed at a great remove from actual snapshots. The size and tonal saturation of her prints, made from 2¼ × 2¼ inch black-and-white negatives exposed with a twin-lens reflex camera at a time when everyday picture takers overwhelmingly used pocket cameras and 35mm color film, sets them entirely apart from trends in home photography. Her photographs evoke the form of ordinary snapshots only at a distance then, but they establish a conceptual affinity to snapshots closer than that of any of her colleagues in photography. Arbus understood that modern daily life is an endless collection of rituals, which are made, consciously or not, to be photographed (fig. 4.5). In her foundational project, the Solomon R. Guggenheim fellowship "American Rites, Manners and Customs" (1963–1964), Arbus pursued what she called "the considerable ceremonies of our present," by which she meant celebratory "Pageants, Festivals, Feasts, Conventions," but also "Places" and "Costumes," or "Dancing Lessons, graduations…Waiting Room, factory, masquerade…hotel lobby, birthday party," in short, everything: "The etcetera." "These are our symptoms and our monuments," Arbus

concluded her fellowship application. "I want simply to save them, for what is ceremonious and curious and commonplace will be legendary."[16]

In this wish to render the "commonplace… legendary," Arbus presciently captured the character of American society in the postwar media age. "Ceremonies of Fame: Winners Win, the Lucky are Chosen," a signal category in her application, touched at the core of the emerging culture, in which winning and celebrity seemed within everyone's reach. Coincidentally, just as her images monumentalized the standard 1960s snapshot, her uncropped square prints evoked its most typical format. Classically centered, awkwardly posed, and erratically lit and exposed (though printed to exacting standards), Arbus's photographs immortalize strangely ordinary people as if seen by themselves. In doing so, each picture realizes the promise of *An American Family*, as encapsulated by Lance Loud: to celebrate and consume its subject.

Consumption was crucial to Arbus's creative enterprise, as she tacitly acknowledged. "I want to gather [these ceremonies], like somebody's grandmother putting up preserves," she wrote, and we may accept the idiosyncrasy of this simile as an indication of its significance in her mind. Taking a photograph means sealing off a figment of the present for future delectation. The resulting act of commemoration, however well intentioned, is short-lived, for the reward it brings can be enjoyed only by breaking the seal and thus starting the process of final decomposition (people, unlike fruit, do not grow back the next year). This struggle between preservation and demise is the work of memory, which from around 1970 is understood to be the province of the photographic snapshot as well.

One of the first artists to interrogate questions of memory and human existence through snapshots is Christian Boltanski, the French artist best known for his "reliquaries" on the Holocaust from the 1980s and 1990s. Boltanski began his career in 1969 with actions and ephemeral art in a variety of media that, through the device of personal histories, obfuscated boundaries between truth and fiction. A set of snaps found by a fellow artist in a desk drawer became the book *Everything I Know about a Woman Who Is Dead and Whom I Did Not Know* (May 1970), also called *The Photographic Documents that Follow Were Given to Me by Luis Caballero*.[17] These "documents," whose subject was very likely alive and well at the time of the book's creation, were described in the factitious prose of Robbe-Grillet and other *nouveau roman* writers. For a similar idea enacted at the art fair Documenta in 1972, Boltanski presented 150 enlargements of childhood photographs belonging to his friend and future gallerist Michel Durand, under the title *Photo Album of Family D, 1939–1964*, a presentation that pointedly refused to recount anything of the family so honored — in this case one he knew well.

Underlying these and other exercises in misinformation is a conviction regarding the uncertainty of living, communicable memory in the face of death, which is solitary, impossible to communicate, and all too certain. One of Boltanski's earliest projects makes this conviction clear. Entitled *Research and Presentation of All That Remains of My Childhood, 1944–1950* (May 1969), this nine-page book of fifteen photographs was sent to friends and strangers through the mail at a time when the author was totally unknown as an artist. Pictures of Boltanski's kindergarten class and of him on the toilet figure alongside others showing his brother in his place, a lock of his own "child-

hood" hair cut off only recently, or a t-shirt worn by his nephew in the year of the book's creation. The aura of uniqueness invested in infants and children is dispersed here through its dissemination as a handful of finds, severely inadequate to the task of reconstructing a life.

The book also included an untitled text that begins, "One can never observe often enough that death is a shameful thing" (*On ne remarquera jamais assez que la mort est une chose honteuse*). The dryly written statement continues:

What we need is to attack the basic problem through a great collective effort in which everyone will work to ensure his own survival and that of everyone else. This is why, for someone must set an example, I have decided to tie myself to a project that I have long held dear: to preserve myself whole, to keep a trace of every instant in my life, of every object that has accompanied me, of everything I have ever said and that has ever been said around me — this is my aim. It is an immense task and my means are few. Why did I not start earlier? . . . It is only with great difficulty that I recovered the meager pieces presented here. Proof of their authenticity and their exact place and date was possible only thanks to my endless, minute queries. But . . . how many years will I spend occupied in researching, studying, classifying, before my life is secure, carefully ordered, and labeled in a place safe from theft, fire, and atomic war, whence I could retrieve and reconstitute it at any moment, so that, assured of never dying, I might at last relax.[18]

This is the messianic burden of the snapshot circa 1970, and though camera phones and Web feeds (a new metaphor of consumption) have since made it nearly possible to fulfill Boltanski's sardonic wish, we are no closer to relaxing.

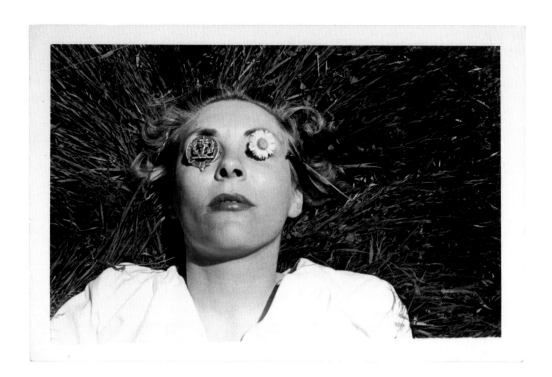

212

gelatin
silver print,
1960s

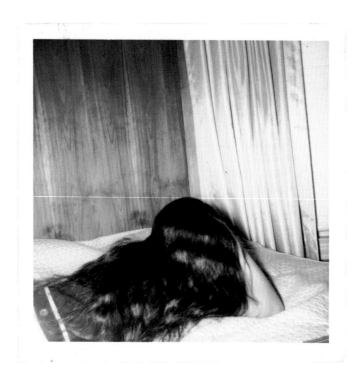

213

**chromogenic
print, 1970s**

214

**chromogenic
print, 1960s**

215

———

"A.T.M.,"
gelatin
silver print,
1963

216

———

Polaroid
silver print,
1960s

217

———

gelatin
silver print,
c. 1970

218
—
chromogenic
print,
August 1961

219
—
"Hazel Bauer,"
chromogenic
print, 1960s

220
—
chromogenic
print,
November
1967

221
—
chromogenic
print,
August
1965

222
—
"#14 Tuesday...
at Cromwell
—Bill home—
His 20th
Birthday,"
chromogenic
print,
August 23,
1967

223
—
chromogenic
print,
March 1972

224
—
chromogenic
print,
July 1961

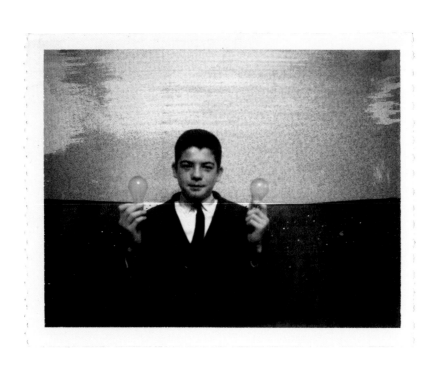

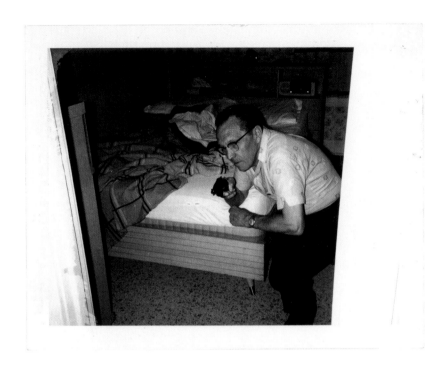

225
—
Polaroid
silver print,
1960s

226
—
Polaroid
silver print,
1960s

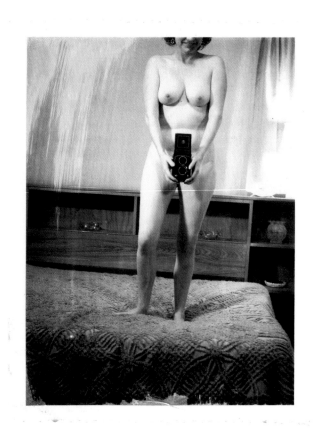

227
—

**Polaroid
silver print,
1960s**

228
—

**chromogenic
print,
July 1974**

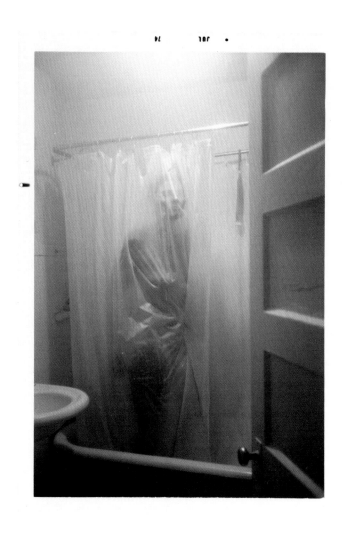

229
—
"Stater 2,"
Polaroid
silver print,
c. 1970

230
—
gelatin
silver print,
March
1963

231
———
gelatin
silver print,
1960s

232
———
gelatin
silver print,
August
1963

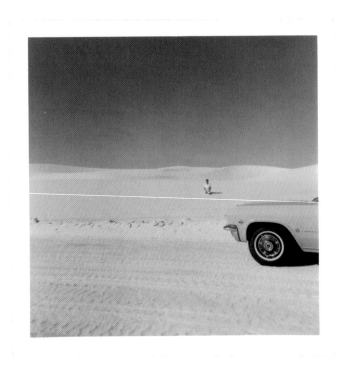

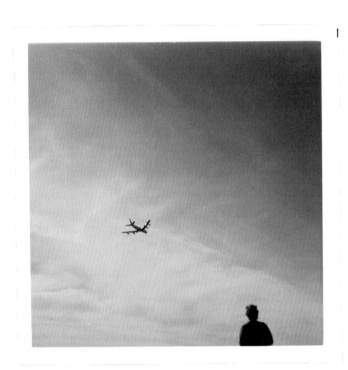

233
—

chromogenic
print,
July 1965

234
—

"One of the
many jets
preparing to
land at the
airport
just outside
of Nice.
In the fore-
ground is
Ronnie,"
chromogenic
print,
February
1970

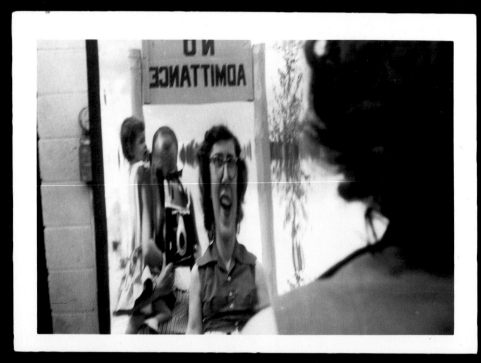

Afterword / Robert E. Jackson

It is not surprising that snapshot photography has only recently been given its due. As the twentieth century (when most snapshots were taken) becomes viewed through the lens of a more angst-ridden and increasingly digital age, we are beginning to consider images on paper, especially those produced by amateurs, in ways that typically differ from the work's original intent. Snapshots have come to be appreciated and studied as both nostalgic curiosities and sociological artifacts, revealing who we were and how we related to friends and family and to the larger world via the act of taking a photograph. This afterword has a twofold purpose: first, to elucidate some of my thoughts on snapshots — what makes them unique and why I am drawn to them versus fine art photography; and second, to acknowledge personally the many individuals who have aided me in forming my collection.

In many ways snapshot photography arises from a different set of impulses and approaches to subject matter than is found in fine art photography. While the body of work by many professional photographers reflects that person's career, snapshots by an amateur essentially represent that person's private life: the people and family loved, the places visited, the good times enjoyed, the accomplishments reached and milestones attained, the cars and houses purchased. It is this narrative impulse and thrust that make snapshot photography

so distinctive. So-called snapshooters try to capture and impart meaning to their lives by staging scenes that encapsulate the essence of a moment before it passes. That is why, for example, the subjects being photographed are often encouraged to smile ("Say 'cheese'!") and to stand in front of the most scenic backdrop on a vacation road trip. The province of snapshots is that of picnics, vacations, and all of life's major rituals, including weddings, graduations, and birthdays. Snapshots frequently concern themselves with firsts — the first car, first girlfriend, first house, first big fish, and so on. What is being photographed can represent a visual trophy of an achievement. In sum, a single snapshot signifies one moment in the narrative thread of a person's life, and it is in a private or family album of those snapshots where that narration can often be best understood.

One goal of the snapshot is to be a substitute for memory. In fact, in time the images actually *become* the memory. But it is selective memory and selective life experiences that are presented. Snapshots rarely record painful or distressing events, as routinely explored by eminent photographers, but are mostly concerned with happy (or sometimes bittersweet) occasions. Thus the past is altered through the snapshot's content, being transformed into nostalgic remembrances. A professional photographer attempts to delve under the surface of human existence or to dissect elements that are around all of us in a cityscape or landscape in order to impart some universal and timeless truths about the constructs of seeing and the emotional essence of what it is to be human. Such an effort is also selective, but that selectivity serves to produce images that represent the photographer's mastery of the medium or interpretive artistic intentions. The snapshot, on the other hand, seeks to preserve an idealized and individualized moment in time.

Another basic difference between snapshot and fine art photography is that snapshooters generally know their subjects — not simply having befriended them, as certain famous photographers did in the course of their careers, but often sharing a body of mutual life experiences. This relationship typically is manifested by the subject's freedom in front of the camera as well as in the photographer's lack of concern with proper lighting, pose, and so on, because of a familiarity with the subject's basic features (which already have been committed to memory). It is the specificity of a moment in time that concerns the amateur ("this photo is of my son at age seven"), not the universality of the moment or subject. The aim of the snapshot is to etch in time (and thus in memory) the uniqueness of the individual or documented event.

Personal snapshots are meant to be held in one's hand, displayed on a desk or shelf in one's home, admired in an album (or now viewed on a computer monitor, having been stored as digital files). They become for the photographer or the subject a visual surrogate for a written account of their lives. Indeed, the ability to manipulate our past through the arrangement of snapshots creates a piece of modern-day folk art. One expects to see art photographs hanging in a gallery or reproduced in newspapers or books and therefore removed from a personal context. By contrast, the public and occasionally even commercial presentation of snapshots may at first seem a surprising invasion of their original domestic or private setting.

How and why do snapshots find their way from the private realm into an independent collection, onto a museum's walls, or into a book on the subject? In other words, what is it about snapshots that attracts outside individuals (including collectors like me) who have no knowledge

of the photographer or the subject represented? Part of the appeal lies in the exuberant and daring inventiveness found in many of these works. Should such creativity be viewed as intentional, accidental, or existing somewhere in between? To use the word "accidental" in relation to snapshots may reflect a prejudicial and elitist approach to photography vis-à-vis the great masters of the medium. Yet one realizes, after looking at a number of exemplary snapshots, that professional photographers did not — and do not — have a monopoly on producing eloquent, powerful, or captivating images. Thus snapshots reflect the democratization of image making that arises from the passionate need of photographers to experiment with the camera. For a snapshot collector, the photographer's name, renown, or worth in the art market are not important. Rather it is the anonymous snapshot's immediacy, inherent honesty, and unstudied freedom from external influence that are the draw. It must be noted, however, that scholarship surrounding snapshot or amateur photography is very much in its infancy, and any definitive influences on, or source documentation for, associated imagery have yet to be discovered or discussed in much detail. It is my belief that this catalogue will make an important contribution to such a dialogue.

Another aspect of the snapshot's appeal may derive from the confessional age in which we live, whereby people's darkest secrets are aired via a reality television show or made public through a personal online blog or Web site. The unguarded snapshot moment exerts a similar fascination, creating the impression that we have caught an unvarnished glimpse of life and now are privy to an intimacy that has been revealed through the photograph. The modernist "reading" of the snapshot makes us voyeurs in much the same way as

viewing a photograph by Diane Arbus allows us to witness some inchoate mystery of the human psyche.

Stylistically, the visual vocabulary of impressionism, cubism, and surrealism, although radical when introduced, has made us generally comfortable with the aesthetics of snapshots. Therefore it is not surprising that collectors are intrigued by double exposures, out-of-focus photographs, and oddly lit environments containing costumes and activities that are not readily understood by the casual viewer. In objectifying the anonymous snapshot experience, the personal can therefore become impersonal. This often translates into the formal qualities of the photograph being appreciated apart from a "who, what, when, where" narrative reading. The result is that a good snapshot is valued by many collectors as a work of art, sharing many of the same characteristics found in fine art photography.

At the same time, a collector can have a subjective interest in a snapshot's narrative content as a surrogate for life experiences. Thus the personal remains personal, if you will. Not only does the snapshot often represent to the photographer a nostalgic remembrance of a time that is now (or will be soon) gone, but the viewer can also recognize and identify with that nostalgia, believing the image represents a simpler and happier time in our collective, or personal, history. Indeed, a snapshot can become a touchstone for our own childhood by recalling a favorite toy or an event in which we participated. This often culminates in a strong desire to acquire that photograph as a means of holding onto the past or onto a part of one's past for which no personal photographic record survives.

It is easy to see why the distance of time is so important in collecting snapshots. It may be years before a photograph resonates with a memory of the

past. Furthermore, there is a symbiotic relationship between the concept of historical distance and the time it takes photographs to leave the overflowing family album, refrigerator door, or unsorted box of loose prints in the basement or attic. For me that period is about twenty to thirty years. That is why my collection and this exhibition extend only into the 1970s. I am too close to the 1980s and beyond to be able to "see" a good snapshot objectively.

Building a collection of snapshots is different than building a collection of fine art photographs for several reasons. First, although there are many established dealers, auction houses, and shows devoted to photography (such as events sponsored by the Association of International Photography Art Dealers), most cater more to a sophisticated and growing market for art photography than to collectors of anonymous or amateur photographs. Collectors of snapshots, therefore, must rely on extensive networking; sifting through dusty bins and boxes of photographs at weekend flea markets; the biannual MPM All Image Show in Emeryville, California; other shows around the country featuring works on paper and photographic ephemera; and last but not least, eBay. The impact of eBay on the burgeoning interest in snapshots is incalculable: week after week thousands of images appear on this vast Web site, offered by dealers who have mined countless garage and estate sales, attics, and flea markets.

Forming a snapshot collection, consequently, means looking at great numbers of photographs, both online and in person, calling dealers to see if they have something new to sell, and traveling extensively. Many contacts were willing to give me the names of others who might have snapshots for sale. This exhibition therefore represents not only my eye as the collector but the expertise and enthusiasm of myriad individuals with whom I have formed enduring friendships through the years based on our mutual passion for snapshot photography. Much gratitude is owed to a host of people for the photographs that have found their way into my collection (and in some instances into this exhibition), and I wish to recognize and thank them here.

I first began to collect snapshots in early 1997, primarily from three Seattle dealers: Mike Fairley, Michael Maslan, and Mary Patterson. I continue to be a loyal customer of all three and cannot thank them enough for their early support and encouragement. Others in Seattle or Washington State who helped me assemble my collection include David Chapman, Richard Clearman, Julie Cutler, Michael Dunsford, Danny Eskenazi, Ann Garretson, John and Amy Hanawalt, Myles Haselhorst, George Hunter, Meg Kaufman and Ken Nelson, John Lang, Bill Mix, Dave Morris, Barbara Mowitch, Betsy H. Ogden and Keith Shockley, Rocky Shaw, and Alyssa Stevens and Aaron Cone. I want to pay particular tribute to Alan Lawrence, an avid collector with whom I have spent many hours poring over snapshots. In addition, Tammra Engum, whose snapshot inventory has yielded some of my favorite images, has done more for me through the years than I can adequately acknowledge; and Darrin Stouffer has been a true friend since the early days of my collecting and always has interesting snapshots to sell. I have many fond memories of time spent with Larry and Sabine Calkins at their home in the country looking at photographs and have acquired a number of wonderful snapshots from them. Patti McKillop has an excellent, wide-ranging snapshot collection and has shown me great hospitality and kindness over the years.

Eventually looking outside the state of Washington to pursue my photographic interests,

I was most fortunate to meet David Winter, who deserves profound thanks for his contribution to the quality of the snapshots in my collection. I have benefited enormously not only from his extraordinary inventory but also from his generosity in referring me to snapshot dealers in New York City at a time when I knew very few such individuals. Others in New York who must be mentioned include Jack Banning, Steven Kasher, and Carl Morse as well as Larry Baumhor, who consistently has great material for sale; Peter Cohen, who has one of the best snapshot collections around; Katrina Doerner, a dealer whom I count as a cherished friend; Thomas Harris, who has shown me warm hospitality and who has a notable photograph collection; Estelle Rosen, a pioneer in the selling of snapshots to whom all such collectors owe much gratitude; and Joel Rotenberg, from whom I have purchased some remarkable photographs and who is himself a passionate collector. I need to say a special thank you to Richie Hart, whose strong support has meant so much to me (and to my collection). The caliber of the photographs I have purchased from him through the years is second to none.

I am also indebted to many people in New England who have enriched my life and collection in many ways: David Chow, Andrew Flamm and Michelle Hauser, and Clare Goldsmith as well as Larry Collins, whose friendship I value highly; Mark Glovsky, whose excellent collection testifies to his keen eye for snapshots; Rodger Kingston, a trailblazer in the area of vernacular collecting, including snapshots, who has raised the bar for a lot of us in collecting such material; and Stacy Waldman, who can always be counted on to have outstanding photographs for sale. I would also like to offer warm thanks to Sabine Ocker and Phil Storey, with whom I have spent many happy hours looking at their impressive collections and talking about snapshots; and to my friend and fellow collector John Phelan, who has brought great enthusiasm to our snapshot discussions.

My collection also reflects the contributions of several dealers in California. In the San Francisco area I would like to thank Ralph Jaffee, Susan Raymond, Julie Santangelo, Andy Smith, and Keith Tower as well as Bruce Barton, who has been the source of a number of my favorite snapshots; Jeff Carr, who always surprises me with the snapshots and other material he uncovers; Barbara Levine, who has offered me many encouraging words over the years and who always has a superb selection of albums and individual photographs for sale; and Kevin Randolph, who showed me some of the most compelling snapshots I had seen in the early days of my collecting. Special mention must go to Robert Tat, who continues to add immeasurably to my collection and my life in general. In Los Angeles and southern California, thanks are due to Tony Davis, Ray Hetrick, Paul Kopeikin, Ed Krug, Larry Lightfoot, John Nichols, and Tim Roller as well as Jane Handel, who was a good friend and supporter at a time when I needed someone in whom to confide about this exhibition; Babbette Hines, who has sold me some amazing images; Norman Kulkin, whose inventory always contains the most intriguing photographs; Jim Nocito, whom I owe tremendous gratitude, and who has sold me numerous wonderful photographs; Cheryl Ohland, who has provided me with many terrific snapshots; Gail Pine and Jackie Woods, two friends who share my passion for, and love of, snapshots. I must pay special tribute to James Lamkin, who has earned a reputation for finding remarkable snapshots, which he has made available to me and other collectors. I would like to extend sincere thanks to Steve Bannos.

The caliber of the images I own is due in large part to the snapshots I have purchased from him over the years.

There are many others whom I wish to recognize for their help in building my collection or for inspiring and invigorating the entire field. They include Nicholas Osborn, from whom I acquired some of my favorite images. He has a discerning eye and an enviable collection. My collection also owes a great deal to Theodora (Teddi) Thomas, whom I first knew as "the snapshot lady" and who sold photographs at the Rose Bowl flea market. I have only the highest praise for Terry Toedtemeier, an early and influential collector of snapshots, whom I am honored to call a friend. I would also like to acknowledge and thank Roger Anderson, Frish Brandt, Ivan Briggs, Ralph Bowman, Robert Childs, Randall de Rijk, Obadiah Tarzan Greenberg, Brett Harrison, Bill Hunt, Annette and Rudolf Kicken, Frank Lavigne, Steven Lewandowski, Glenn and Judith Mason, Reed Massengill, Sherry Pardee, Judith Rafferty, Bob Ward, Erin Waters, Roy H. Williams, and Ross Winter. In addition, Jo Tartt consistently has interesting snapshots for sale; Angelica Paez offers some of the best snapshots on the market; Maria DiElsi Connolly has been a great sounding board and treasured friend; Don Hirt has thousands of snapshots that dependably yield exciting finds; Robert Flynn Johnson has a collection of fascinating photographs; and John Foster, a collector with a passion for the unusual image, has made a significant contribution to the world of snapshots with his traveling exhibition.

Finally, I want to recognize all of the dedicated individuals at the National Gallery of Art whose expertise and experience were instrumental in making the exhibition and catalogue possible.

Most importantly, without the initial support of the director, Earl A. Powell III, and deputy director, Alan Shestack, this exhibition would not have occurred. I deeply appreciate the tireless efforts of members of the department of photographs, including interns Yali Lewis for her preliminary work on the exhibition and Jessica Maxwell for her help preparing the bibliography and the chronology that follows the acknowledgments, as well as securing comparative illustrations for the catalogue; and Molly Bloom for attending to numerous details relating to both the exhibition and the catalogue. My utmost gratitude, however, is reserved for the four photograph curators, who have spent countless hours on the exhibition and catalogue. Sarah Kennel and Matthew Witkovsky each contributed thought-provoking essays to the catalogue while at the same time organizing two other important photography exhibitions for the National Gallery that opened during 2007. Diane Waggoner wrote the opening essay for the present catalogue, establish-ing the foundation for our understanding of the early development of snapshot photography, and simultaneously oversaw a seemingly endless series of tasks to prepare for the mounting of this exhibition and publication of the catalogue. I extend to her my profound gratitude. Yet I owe my greatest debt to Sarah Greenough for her support and encouragement through the many stages of this endeavor. I thank her for writing an engaging essay for the catalogue as well as for her enthusiasm and belief that an important but little-studied area of photography was worthy of formal presentation by the National Gallery. It is because of the National Gallery staff's many contributions that snapshot photography can now begin to be revealed in a different light.

Acknowledgments / **Sarah Greenough**

Every exhibition has its own rich history, and *The Art of the American Snapshot, 1888–1978: From the Collection of Robert E. Jackson* is no exception. It began with a series of letters and e-mails that Robert Jackson sent me in 2000 and 2001 describing his collection of American snapshots. With my interest piqued, I arranged to meet him in New York. When he opened his albums and showed me a few of the photographs he had found, I was dazzled both by their power and vibrancy and by the scope of the collection itself, and I knew immediately that this material could make a compelling exhibition. In the years since that first meeting, Mr. Jackson has substantially augmented his holdings, and each new addition further whetted my interest. We thus owe our greatest debt of gratitude to him for his vision in conceiving this collection and his passionate commitment to acquiring the most creative and captivating snapshots. He has also generously shared with us his knowledge of the subject, and he has donated 138 snapshots to the National Gallery of Art that will significantly enhance our ability in the years to come to describe the complex history of late nineteenth- and twentieth-century photography.

From its inception this undertaking has been an unusual one for the National Gallery. For a museum dedicated to collecting, preserving, and fostering understanding of the finest works of art from around the world, snapshots — which nearly everyone makes and owns and which seem so common as to be almost unnoticed — have not traditionally been within our purview. That so many colleagues have responded so enthusiastically to the project is a testament to their willingness to be challenged by new ideas as well as to the vitality of the snapshots themselves. I am especially indebted to director, Earl A. Powell III, and deputy director,

Alan Shestack, for their steadfast support of this exhibition and the overall photography program at the National Gallery. I am also grateful to Judy Metro, editor in chief, D. Dodge Thompson, chief of exhibitions, and Mark Leithauser, chief of design, for their astute guidance in all phases of this project.

In the department of photographs, I particularly wish to thank Diane Waggoner, who co-curated the exhibition with me, collaborating on the selection of works and preparation of the catalogue. I greatly appreciate her excellent judgment and sensitive eye in handling the myriad details that have demanded daily attention while also writing the opening essay for this publication. Diane joins me in thanking Sarah Kennel and Matthew S. Witkovsky, who wrote important and provocative essays for this book while simultaneously curating their own exhibitions; Jessica Maxwell, who provided essential support in organizing and cataloguing the snapshots, did significant research for the chronology, and compiled the bibliography; as well as Molly Bloom, whose seemingly effortless coordination of many, often last-minute details facilitated everyone's work on both the exhibition and the catalogue. This project is the first to include substantial contributions from all members of the department, and all deserve special recognition for their tireless dedication and imaginative insights. We also thank former intern Yali Lewis for her help with preliminary research. In addition, Constance McCabe, senior photograph conservator, shared her intimate knowledge of the subject, enriching both the essays and the chronology, and she also allowed us to illustrate the latter with several of the cameras she owns. We are extremely grateful for her close and collegial ongoing relationship with our department.

We have benefited enormously from the expertise and goodwill of numerous colleagues around the country. We wish to thank especially Kathy Connor, Alison Nordstrom, Joe R. Struble, and Rachel Stuhlman of the George Eastman House; Patricia Collado and Joseph Ruh of Eastman Kodak Company; Chris Cottrill, Jim Roan, Stephanie Thomas, and Mike Hardy of the Smithsonian Institution Libraries; as well as Wanda Corn, John Gossage, Bill Hunt, Douglas R. Nickel, Joe Tartt, and Thomas Walther.

This exhibition will travel to the Amon Carter Museum, and we are grateful to Ron Tyler, director, and particularly John Rohrbach, senior curator of photographs, and his colleagues in the department of photographs, for their enthusiastic and insightful presentation of this material.

At the National Gallery many other individuals have been critical to the success of this project. We wish to thank Joseph J. Krakora, executive officer, development and external affairs; Carol Kelley, chief of protocol and special events; Christine Myers, chief development and corporate relations officer, Cathryn Scoville, senior associate for development, Patricia Donovan, senior associate, and Jeanette Crangle Beers, project specialist; and Deborah Ziska, chief press and public information officer, Anabeth Guthrie, senior publicist, and Steven Konick, publicist. Hugh Phibbs, coordinator of preservation services, with Jenny Ritchie, Stephen Muscarella, and Caroline Danforth provided the excellent matting and framing of the snapshots as well as expert advice concerning how best to present these works. Sarah Wagner, Kress photograph conservator, generously permitted us to photograph several cameras in her collection to illustrate the chronology. We are indebted to Sally Freitag, chief registrar, along with Theresa Beall,

Melissa Stegeman, and Bethann Heinbaugh; Wendy Battaglino in the department of exhibitions; Susan Arensberg, head of exhibition programs; Gordon Anson, deputy chief of design, along with Jamé Anderson, Elma Hajric, John Olson, and Lisa Farrell; Elizabeth A. Croog, secretary and general counsel, and Julian Saenz, associate general counsel; Alan Newman, chief of imaging and visual services, Lorene Emerson, supervisory photographer, Lee Ewing and Kenneth Fleisher, photographers; and Neal Turtell, executive librarian, along with Ted Dalziel and Thomas McGill Jr.

For this publication we want to thank Tam Curry Bryfogle for her superb editing, accomplished with discernment, thoroughness, and tact; Margaret Bauer for her exceptional design, which beautifully compliments the freshness and immediacy of the photographs themselves; and Chris Vogel for overseeing the production with his well-honed efficiency and skill, assisted by Mariah Shay. Ira Bartfield secured many of the comparative illustrations. And Robert J. Hennessey, who has rendered invaluable assistance with so many of our photography exhibition catalogues, deserves special commendation for enabling us to reproduce these snapshots with great sensitivity.

Finally, and by no means least, we would like to thank the Getty Foundation for its support of this publication. We extend our deepest thanks to Ryna and Melvin Cohen of the Ryna and Melvin Cohen Family Foundation — whose son Neil also allowed us to illustrate some of the cameras in his collection — and to especially Betsy Karel of the Trellis Fund. Their critical support for both the National Gallery and photography has enabled us to ensure that exhibitions presented in our newly dedicated photography galleries have remained a continuing source of delight and discovery.

Technical Milestones in Snapshot Cameras and Film

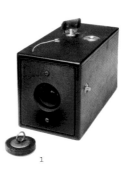

1

1850 1860 1870 1880

1855

Frederick Scott Archer in Great Britain patents what may be the first flexible transparent negative: a "stripping film," which consists of a collodion image layer that is peeled from its paper base and reinforced with a gutta-percha coating.

1871

Richard Leach Maddox invents gelatin dry-plate glass negatives in Great Britain. Unlike earlier negatives, which require preparation by hand, commercially manufactured dry plates can be kept for months before being exposed and processed.

1873

Hermann Vogel in Germany introduces orthochromatic emulsions, which are more sensitive than earlier emulsions to the green and yellow parts of the spectrum.

Agfa, first established as a color dye factory in 1867, registers its name in Germany. It will later become a major manufacturer of film and cameras in the twentieth century.

1875

Leon Warnerke invents a roll-film holder for paper coated with gelatin silver emulsions.

1881

George Eastman incorporates the Eastman Dry Plate Company, based in Rochester, New York, which will dominate the industry for decades.

In Great Britain, Thomas Bolas patents a box camera meant to be held in the hand and coins the term "detective camera." The first commercially popular camera of this type is the Patent Detective Camera, registered by William Schmid in 1883. Several similar cameras are soon manufactured by different companies.

1883

E. Stebbing in Great Britain announces the first camera with a built-in roll holder for a length of sensitized paper. He markets it as the Stebbing Automatic Camera.

1884

Eastman Negative Paper, with a light-sensitive gelatin silver emulsion, is introduced.

1. No. 1 Kodak, manufactured 1889–1895

1880

1890

Eastman patents "American Film," a long-roll film consisting of a gelatin silver emulsion over a soluble gelatin layer that, once chemically processed, allows the image layer to be transferred from its paper support to a transparent gelatin support. He introduces it commercially in 1885.

Vogel creates panchromatic emulsions, incorporating "azaline" dyes that increase sensitivity to all parts of the visible color spectrum.

1885

Eastman and William Hall Walker patent the Eastman-Walker Roll-Holder for use with American Film as an interchangeable part in a standard dry-plate camera.

1888

Eastman registers "Kodak" as a trademark and introduces the Kodak camera, a box camera loaded with a 100-exposure roll of American Film. It produces negatives and prints with circular images 2½ inches in diameter. Other manufacturers soon introduce roll-film box cameras in the wake of the Kodak's suc-

cess. The Kodak, and its immediate successor, the No. 1 Kodak, are discontinued in 1889 and 1895, respectively.

John Carbutt, a dry plate manufacturer, sells the first commercial transparent flexible negative sheet film, which uses Celluloid (patented by John Wesley and Isaiah Hyatt of the Celluloid Manufacturing Company in the early 1870s) rather than glass as the support.

1889

Eastman introduces transparent cellulose nitrate roll film, which, like Carbutt's flexible film, no longer requires stripping from its paper support.

Eastman releases the No.2 Kodak, a larger version of the No. 1 Kodak, which includes a small viewfinder. It produces negatives and prints with circular images 3½ inches in diameter. It is discontinued in 1897.

B. J. Edwards patents a camera that incorporates the innovation of pre-spooled film in light-tight cartons, allowing the film to be loaded and unloaded in daylight.

1891

Eastman introduces Daylight Kodaks with a system for loading film outside the darkroom that is similar to the one devised by Edwards.

1892

Samuel N. Turner, founder of the Boston Camera Company in 1884, patents a design in which the film and a protective paper are spooled together to allow daylight loading and unloading. It incorporates numbered markings on the protective paper, visible through a window on the back of the camera. Turner implements this system in the Bull's Eye Camera.

The Eastman Dry Plate Company becomes the Eastman Kodak Company (following intermediate stages as the Eastman Dry Plate and Film Company after 1884 and the Eastman Company after 1889).

1895

Eastman Kodak purchases Turner's patent and company and takes over the manufacturing of the Bull's Eye Camera. It also markets the Bullet Camera, its own box camera adopting the daylight-loading and numbered film system.

Eastman Kodak issues the Pocket Kodak and Folding Pocket Kodak, which are inexpensive, small, lightweight, and make rectangular negatives and prints that measure 1½ x 2 inches.

2

3

4

1900

1910

1900

Eastman Kodak introduces
a $1.00 box camera, the
Brownie. Competitors fol-
low with similar inexpen-
sive cameras. Versions
of the Brownie are manu-
factured until 1970.

1901

The Anthony and Scovill
Company is formed from a
merger of the E. and H. T.
Anthony Company with
the Scovill Manufacturing
Company. Based in Bing-
hamton, New York, the
firm is renamed Ansco in
1907 and becomes a major
manufacturer of amateur
cameras.

1902

Eastman Kodak issues a
film developing tank
that allows processing in
daylight.

Britannia Works, founded
in England in 1879, becomes
Ilford, Limited, which will
be one of the twentieth-
century's major suppliers
of film and photographic
papers.

1903

Eastman Kodak releases
an improved roll film that
does not curl.

1906

Wratten and Wainwright's
black-and-white panchro-
matic plates, sensitive
to all colors, are commer-
cially produced in England.

1907

Auguste and Louis Lumière
introduce the Autochrome
color process, the first
used by amateurs. While
Autochromes are glass
plates, color roll film that
uses a similar technology,
including Lumière Film-
color and Dufaycolor,
begins to supplant the
more fragile glass plates
in the 1930s.

1908

Safety film is introduced,
replacing flammable
cellulose nitrate with
cellulose acetate.

1910

Eastman Kodak issues
cameras with the Autotime
Scale, which allows the
photographer to calculate
the proper shutter speed
and aperture according to
film type, lighting condi-
tions, and subject.

1912

Eastman Kodak begins sell-
ing the Vest Pocket Kodak,
marketed as "The Soldier's
Kodak Camera" during
World War I. It is discon-
tinued in 1926.

1913

Eastman Kodak develops
a panchromatic film
emulsion, sensitive to red,
green, and blue light,
which is used initially for
motion pictures. Pan-
chromatic emulsions be-
come standard for still
pictures during the 1920s.

1914

Eastman Kodak issues the
Autographic Kodak, which
allows the photographer
to write information on the
negative through a small,
hinged door on the back of
the camera using a pencil
or stylus. The technology,
patented in 1913 and 1914
by Henry J. Gaisman and
purchased by Eastman, is
incorporated in cameras
produced through the
1930s.

1916

Eastman Kodak introduces
unperforated 35mm film for
use in its No. 00 Cartridge
Premo Camera.

5 6 7 8 9 10 11

1920 1930

1925

The Leica is introduced, the first successfully mass-marketed compact camera using 35mm film, which was originally made for motion pictures. The 35mm will eventually become the most common camera type, produced by numerous companies.

Austrian Paul Vierkötter patents the flashbulb, which encases fine magnesium fibers in glass.

1930

Flashbulbs first become commercially available in Germany. General Electric begins to manufacture flashbulbs in the United States.

1935

Eastman Kodak releases Kodachrome, a positive color motion picture film. A 35mm still-picture version follows the next year and is widely adopted by amateurs after World War II.

1936

Agfa issues Agfacolor-Neu, another positive color film.

The German Exakta, the first camera with synchronized flash, is released by Ihagee Kamera Werk, founded in 1912.

The Argus Model A, its design based on the Leica, is the first 35mm camera mass-produced in the United States.

1937

Edwin Land's Polaroid Corporation founded.

1938

Eastman Kodak releases the Super Kodak Six-20, the first camera to have automatic exposure control. It is discontinued in 1944.

12

5. Vest Pocket Kodak Model B, manufactured 1925–1934 6. Brownie with carrying case, c. 1930 7. Agfa Ansco Readyset Traveler 1A, c. 1930s 8. Beau Brownies in two different colors, manufactured 1930–1933 9. Jiffy Kodak Six-16, manufactured 1933–1937 10. Six-20 Kodak, manufactured 1932–1937 11. Baby Brownie, c. 1935 12. Various roll films

13 14 15 16 17 18

1940 1950 1960 1970

1942

Eastman Kodak introduces Kodacolor, a color negative film, making it easy for amateurs to have color prints made. By the 1960s color prints are more common than black-and-white.

1946

Eastman Kodak introduces Ektachrome positive transparency film, the first color film that photographers can process themselves.

1948

Edwin Land releases the Polaroid Land Camera, which makes black-and-white prints in sixty seconds.

1950s

Synchronized flash becomes a standard feature on amateur cameras.

1963

Polaroid introduces Polacolor Type 48, the first instant color print.

Eastman Kodak produces the Kodak Instamatic, which employs a foolproof drop-in film cartridge and becomes the most common amateur camera type. It is discontinued in 1988.

1965

The Japanese company Fuji Photo Film Company, Limited, founded in 1934, opens an American branch, Fujifilm USA.

1966

The Kodak flashcube is introduced, which contains four small flashbulbs in a transparent cube.

1972

Polaroid introduces the SX-70, a folding camera with cartridge film that exposes and develops color prints instantly and automatically.

Kodak introduces the Pocket Instamatic, with a new, smaller-format film cartridge.

1978

The Japanese company Konishiroku Photo Industry Company, Limited, founded in 1873, introduces the Konica C35 AF, the first camera with autofocus.

19

13. Ansco Shur Shot, manufactured 1934–1941 14. Bullet Camera, Eastman Kodak, c. 1940; 15. Brownie Hawkeye Camera Flash Model, manufactured 1950–1961 16. Brownie Starflash, manufactured in red 1958–1960 17. Savoy, Imperial Camera, c. 1960s 18. Kodak Instamatic 100, manufactured 1963–1966 19. "Under-$20 Polaroid Land Camera Announced," press release for the Swinger Camera, Polaroid Corporation, July 18, 1965

Notes

Introduction

1. Charles M. Taylor Jr., *Why My Photographs Are Bad* (Philadelphia: G. W. Jacobs and Co., 1902), 9. My thanks to John Gossage for alerting me to this publication. I would also like to thank Robert Jackson for the numerous conversations we have had about snapshots, which have deeply enriched my understanding of the subject.

2. Taylor 1902, 11.

3. The first reference to "snap-shot" photographs in the *New York Times* was on July 9, 1896, when they were submitted as evidence by Anthony Comstock of illicit activities by the mayor of Long Island City; see "Raid in Gleason's Domain," 8.

4. Ann Thomas, *Lisette Model*, exh. cat. (Ottawa: National Gallery of Canada, 1990), 44.

5. Walker Evans, "Twenty Thousand Moments under Lexington Avenue: A Superfluous Word," draft text for maquette of *Lex. Ave. Local*, 1966, as quoted in Sarah Greenough, *Walker Evans: Subways and Streets*, exh. cat. (Washington, DC: National Gallery of Art, 1992): 127.

6. Roland Barthes, *Camera Lucida: Reflections on Photography*, trans. Richard Howard (New York: Hill and Wang, 1981). For further discussion, see Geoffrey Batchen, "Vernacular Photographies," and Douglas R. Nickel, "Roland Barthes and the Snapshot," *History of Photography* 24, no. 3 (Autumn 2000): 262–271 and 232–235.

7. Barthes 1981, 3.

8. Michael Lesy, *Wisconsin Death Trip* (New York: Pantheon Books, 1973); Larry Sultan and Mike Mandel, *Evidence*, with an afterword by Robert F. Forth (Greenbrae, CA: Clatworthy Colorvues, 1977); and Barbara Norfleet, *The Champion Pig: Great Moments in Everyday Life* (Boston: David R. Godine, 1979).

9. For discussions of snapshots and the creation of personal and group identity see Catherine Smith and Cynthia Greig, *Women in Pants: Manly Maidens, Cowgirls, and Other Renegades* (London: Harry N. Abrams, Inc., 2003); Russell Bush, *Affectionate Men: A Photographic History of a Century of Male Couples* (New York: St. Martin's Press, 1998); John Ibson, *Picturing Men: A Century of Male Relationships in Everyday American Photography* (Washington, DC: Smithsonian Institution Press, 2002); for ethnic identity, see Brian Wallis and Deborah Willis, *African American Vernacular Photography: Selections from the Daniel Cowin Collection* (New York: International Center of Photography; Göttingen: Steidl Publishing, 2005); for family history, see Michael Lesy, *Time Frames: The Meaning of Family Pictures* (New York: Pantheon Books, 1980); Nancy Martha West, *Kodak and the Lens of Nostalgia* (Charlottesville: University Press of Virginia, 2000); and for memory, see Geoffrey Batchen, *Forget Me Not: Photography and Remembrance* (New York: Princeton Architectural Press, 2004).

10. *The American Snapshot: An Exhibition of the Folk Art of the Camera*, exh. cat. (New York: The Museum of Modern Art, 1944).

11. John Szarkowski, *The Photographer's Eye*, exh. cat. (New York: The Museum of Modern Art, 1966), unpaginated.

12. Douglas R. Nickel, *Snapshots: The Photography of Everyday Life, 1888 to the Present*, exh. cat. (San Francisco: San Francisco Museum of Modern Art, 1998); Thomas Walther and Mia Fineman, *Other Pictures: Anonymous Photographs from the Thomas Walther Collection* (Santa Fe: Twin Palms Publishers, 2000); for a discussion of other exhibitions, see Joel Smith, "Roll Over: The Snapshot's Museum Afterlife," *Afterimage* 29, no. 2 (September/October 2001): 8–11.

13. Walther and Fineman 2000, unpaginated.

14. Susan Sontag, *On Photography* (New York: Farrar, Straus and Giroux, 1973), 21; Janet Malcolm, *Diana & Nikon: Essays on the Aesthetic of Photography* (Boston: David R. Godine, 1980), 31, 59–73. For further discussion, see A. D. Coleman, "Quotidian or Vernacular Photography: Premises, Functions, and Contexts," *Impact of Science on Society* 42, no. 4 (1992): 315–327; and Nickel 1998, 1–15.

15. See Geoffrey Batchen, ed., "Responses to a Questionnaire," and Geoffrey Batchen, "Vernacular Photographies," *History of Photography* 24, no. 3 (Autumn 2000): 229–231, 262–271; and Nickel 1998, 13.

16. Walker Evans, "The Unposed Portrait," *Harper's Bazaar* 95 (March 1962): 120.

17. See Batchen 2000, 229–231, and 262–271; Coleman 1992, 315–327. On November 5–6, 2004, Boston University Art Gallery hosted the symposium "Vernacular Reframed: An Exploration of the Everyday," which sought to "confront the crisis in the history of photography provoked by vernacular images." It had as one of its stated goals to "analyze and problematize the history of vernacular images."

18. Alfred Stieglitz, artist's statement in *Second Exhibition of Photography by Alfred Stieglitz*, exh. cat. (New York: Anderson Galleries, 1923), unpaginated.

19. Augustus Wolfman, *1978–1979 Wolfman Report on the Photographic Industry* (New York: Modern Photography Magazine, 1979), 38.

Photographic Amusements

I would especially like to thank Kathy Connor and Joe R. Struble of the George Eastman House for their assistance.

1. See Steven Mintz, *Domestic Revolutions: A Social History of American Family Life* (New York: Free Press; and London: Collier Macmillan, 1988); and Jessica H. Foy and Thomas J. Schlereth, *American Home Life, 1880–1930: A Social History of Spaces and Services* (Knoxville: University of Tennessee Press, 1992).

2. See Karin Calvert, *Children in the House: The Material Culture of Early Childhood, 1600–1900* (Boston: Northeastern University Press, 1992); and Mary Lynn Stevens Heininger, *A Century of Childhood, 1820–1920* (Rochester, NY: Margaret Woodbury Strong Museum, 1984).

3. See Joseph F. Kett, *Rites of Passage: Adolescence in America, 1790 to the Present* (New York: Basic Books, 1977).

4. The history of George Eastman and the Kodak camera has been recounted several times. See Reese V. Jenkins, *Images and Enterprise: Technology and the American Photographic Industry, 1839–1925* (Baltimore: The Johns Hopkins University Press, 1975); Douglas Collins, *The Story of Kodak* (New York: Harry N. Abrams, Inc., 1990); Colin Ford, ed., *The Story of Popular Photography* (North Pomfret, VT: Trafalgar Square Publishing, 1989); Brian Coe and Paul Gates, *The Snapshot Photograph: The Rise of Popular Photography, 1888–1939* (London: Ash & Grant, 1977); Colin Ford and Karl Steinorth, eds., *You Press the Button, We Do the Rest* (London: Dirk Nishen Publishing, 1988).

5. Collins 1990, 56.

6. Nancy Martha West, *Kodak and the Lens of Nostalgia* (Charlottesville: University Press of Virginia, 2000), 24, cites this figure from information provided by Todd Gustavson, curator of technology at George Eastman House.

7. "Tips for Tyros," *The American Amateur Photographer* 18, no. 3 (March 1906): 114 (originally published in *The Amateur Photographer*); and W. E. Partridge, "The Hand-Camera without a Finder," *The American Amateur Photographer* 4, no. 11 (November 1892): 490.

8. This c. 1890 sample album is in the collection of the George Eastman House, Rochester, New York, and was probably produced to distribute to Kodak's local dealers. The text also appeared in *The Kodak Primer*, which was included with the purchase of the first Kodak cameras. See West 2000, 48.

9. Collins 1990, 92 and 97. West 2000, 75, shows figures provided by Gustavson.

10. Collins 1990, 98.

11. See Marc Olivier, "George Eastman's Modern Stone-Age Family: Snapshot Photography and the Brownie," *Technology and Culture* 48, no. 1 (January 2007), 1–19, for a history of Palmer Cox's Brownie characters, their widespread use in product advertisements, Eastman's unauthorized appropriation of them for the Brownie camera, and the symbolic implications of the combination of Brownies and the camera.

12. See Jenkins 1975 for a comprehensive examination of the technological innovations and growth of the photography market at the turn of the century.

13. See Sarah Greenough, "'Of charming glens, graceful glades, and frowning cliffs': The Economic Incentives, Social Inducements, and Aesthetic Issues of American Pictorial Photography, 1880–1902," in Martha A. Sandweiss, *Photography in Nineteenth-Century America* (Fort Worth: Amon Carter Museum; and New York: Harry N. Abrams, Inc., 1991), 270.

14. Other magazines introduced at this time were *The Amateur Photographer's Weekly, Photo-Miniature, Photographic Mosaics,* and *Wilson's Photographic Magazine.*

15. Eduard J. Steichen, "Ye Fakers," *Camera Work* 1 (January 1903): 48.

16. Catherine Weed Barnes, "A Woman to Women," *The American Amateur Photographer* 2, no. 4 (April 1890): 188.

17. Howard Park Dawson, "Hints for Kodak Workers," *The American Amateur Photographer* 4, no. 11 (November 1892): 481.

18. Alfred Stieglitz, "The Hand Camera —Its Present Importance," *The American Annual of Photography and Photographic Times Almanac for 1897* (1896): 19–27.

19. Seneca Camera Manufacturing Co., *The Amateur Photographer's Manual* (Rochester, NY, 17th ed., n.d. [1890s]).

20. Seneca [1890s], 10.

21. See Nancy Mowll Mathews, ed., *Moving Pictures: American Art and Early Film, 1880–1910* (Williamstown, MA: Williams College Museum of Art; and Manchester, VT: Hudson Hills Press, 2005), 6.

22. See Paul Spencer Sternberger, *Between Amateur and Aesthete: The Legitimization of Photography as Art in America, 1880–1900* (Albuquerque: University of New Mexico Press, 2001); and Greenough 1991.

23. West 2000, 19–20.

24. See West 2000.

25. Letter to the editor, *The American Amateur Photographer* 3, no. 3 (March 1891): 112.

26. All of these slogans date to c. 1900–1910.

27. See West 2000; and Stephanie Snyder, Barbara Levine, et al., *Snapshot Chronicles: Inventing the American Photo Album* (New York: Princeton Architectural Press; Portland, OR: Douglas F. Cooley Memorial Art Gallery, Reed College, 2006), 27.

28. West 2000, 57.

29. See Martha Banta, *Imaging American Women: Ideas and Ideals in Cultural History* (New York: Columbia University Press, 1987).

30. West 2000, 24; and Collins 1990, 84.

31. West 2000, 27; and W. M. M., "Two Kodak Exhibitions," *Camera Notes* 1, no. 4 (April 1898): 97–99.

32. See Snyder, Levine, et al. 2006, and Marilyn F. Motz, "Visual Autobiography: Photograph Albums of Turn-of-the-Century Midwestern Women," *American Quarterly* 41, no. 1 (March 1989): 63–92, for discussions of American snapshot albums.

33. *Picture Taking and Picture Making* (Rochester, NY: Eastman Kodak Company, 1899), 35.

34. Seneca [1890s], 21.

35. See Christina Kotchemidova, "Why We Say 'Cheese': Producing the Smile in Snapshot Photography," *Critical Studies in Media Communication* 22, no. 1 (March 2005): 2–25, for an in-depth exploration of smiling in twentieth-century snapshots.

36. See Foy and Schlereth 1992.

37. See Jay Ruby, *Secure the Shadow: Death and Photography in America* (Cambridge, MA: MIT Press, 1995); Barbara P. Norfleet, *Looking at Death* (Boston: David R. Godine, 1993); and West 2000, 136–165. Both Ruby and Norfleet discuss how taboos surrounding death led postmortem photographs (generally taken by professionals rather than family) to be kept private by the late nineteenth century. Though professional photographers still accepted such commissions, they had stopped advertising the service by the 1880s. The drop in postmortem photography may also reflect the fact that laying out of the body increasingly became the province of the undertaker rather than the family at the same time more amateurs came to own cameras.

38. W. H. Burbank, "The Dangers of Hand Camera Work," *The American Amateur Photographer* 2, no. 9 (September 1890): 328.

39. Donna R. Braden, "The Family That Plays Together Stays Together: Family Pastimes and Indoor Amusements, 1890–1930," in Foy and Schlereth 1992, 145–161.

40. I wish to thank Robert Jackson for bringing this to my attention.

41. Carleton B. Case, *Parlor Games and Parties for Young and Old: Amusement Ideas for All the Family All the Year* (Chicago: Shrewsbury Publishing Co., 1916).

42. See Snyder, Levine, et al. 2006, 88–91, for an entire album devoted to photographs of a mock wedding. Also see John Ibson, *Picturing Men: A Century of Male Relationships in Everyday American Photography* (Washington, DC: Smithsonian Institution Press, 2002), for another example.

43. See Banta 1987, 593–671, for a discussion of the importance of amateur theatricals and posing in American social life.

44. Maud Hart Lovelace, *Betsy and Joe* (New York: Thomas Y. Crowell Company, 1948), 32–33.

45. Lovelace 1948, 168–169.

46. Sadakichi Hartmann, "A Few Reflections on Amateur and Artistic Photography," *Camera Notes* 2, no. 2 (October 1898): 41.

47. Sternberger 2001, 134. See also Jay Ruby, "The Wheelman and the Snapshooter, or, the Industrialization of the Picturesque," in Kathleen Collins, ed., *Shadow and Substance: Essays in the History of Photography, in Honor of Heinz K. Henisch* (Troy, MI: The Amorphous Institute Press, 1990), 261–268.

48. "Musings of the Kodak Philosopher," *Kodakery* 2, no. 9 (May 1915): 3–4.

49. West 2000, 15–17.

50. "The Parting Gift — A Vest Pocket Kodak," advertisement in the collection of George Eastman House.

51. Collins 1990, 155.

Quick, Casual, Modern

1. Vachel Lindsay, *The Art of the Moving Picture* (1915, rev. 1922; New York: Modern Library, 2000), 14. This discussion of the "hieroglyphic civilization" appears only in the preface to the 1922 edition. N. "Ding" Darling (1876–1962) authored approximately 15,000 editorial cartoons chronicling the history, trends, and politics of the United States from 1912 to 1962.

2. *Advertising and Selling* (June 29, 1927): 14; cited in Roland Marchand, *Advertising the American Dream: Making Way for Modernity 1920–1920* (Berkeley, Los Angeles, and London: University of California Press, 1985), 1.

3. The term "Big Society," referring to the mass culture of the 1920s, was coined by Paul Carter, *The Twenties in America* (New York: Thomas Y. Crowell Company, 1968), 50.

4. "Musings of the Kodak Philosopher," *Kodakery* 2, no. 9 (May 1915): 3–4.

5. For a discussion of the efforts to industrialize the family farm after World War I, see Deborah Fitzgerald, *Every Farm a Factory: The Industrial Ideal in American Agriculture* (New Haven: Yale University Press, 2003).

6. Roger Child Bayler, *Hand Cameras: A Handbook for Amateurs* (London: Iliffe, 1923), 29.

7. Ida D. Cone, "Making Silhouettes Is Fun," *Popular Photography* (January 1938), in *The Best of Popular Photography*, ed. Harvey V. Fondiller (New York: Ziff Davis, 1979), 152–154; Jacob Deschin, *Photo Tricks and Effects* (New York: Little Technical Library, 1940). The 1931 edition of Woodbury's *Photographic Amusements* also offered an expanded discussion of silhouette making.

8. Deschin 1940, 48.

9. John L Swayze Jr., "Art and the Snapshot," *Photo-Era Magazine* (May 1927): 243, 245, 246.

10. William Stend, *The Secrets of Snapshots without Failures* (New York: Galleon, 1939), 14.

11. Stend 1939, 14–15, 18. These terms were commonly used. See, for example, "As the Worm and the Bird See It," chap. 7, in Jacob Deschin, *New Ways in Photography: Ideas for the Amateur* (New York and London: Whittlesey House, McGraw-Hill Book Company 1936).

12. *How to Make Good Pictures* (Rochester, NY: Eastman Kodak Company, 1936), 70–71.

13. Alfons Weber, "The March of Progress," *Camera Craft* (January 1931): 4.

14. See the discussion of the Kodak Girl in Nancy Martha West, *Kodak and the Lens of Nostalgia* (Charlottesville: University of Virginia Press, 2000), 109–135.

15. David Skal, *Death Makes a Holiday: A Cultural History of Halloween* (New York: Bloomsbury Press, 2002), 34.

16. Warren I. Susman, *Culture and History: The Transformation of American Society in the Twentieth Century* (1973; repr. Washington, DC: Smithsonian Institution Press, 2003), xx–xxiv.

17. George S. Brooks, "Gas and the Games," *Scribner's Monthly* 84 (August 1928), 189–193, cited in Mark Dyreson, "The Emergence of Consumer Culture and the Transformation of Physical Culture: American Sport in the 1920s," *Journal of Sport History* 16, no. 3 (Winter 1989), 270. For a discussion of the rise of leisure, marketing, and mass culture in the 1920s, see James W. Protho, *The Dollar Decade: Business Ideas in the 1920s* (Baton Rouge: Louisiana State Press, 1954).

18. Douglas Collins, *The Story of Kodak* (New York: Harry N. Abrams, Inc., 1990), 56.

19. *Motoring with a Kodak* (Rochester, NY: Eastman Kodak Company, 1910), 27.

20. John Jakle, *Tourist: Travel in Twentieth-Century North America* (Lincoln: University of Nebraska Press, 1985), 121.

21. Jakle 1985, 121–122.

22. Wallace Nutting, *Photographic Art Secrets* (New York: Dodd Mead, 1927), 86–88, 108.

23. *How to Make Good Pictures*, 1936, 77.

24. Jakle 1985, 141.

25. Edward D. Wilson, "Beauty in Ugliness," *Photo Era* (June 1930), 303.

26. Eastman Kodak general ad copy, 1938.

27. While Kodak introduced the rangefinder on its 3A Autographic camera in 1916, it was not until the 1930s that this feature became common, improving on the occasionally frustrating ground-glass focusing. Through the 1920s most Kodak cameras were of the box-style or folding design and had some form of "brilliant" waist-level finder (two lenses and a mirror) or a simple non-optical frame set for eye-level use. These forms of viewfinder continued to appear on inexpensive Kodaks throughout the 1950s. In the mid-1930s optical eye-level viewfinders began to appear on some cameras, including the Bantams, 35mm models such as the Retina, and the larger roll-film cameras, sometimes with range finder companions.

28. Earlier cameras using 35mm film include Kodak's Tourist Multiple, introduced in 1913. But at the cost of $175 it was, like other 35mm cameras on the market, out of reach for most amateur photographers.

29. Stend 1939, 39.

30. Robert L. Duffus, "The Age of Play," *The Independent* 113 (December 20, 1924), 539.

31. Jay Ruby, *Secure the Shadow: Death and Photography in America* (Cambridge, MA: MIT Press, 1995), 75.

32. For an excellent discussion of the impact of photography in America during the 1930s, see John Raeburn, *A Staggering Revolution: A Cultural History of Photography in the Thirties* (Urbana: University of Illinois Press, 2006).

33. Quoted in Beaumond Newhall, "This Was 1937," in Fondiller 1979, 6.

34. *How to Make Good Pictures*, 1936, 8.

35. Raeburn 2006, 276–279.

36. Deschin 1936, 3.

37. Deschin 1936, 22.

38. Horace Bristol, "The Miniature Camera: Social Dynamite!" *Camera Craft* (January 1937): 3.

39. Coursin Black, "Candid Photography Is Making Us Human Goldfish," *Photography* 6, no. 39 (May 1938), n.p.

40. William Mortensen, "Let's Be Candid about the Candid Camera," *Camera Craft* (January 1938): 3–4.

41. Mortensen 1938, 4.

42. Mortensen 1938, 4.

Fun under the Shade of the Mushroom Cloud

1. William K. Young and Nancy K. Young, *The 1950s* (Westport, CT: Greenwood Press, 2004), 10.

2. Young and Young 2004, 62.

3. See Young and Young 2004; Karal Ann Marling, *As Seen on TV: The Visual Culture of Everyday Life in the 1950s* (Cambridge, MA: Harvard University Press, 1994); and David Halberstam, *The Fifties* (New York: Villard Books, 1993).

4. "The Leisured Masses," *Business Week* (September 12, 1953): 142.

5. Young and Young 2004, 121.

6. Marling 1994, 51–84, provides a fascinating account of the American obsession for hobbies in the 1950s and especially the fad for "paint-by-number" picture kits.

7. "Each Advertisement Brings Customers," *New York Times*, July 3, 1949, X9; "A Camera Is the Finest Gift for Youngsters Going to Camp," *New York Times*, June 9, 1949, 24.

8. "Postwar Supply of Cameras to Be Shutterbug's Paradise," *Washington Post*, June 24, 1945, B6, reported that "trade sources" estimated that "an astronomical 4,679,700,000,000 average photographs could have been made with the total amount of film used by the armed services last year."

9. See "The Wonderful New Color Film," *US Camera* 7 (June 1944): 2; "The War Isn't Over…But…," *US Camera* 7 (October 1944): 12.

10. Douglas Collins, *The Story of Kodak* (New York: Harry N. Abrams, Inc., 1990), 258.

11. "Snapshots in Color for All Available by New Process," *Christian Science Monitor,* December 18, 1941, 8.

12. Collins 1990, 258.

13. See "Give Color for Christmas," *New York Times,* November 29, 1953, X19.

14. "Everybody's Happy," *New York Times,* December 8, 1949, 41.

15. "History of Kodak Cameras," Eastman Kodak Company, Rochester, NY, March 1999, publication no. AA-13 (*www.brownie-camera.com/manuals/AA13.pdf,* accessed January 2007).

16. "History of Kodak Cameras," 1999.

17. "Sears Camera Catalog" (Chicago, 1952), unpaginated.

18. *Fortune,* as quoted in *www.arguscamera.com/history* (accessed January 2007).

19. "A Round-Up of 35mm Cameras Under $100," *Popular Photography* 40 (March 1957), 76–79, 89.

20. "Films Developed and Enlarged," *New York Times,* June 14, 1953, S11.

21. Colin Ford, *The Story of Popular Photography* (North Pomfret, VT: Trafalgar Square Publishing, 1989), 88.

22. Young and Young 2004, 181.

23. Young and Young 2004, 213.

24. Marling 1994, 5, 287, and 6.

25. "12 Ways to Make a Snapshot," *US Camera* 17 (April 1954), 63.

26. Margery Lewis, "Learn to SEE," *Photography* 33 (July 1953), 62.

27. Nancy Martha West, *Kodak and the Lens of Nostalgia* (Charlottesville: University Press of Virginia, 2000), 34–35, notes that Kodak intentionally used photographs in its advertisements that appeared unsophisticated and amateurish.

28. "A Kodak Camera," *New York Times,* December 3, 1952, 37.

29. "Every Weekend Has Its Story," *New York Times,* June 11, 1952, 22; and "Smiles that Will Always Be Bright in Snapshots," *Life* 36 (May 31, 1954): 53.

30. Dorothy Fields, "What Happened to the Snapshot?" *Popular Photography* 38 (May 1956): 59.

31. Fields 1956, 59, 114, 115.

32. John Ibson, *Picturing Men: A Century of Male Relationships in Everyday American Photography* (Washington, DC: Smithsonian Institution Press, 2002), 159–195, notes the dramatic rise in the number of intimate male-to-male photographs made during World War II and the abrupt and equally dramatic decrease in such photographs once peace was declared.

33. In October 1949 Maidenform released the first of its highly successful and long-running advertisements "I Dreamed I Went Shopping in My Maidenform Bra," featuring a drawing of a woman, clad only in a skirt and a bra, shopping at a grocery store. The advertisements quickly became part of the 1950s lingo: when Mamie Eisenhower went backstage at a Washington fashion show, a startled model was later said to have cried out, "Gosh, I never dreamt I'd meet Mrs. Eisenhower in my Maidenform bra!" See Marling 1994, 17–19.

Although people throughout history have claimed to see UFOs, the number of alleged sightings in the United States escalated markedly after 1947 when a pilot reported seeing objects outside his plane that looked like flying saucers (see "'Flying Saucers' Mystify Experts, May Be Prank of Nature, They Say," *New York Times,* July 1, 1947, 1). Thereafter, many other sightings and encounters were rumored throughout the 1950s. Hollywood quickly picked up on the obsession and released numerous films on the subject, including *The Flying Saucer* (1950), *The Day the Earth Stood Still* (1951), and *The War of the Worlds* (1953).

34. Winogrand, as quoted in Janet Malcolm, *Diana & Nikon: Essays on the Aesthetic of Photography* (Boston: David R. Godine, 1980), 37.

35. "Greatest Slide Show on Earth," *New York Times,* October 8, 1952, 24.

36. B. F. March, "Polaroid Photography Perks up Party," *Popular Photography* 40 (March 1957): 92.

37. Harrison Forman, with foreword by Ivan Dmitri, *How to Make Money with Your Camera* (New York: McGraw-Hill Book Company, 1952), 1.

38. Foreman 1952, 49.

39. "Easy! Win $5000 Cash," *Life* 36 (May 10, 1954): 73.

40. "Easy! Win $5000 Cash," 1954, 73.

41. Willard Morgan, *The American Snapshot,* exh. cat. (New York: The Museum of Modern Art, 1944), unpaginated.

42. Norris Harkness, *The New York Sun,* as quoted in "The American Snapshot," *US Camera* 7 (May 1944): 36.

43. John Adam Knight, *New York Post,* as quoted in *US Camera* 7 (May 1944): 36.

44. For more discussion, see Alison Nordström and Peggy Roalf, *Colorama: The World's Largest Photograph, from Kodak and the George Eastman House* (New York: Aperture, 2004).

45. See Christopher Gray, "The End of the Line for Grand Central's Big Picture," *New York Times,* June 18, 1989, R8; and "Photographic Center: Eastman Opens Information Site in Grand Central," *New York Times,* May 16, 1950, 43.

46. "The End of the Line for Grand Central's Big Picture."

47. Nordström and Roalf 2004, 5.

48. For an extensive discussion of this exhibition and its publication, see Eric J. Sandeen, *Picturing an Exhibition: The Family of Man and 1950s America* (Albuquerque: University Press of New Mexico, 1996).

49. Sandeen 1996, 40 and 46.

50. Sandeen 1996, 49.

51. See Nina C. Leibman, *Living Room Lectures: The Fifties Family in Film and Television* (Austin: University of Texas Press, 1995).

When the Earth Was Square

1. See *Camera Work,* no. 41 (January 1913); the set of four photographs, each titled *A Snapshot, Paris,* is reproduced in Sarah Greenough, *Alfred Stieglitz: The Key Set,* 2 vols. (Washington: National Gallery of Art; and New York: Harry N. Abrams, Inc., 2002), 1: 220–222.

2. Martin Parr and Gerry Badger, *The Photobook: A History,* 2 vols. (London: Phaidon Press, 2004 and 2006).

3. Benjamin Buchloh, "Conceptual Art 1962–1969: From the Aesthetic of Administration to the Critique of Institutions" (1989), in Alexander Alberro and Blake Stimson, eds., *Conceptual Art: A Critical Anthology* (Cambridge, MA: MIT Press, 1999), 525–527. Buchloh takes his phrase from El Lissitzky's children's book *Pro dva kvadrata: suprematicheskii skaz v 6-ti postroikakh* (Of Two Squares: A Suprematist Tale in Six Constructions), which appeared in Berlin in 1922.

4. *Life* did not, however, credit Zapruder when it published stills from his film; see Barbie Zelizer, *Covering the Body: The Kennedy Assassination, the Media, and the Shaping of Collective Memory* (Chicago: University of Chicago Press, 1992), 68. The original film, deposited for safekeeping in the National Archives, was claimed by the United States government in 1998 under the law of eminent domain, at which point its maker's heirs were awarded $16 million in compensation. Copies made by *Life* magazine, which had been restored to the Zapruder family in 1975 for the token sum of $1, are now the property of a museum established in Dallas to commemorate Kennedy's assassination, along with copyright to the film. See *http://en.wikipedia.org/wiki/Zapruder* (accessed November 2006).

5. See Jeffrey Ruoff, *An American Family* (Minneapolis: University of Minnesota Press, 2002).

6. See *http://www.pbs.org/lanceloud/about* (accessed December 2006), source unspecified.

7. Diane Waggoner points out in her essay for the present catalogue that children formed a significant market for snapshot cameras at their inception and for decades afterward.

8. Herbert Kalmus and his company, Technicolor, developed dye transfer as a method for printing film stock in color during the 1920s. Technicolor rose to dominance in the 1930s–1950s, then was slowly forced out of business by 1974, only to make a comeback in the 1990s and more recently. On the heyday of Technicolor, see Richard W. Haines, *Technicolor Movies: The History of Dye Transfer Printing* (Jefferson, NC: McFarland, 1993).

9. William Eggleston, *Ancient and Modern*, exh. cat. (London: Barbican Art Gallery, 1992), 56.

10. John Szarkowski, *Garry Winogrand: Figments from the Real World,* exh. cat. (New York: The Museum of Modern Art, 1988), 35–36. See also "Winogrand Leaves One-Third of a Million Unedited Frames Behind," *Popular Photography* 98, no. 4 (April 1986): 14–15.

11. "Monkeys Make the Problem More Difficult: A Collective Interview with Garry Winogrand," *Image* 15, no. 2 (July 1972): 4, paraphrased in Szarkowski 1988, 23.

12. Szarkowski 1988, 30, paraphrases Winogrand to this effect in discussing a "snapshot aesthetic," a phrase he says was coined for Winogrand; the origins of the term in mid-1960s literature have yet to be pinpointed, however.

13. "John Baldessari: An Interview by Nancy Drew," in *John Baldessari*, exh. cat. (New York: The New Museum, 1981), 63.

14. Graham began "Homes for America" as a photographic project in mid-1965, working first with a Kodak Instamatic, then with 24 × 36 mm slide film. On the occasion of the exhibition *Projected Art* at the Finch College Museum of Art in Manhattan, in which Graham showed approximately twenty of these slides, *Arts Magazine* arranged to publish a sequence of texts and images on this subject, for which Graham prepared several mockups, including the one reproduced in the present essay. The published text, however ("Homes for America: Early 20th Century Possessable House to the Quasi-Discrete Cell of '66," *Arts Magazine* 41:3 [December 1966–January 1967]: 21–22), included no photographs by Graham. *See* Jean-François Chevrier, "Dual Reading/Double Lecture," in Chevrier, Allan Sekula, and Benjamin H. D. Buchloh, *Walker Evans and Dan Graham*, exh. cat. (New York: Whitney Museum of American Art, 1992), 23 nn. 4 and 5; and Marianne Brouwer, ed., *Dan Graham Oeuvres 1965–2000*, exh. cat. (Porto, Portugal: Museu de Arte Contemporânea de Serralves, 2001), 102–105.

15. Kate Linker, *Vito Acconci* (New York, 1994), 8–9.

16. Sandra S. Phillips et al., *Diane Arbus: Revelations*, exh. cat. (San Francisco: San Francisco Museum of Modern Art, 2003), 41.

17. Christian Boltanski, *Tout ce que je sais d'une femme qui est morte et que je n'ai pas connue,* [or] *Les documents photographiques qui suivent m'ont été transmis par Luis Caballero* (1970), in Jennifer Flay, ed. *Christian Boltanski: Catalogue; Books, Printed Matter, Ephemera, 1966–1991* (Cologne and Frankfurt: Portikus Books, 1992), 30–31.

18. Christian Boltanski, *Recherche et présentation de tout ce qui reste de mon enfance, 1944–1948* (1969) in Flay 1992, 10. Translation by Matthew S. Witkovsky.

Technical Milestones in Snapshot Cameras and Film

Auer 1975; Coe 1978; Coe and Gates 1977; Collins 1990; Ford 1989; Ford and Steinorth 1988; Nickell 2005; and Wade 1979; as well as *www.kodak.com; www.agfa.com; www.ilfordphoto.com;* and *www.fujifilmusa.com*

Select Bibliography

Akeret, Robert U. *Photoanalysis: How to Interpret the Hidden Psychological Meaning of Personal and Public Photographs.* New York: Peter H. Wyden, Inc., 1973.

Albers, Phillip, and Michael Nowak. "Lomography: Snapshot Photography in the Age of Digital Simulation." *History of Photography* 23, no. 1 (Spring 1999): 101–104.

The American Image: Photographs from the National Archives, 1860–1960. New York: Pantheon Books, 1979.

The American Snapshot: An Exhibition of the Folk Art of the Camera. Exhibition catalogue. New York: The Museum of Modern Art, 1944.

Aries, Philippe. "Pictures of the Family." In *Centuries of Childhood: A Social History of Family Life.* Translated by Robert Baldick. New York: Vintage Press, 1962.

Auer, Michael. *The Illustrated History of the Camera: From 1839 to the Present.* Boston: New York Graphic Society, 1975.

Barthes, Roland. *Camera Lucida: Reflections on Photography.* Translated by Richard Howard. New York: Hill and Wang, 1981.

Batchen, Geoffrey. *Forget Me Not: Photography and Remembrance.* New York: Princeton Architectural Press, 2004.

———. *Photography's Objects.* Exhibition catalogue. Albuquerque: University of New Mexico Art Museum, 1997.

———. "Responses to a Questionnaire" and "Vernacular Photographies." *History of Photography* 24, no. 3 (Autumn 2000): 229–231, 262–271.

Bayler, Roger Child. *Hand Cameras: A Handbook for Amateurs.* London: Iliffe, 1923.

Bentley, Kevin. *Sailor: Vintage Photos of a Masculine Icon.* Tulsa: Council Oak Books, 2001.

Bernard, Bruce. *One Hundred Photographs: A Collection by Bruce Bernard.* London: Phaidon Press, 2002.

Bush, Russell. *Affectionate Men: A Photographic History of a Century of Male Couples.* New York: St. Martin's Press, 1998.

Chalfen, Richard. *Snapshot Versions of Life: Explorations of Home-Made Photography.* Bowling Green, OH: Bowling Green State University Popular Press, 1987.

Chien, David. *About 85 Years Ago: Photo Postcards from America, 1907–1920.* Niwot, CO: Roberts Rinehart Publishing, 1997.

Clarke, Deborah. "Family Photos: The Living and the Dead." *Globe and Mail* 11 (April 1995): A20.

Coe, Brian. *Cameras: From Daguerreotypes to Instant Pictures.* Gothenburg, Sweden: AB Nordbok, 1978.

———, and Paul Gates. *The Snapshot Photograph: The Rise of Popular Photography, 1888–1939.* London: Ash & Grant, 1977.

Coleman, A. D. "Quotidian or Vernacular Photography: Premises, Functions, and Contexts." *Impact of Science on Society* 42, no. 4 (1992): 315–327.

———. *Snapshots: The Extraordinary Ordinary.* Exhibition booklet. New York: Ubu Gallery, 1999.

Collins, Douglas. *The Story of Kodak.* New York: Harry N. Abrams, Inc., 1990.

Czech, Kenneth P. *Snapshot: America Discovers the Camera.* Minneapolis: Lerner Publications Company, 1996.

Darrah, William Culp. *Stereoviews.* Gettysburg: Times and News Publishing Co., 1964.

Dean, Tacita. *Floh.* Göttingen: Steidl Publishing, 2001.

Doris, David. "'It's the Truth, It's Actual…': Kodak Picture Spots at Walt Disney World." *Visual Resources* 14 (1998): 321–338.

Drugstore Photographs: Snapshots from the Collections of Christopher Rauschenberg and Terry Toedtemeier. Portland, OR: Pair-o-dice Press, 1976.

Duve, Thierry de. "Time Exposure and Snapshot: The Photograph as Paradox." *October* 5 (Summer 1978): 113–125.

Dykstra, Jean. "In the Vernacular." *Art and Auction* 21 (September 21–October 4, 1998): 49.

Dylong, John. *Living History, 1925–1950.* Chicago: Loyola University Press, 1988.

Edwards, Elizabeth. *We Are the People: Postcards from the Collection of Tom Phillips.* London: National Portrait Gallery, 2004.

Ford, Colin, ed. *The Story of Popular Photography.* North Pomfret, VT: Trafalgar Square Publishing, 1989.

Ford, Colin, and Karl Steinorth, eds. *You Press the Button, We Do the Rest.* London: Dirk Nishen Publishing, 1988.

Foresta, Merry A., and Jeana Kae Foley. *At First Sight: Photography and the Smithsonian.* Washington, DC: Smithsonian Institution Press, 2003.

Foster, John, and Teenuh Foster. *Accidental Mysteries: Extraordinary Vernacular Photographs from the Collection of John and Teenuh Foster.* Self-published, 2006.

Frizot, Michel. *A New History of Photography.* New York: Koneman, 1998.

Garrett, Craig. "Coerced Confessions: Snapshot Photography's Subjective Objectivity." *Flash Art International* 36, no. 233 (November–December 2003): 72–75.

Germain, Julian. *Brief Encounter.* Exhibition catalogue. Salford, England: Viewpoint Photography Gallery, 1995.

Gottlieb, Lenny. *Lost and Found in America: The Homefront, Fall 1968, Family Photos during the Vietnam War.* Stockport, England: Dewi Lewis Publishing, 2004.

Graves, Ken, and Mitchell Payne. *American Snapshots.* Oakland: Scrimshaw Press, 1977.

Green, Jonathan. "The Snapshot." *Aperture* 19, no. 1 (1974): 36.

Hall, Michael, Shirley Teresa Wajda, and James Rutowski. *Family Album: The James Rutowski Collection of American Photographs.* Exhibition catalogue. Columbus, OH: Columbus Museum of Art, 2004.

Handy, Roger, and Sharon Delano. *Summer Vacation/Found Photographs.* Santa Barbara: T. Adler Books, 2000.

Hattersley, Ralph. "Family Photography as a Sacrament." *Popular Photography* 68 (June 1971): 106–109.

Henisch, Heinz K., and Bridget A. Henisch. *Positive Pleasures: Early Photography and Humor.* University Park: The Pennsylvania State University Press, 1998.

Hicks, Robert. *The Snapshot Book: An Everyday Guide to Photography.* Secaucus, NJ: Chartwell Books, 1982.

Hill, Kimi Kodani, ed. *Shades of California: The Hidden Beauty of Ordinary Life: California's Family Album.* Berkeley: Heyday Books, 2001.

Hines, Babette. *Love Letters, Lost.* New York: Princeton Architectural Press, 2005.

———. *Photobooth.* New York: Princeton Architectural Press, 1997.

Hirsch, Julia. *Family Photographs: Content, Meaning, and Effect.* New York: Oxford University Press, 1981.

Hirsch, Marianne. *Family Frames: Photography, Narrative, and Postmemory.* Cambridge, MA: Harvard University Press, 1997.

———, ed. *The Familial Gaze.* Hanover, NH: Dartmouth College; University Press of New England, 1999.

Ibson, John. *Picturing Men: A Century of Male Relationships in Everyday American Photography.* Washington, DC: Smithsonian Institution Press, 2002.

Jaguaribe, Claudia. *Anonymous Portraits.* Exhibition catalogue. São Paulo: Museu de Arte de São Paulo, 1997.

Jenkins, Reese V. *Images and Enterprise: Technology and the American Photographic Industry, 1839–1925.* Baltimore: Johns Hopkins University Press, 1975.

Johnson, Robert Flynn. *Anonymous: Enigmatic Images from Unknown Photographers.* New York: Thames & Hudson, 2004.

Jussim, Estelle. "From the Studio to the Snapshot: An Immigrant Photographer of the 1920s." *History of Photography* 1, no. 3 (July 1977): 183–199.

Kalina, Richard. "Painting Snapshots, or, The Cursory Spectacle." *Art in America* 81, no. 6 (June 1993): 92–95, 118.

Kaplan, Daile. *Pop Photographica: Photography's Objects in Everyday Life, 1842–1969.* Exhibition catalogue. Toronto: Art Gallery of Ontario, 2003.

Kardos, Sandor. *Horus Archives: Sandor Kardos.* Budapest: AXON/Laszio Basico, 1989.

Kenyon, Dave. *Inside Amateur Photography.* London: B.T. Batsford Ltd., 1992.

Kessels, Erik, and Tyler Whisnand. *In Almost Every Picture.* Amsterdam: Kessels Kramer, 2005.

Kimmelman, Michael. *The Accidental Masterpiece: On the Art of Life and Vice Versa.* New York: Penguin Press, 2005.

King, Graham. *Say "Cheese!" Looking at Snapshots in a New Way.* New York: Dodd, Mead, 1984.

———. *Snaps as Art: A Brief Study of the Photographic Snap.* London: Pimlico Press, 1978.

Klamkin, Charles. *Photographica: A Guide to the Value of Historic Cameras and Images.* New York: Funk and Wagnall's, 1978.

Koltun, Lilly, ed. *Private Realms of Light: Amateur Photography in Canada, 1839–1940.* Markham, Ontario: Fitzhenry & Whiteside, 1984.

Kotchemidova, Christina. "Why We Say 'Cheese': Producing the Smile in Snapshot Photography." *Critical Studies in Media Communication* 22, no. 1 (March 2005): 2–25.

Kotkin, Amy. "The Family Photo Album as a Folklore." *Exposure* 16 (March 1978): 4–8.

Kuhn, Annette. *Family Secrets: Acts of Memory and Imagination.* London: Verso, 1995.

Langford, Martha. *Suspended Conversations: The Afterlife of Memory in Photographic Albums.* Montreal: McGill-Queen's University Press, 2001.

Lemagny, Jean-Claude, and André Rouillé, ed. *A History of Photography: Social and Cultural Perspectives.* Cambridge: Cambridge University Press, 1987.

Lesy, Michael. *Time Frames: The Meaning of Family Pictures.* New York: Pantheon Books, 1980.

———. *Wisconsin Death Trip.* New York: Pantheon Books, 1973.

Lothrop, Eaton S., Jr. *A Century of Cameras: From the Collection of the International Museum of Photography at George Eastman House.* Dobbs Ferry, NY: Morgan & Morgan, Inc., 1973.

Mainardi, Robert. *Strong Man: Vintage Photos of a Masculine Icon.* Tulsa: Council Oak Books, 2001.

Meikle, Jeffrey. "A Paper Atlantis: Postcards, Mass Art, and the American Scene." *Journal of Design History* 13 (2000): 267–286.

Mensel, Robert. "'Kodakers Lying in Wait': Amateur Photography and the Right of Privacy in New York, 1885–1915." *American Quarterly* 43 (March 1991): 24–45.

Mikkelsen, Tim, and Phyllis Wright-Herman. *Hey Girl!* Riverside, NJ: Andrews McMeel Publishing, 2000.

Morgan, Hal. *Big Time: American Tall-Tale Postcards.* New York: St. Martin's Press, 1981.

———. *Prairie Fires and Paper Moons: The American Photographic Postcard, 1900–1920.* Boston: David R. Godine, 1981.

Motz, Marilyn. "Visual Autobiography: Photograph Albums of Turn-of-the-Century Midwestern Women." *American Quarterly* 41 (March 1989): 63–92.

Naef, Weston. "The Snapshot as Social Memory." *American Art Review* 16, no. 6 (November–December 2004): 144–147.

Nickel, Douglas R. "Roland Barthes and the Snapshot." *History of Photography* 24, no. 3 (Autumn 2000): 232–235.

———. *Snapshots: The Photography of Everyday Life, 1888 to the Present.* Exhibition catalogue. San Francisco: San Francisco Museum of Modern Art, 1998.

Nickell, Joe. *Camera Clues: A Handbook for Photographic Investigation.* Lexington: University Press of Kentucky, 1994; repr. 2005.

Nocito, James. *Found Lives: A Collection of Found Photographs.* Layton, UT: Gibbs Smith, 1998.

Nordstrom, Alison, and Peggy Roalf. *Colorama: The World's Largest Photographs From the Kodak and the George Eastman House Collection.* New York: Aperture, 2004.

Norfleet, Barbara. *The Champion Pig: Great Moments in Everyday Life.* Boston: David R. Godine, 1979.

Ohrn, Karin. "The Photo Flow of Family Life: A Family Photograph Collection." *Folklore Forum* 13 (1975): 27–36.

Olivier, Marc. "George Eastman's Modern Stone-Age Family: Snapshot Photography and the Brownie." *Technology and Culture* 48, no. 1 (January 2007): 1–19.

Osborn, Nicholas. "Nicholas Osborn's Collection." *Gomma* 2 (March 2006): 124–129.

Parry, Eugenia, Max Kozloff, and Adam D. Weinberg. *Vanishing Presence.* Minneapolis: Walker Art Center, 1989.

Paster, James. "Snapshot Magic: Ritual, Realism, and Recall." Ph.D. diss., The University of Texas at Dallas, 1994.

Pine, Gail, and Jackie Woods. "The Art of the Anonymous: Special Feature on Collecting Vernacular Photography." *Black & White Magazine* 38 (August 2005): 32–41.

Pinsent, Richard. "Vernacular Aesthetics and Aesthetic Vernacular." *Art Newspaper* 7 (January 1997): 18.

Reiakvam, Oddlaug. "Reframing the Family Photograph." *Journal of Popular Culture* 26 (Spring 1993): 3–63.

Renno, Rosangela. *Bibliotheca.* Barcelona: Gustavo Gili, 2003.

Rian, Jeff. "Homemade Iconology: Snapshot Artists." *Flash Art* 27, no. 179 (November–December 1994): 57–60.

Robbins, Mark, Sarah Rogers, and Lynne Tillman. *Evidence: Photography and Site.* Exhibition catalogue. Columbus: Ohio State University, Wexner Center for the Arts, 1997.

Roncero, Rafael. *An (Other) History of Photography.* Madrid: Obra Social Caja Madrid, 2000.

Rubin, Cynthia, and Morgan Williams. *Larger than Life: The American Tall-Tale Postcard, 1905–1915.* New York: Abbeville Press, 1990.

Ruby, Jay. "Images of Rural America: View Photographs and Picture Postcards." *History of Photography* 12 (October–December 1988): 327–343.

Schonauer, David. "Triumph of Vernacular." *American Photo* 11 (September–October 2000): 20.

Semorile, Trina. "Exposure to Light: *The American Amateur Photographer* and the Dialogue with Technology, Social Structures, and Cultural Change." Ph.D. diss., New York University, 2004.

Siegel, Alan. "Alan Siegel on Building an Eclectic Collection of Photographs." *Art on Paper* 7 (November–December 2002): 109.

———, et al. *One Man's Eye: Photographs from the Alan Siegel Collection.* New York: Harry N. Abrams, Inc., 2000.

Silber, Mark. *The Family Album: Photographs of the 1890s and 1900s, by Gilbert Wight Tilton & Fred W. Record.* Boston: David R. Godine, 1973.

Simon, Michael A. "The Photographic Snapshot." Master's thesis, Rochester Institute of Technology, 1986.

———. *The Snapshot: Contemporary Folk Art.* Exhibition catalogue. Rockford, IL: The Board of Trustees of Beloit College and Rockford Art Museum, 1991.

Skrein, Christian. *Snapshots: The Eye of the Century.* Stuttgart: Hatje Cantz, 2004.

Slater, Dan. "Domestic Photography and Digital Culture." In *The Photographic Image in Digital Culture,* edited by Martin Lister. New York and London: Routledge, 1995.

Smith, Catherine, and Cynthia Greig. *Women in Pants: Manly Maidens, Cowgirls, and Other Renegades.* London: Harry N. Abrams, Inc., 2003.

Smith, Joel. "Roll Over: The Snapshot's Museum Afterlife." *Afterimage* 29, no. 2 (September/October 2001): 8–11.

Snap! "A Family Album" Compiled and Juxtaposed by Andrew Lanyon. London and Bedford: The Gordon Fraser Gallery Ltd., 1974.

Snyder, Stephanie, Barbara Levine, Matthew Stadler, and Terry Toedtemeier. *Snapshot Chronicles: Inventing the American Photo Album.* New York: Princeton Architectural Press; and Portland, OR: Douglas F. Cooley Memorial Art Gallery, Reed College, 2006.

Spence, Jo, and Patricia Holland, eds. *Family Snaps: The Meanings of Domestic Photography.* London: Virago, 1991.

Starl, Timm. *Knipser: Die Bildgeschichte der privaten Fotografie in Deutschland und Osterreich von 1880 bis 1980.* Munich and Berlin: Koehler & Amelang, 1995.

The Story of the Kodak Camera. Rochester, NY: Eastman Kodak Company, 1951.

Sultan, Larry, and Mike Mandel. *Evidence.* Afterword by Robert F. Forth. Greenbrae, CA: Clatworthy Colorvues, 1977.

Swartz, Joan M., and James R. Ryan, eds. *Picturing Place: Photography and the Geographical Imagination.* New York: I. B. Tauris, 2003.

Symbol and Surrogate: The Picture Within. Essay by Diana Schoenfeld. Honolulu: The University of Hawaii Art Gallery, 1989.

Szarkowski, John. *The Photographer's Eye.* Exhibition catalogue. New York: The Museum of Modern Art, 1966.

Tufte, Virginia, and Barbara Myerhoff. *Changing Images of the Family.* New Haven: Yale University Press, 1979.

Upton, John. *The Photograph as Artifice.* New York: Independent Curators Incorporated, 1979.

Vanderbilt, Paul. *Evaluating Historical Photographs: A Personal Perspective.* Nashville: American Association for State and Local History, 1979.

Vaule, Rosamond P. *As We Were: American Photographic Postcards, 1905–1930.* Boston: David R. Godine, 2004.

Wade, John. *A Short History of the Camera.* Watford, England: Fountain Press, 1979.

Wall, Jeff, and Roy Arden. "The Dignity of the Photograph." *Art Press* 251 (November 1999): 16–25.

Wallis, Brian, and Deborah Willis. *African American Vernacular Photography: Selections from the Daniel Cowin Collection.* New York: International Center of Photography; Göttingen: Steidl Publishing, 2005.

Walther, Thomas, and Mia Fineman. *Other Pictures: Anonymous Photographs from the Thomas Walther Collection.* Santa Fe: Twin Palms Publishers, 2000.

West, Nancy Martha. *Kodak and the Lens of Nostalgia.* Charlottesville: University Press of Virginia, 2000.

White, Stephen. *Harry Smith: Magic Moments; Photographs by a San Francisco Youth, 1940–1913.* Los Angeles: Stephen White Editions, 1981.

———, and Andreas Blühm. *The Photograph and the American Dream, 1840–1940.* Exhibition catalogue. Amsterdam: Van Gogh Museum; New York: Distributed Art Publishers, 2001.

Williams, Roy H. *Accidental Magic: The Wizard's Techniques for Writing Words Worth 1,000 Pictures.* Austin: Bad Press, 2001.

Williams, Val. "Cultural Sniping: The Art of Transgression and Family Secrets." *Creative Camera* 335 (August–September 1995): 37–38.

———. *Who's Looking at the Family?* Exhibition catalogue. London: Barbican Art Gallery, 1999.

Williamson, Glenn. "The Getty Research Institute: Materials for a New Photo History." *History of Photography* 22 (Spring 1998): 31–39.

Willis, Deborah. *Picturing Us: African American Identity in Photography.* New York: New Press, 1994.

Wolff, Laetitia. *Real Photo Postcards: Unbelievable Images from the Collection of Harvey Tulcensky.* New York: Princeton Architectural Press, 2005.

Wright, David. "Photography: Questions about the Vernacular." *The New Criterion* 8 (October 1989): 46–50.

Zanes, Warren. "The Flea Market Museum." *Afterimage* (September/October 2000): 13.

Zeitlin, Steven J., Amy J. Kotkin, and Holly Cutting Baker. *A Celebration of American Family Folklore: Tales and Traditions from the Smithsonian Collection.* Cambridge, MA: Yellow Moon Press, 1982.

Zuromskis, Catherine. "Snapshot Culture: Personal Photography in Everyday Life." Master's thesis, SUNY, Stony Brook, 2000.

Index

Credits

Photography

figs. 1.3, 1.4, 1.6, 1.7, and 1.23 courtesy Ellis Collection of Kodakiana, Emergence of Advertising On-Line Project, John W. Hartman Center for Sales, Advertising & Marketing History, Duke University Rare Book, Manuscript, and Special Collections Library (*http://scriptorium.lib.duke.edu/eaa/*) (acc. nos. K0005, K0033, K0014, K0520, and K0470a)

fig. 1.20, fig. 1.22 (National Gallery of Art Library, Gift of David K. E. Bruce in memory of Andrew W. Mellon), and figs. 3.1, 3.4, 4.1, 4.4, and 4.5: photographs by the National Gallery of Art division of imaging and visual services

fig. 4.2 courtesy John Baldessari, Santa Monica, California

fig. 4.3 courtesy Marian Goodman Gallery, New York

Technical Milestones in Snapshot Cameras and Film:

figs. 1, 4, 5, 15, and 18 courtesy Neil D. Cohen, District Photo, Inc.

figs. 2, 3, 6, 7, 9, 16, and 17 courtesy Sarah Wagner and Steven Puglia

figs. 8 and 12 courtesy Sarah Wagner, Steven Puglia, and Constance McCabe

figs. 10, 11, 13 and 14 courtesy Constance McCabe

fig. 19 courtesy Smithsonian Institution Libraries, Washington, DC

Photographs of cameras in the chronology are by Lee Ewing, while works of art owned by the National Gallery of Art that are reproduced in the catalogue have been photographed by Lorene Emerson and Kenneth Fleisher, division of imaging and visual services.

Collection of Robert E. Jackson

pls. 2, 4, 5, 7–11, 14, 18, 19, 21, 22, 24–29, 31–36, 38, 41, 42, 44, 46–52, 54, 56, 58–62, 64, 68–70, 72, 74, 76, 86–90, 93–104, 111, 112, 114–116, 122, 123, 125, 127, 129–132, 138–142, 144, 147–152, 155–157, 159, 161–163, 165–167, 171–173, 175, 176, 202, 203, 206–208, 212–215, 217–220, 222, 224, 226, 227, 229, and 232–234; and figs. 1.1, 1.2, 1.9–1.19, 1.21, 1.25, 2.2, 2.3, and 2.7

National Gallery of Art, Gift of Robert E. Jackson

pls. 1, 3, 6, 12, 13, 15–17, 20, 23, 30, 37, 39, 40, 43, 45, 53, 55, 57, 63, 65–67, 71, 73, 75, 77–85, 91, 92, 105–110, 113, 117–121, 124, 126, 128, 133, 134–137, 143, 145, 146, 153, 154, 158, 160, 164, 168–170, 174, 177–201, 204, 205, 209–211, 216, 221, 223, 225, 228, 230, and 231

Display images

facing title page: pl. 144
facing Director's Foreword: pl. 39
facing Introduction: pl. 92
opening Waggoner essay:
detail of pl. 15
opening Kennel essay:
detail of pl. 53
opening Greenough essay:
detail of pl. 137
opening Witkovsky essay:
detail of pl. 212
facing Afterword: pl. 164